Monkey Painting

Monkey Painting

THIERRY LENAIN

REAKTION BOOKS

To Claire

Published by Reaktion Books Ltd
11 Rathbone Place, London W1P 1DE, UK

First published 1997
This is a revised and expanded edition of
La peinture des singes published by
Editions Syros Alternatives, Paris, 1990

Copyright © Thierry Lenain, 1997
Introduction © Desmond Morris, 1997

Translated by Caroline Beamish
Designed by Ron Costley
Photoset by Wilmaset Ltd, Birkenhead, Wirral
Printed and bound by BAS Printers, Over Wallop, Hants

British Library Cataloguing in Publishing Data:
Lenain, Thierry
 Monkey painting : history and theory
 1. Animals as artists 2. Painting – Psychological aspects
 3. Monkeys in art
 I. Title
 750.1'9
 ISBN 1 86189 003 6

Published with the support of the Ministry of Education,
Research and Training, French Community of Belgium.

Contents

Introduction by Desmond Morris

When my book *The Biology of Art* was published in 1962 there were three reactions: some were angry, some amused and some intrigued. The angry reactions came from individuals who misunderstood what I was trying to do. They felt that to make a serious study of the picture-making activities of apes was a deliberate insult to academic art and an attempt to reduce all human art to the level of animal behaviour. They wrongly felt that I was making a social comment, when in reality I was engaged in a scientific investigation of the origins of aesthetics.

I retorted to angry critics that, because the artistic impulse in mankind is so difficult to understand and its origins are so obscure, we must grasp at any piece of information we can find in order to improve our chances of comprehending its nature. The work of human infants, of the insane, of primitive tribal peoples and of prehistoric cultures, all these are important, but the painting of chimpanzees is, for me, no less fascinating and revealing. The chimpanzee shows, in its struggle towards order in its simple visual statements, a brain that wants to 'compose' its lines into some kind of pattern. The pattern never becomes representational, but it does change and develop with the passage of time and it does show just enough organization for us to be able to analyse it and study it. If the ape brain were more advanced, analysis would become difficult. So the ape painter is a wonderful subject for study. He is not a joke, he is not a great artist ... he is just at the threshold of art, struggling to pass over into that fascinating world of visual exploration that fills our human art galleries and the walls of our houses with such exciting images. This is why I was so engrossed in the experiments with my young chimpanzee, back in the 1950s.

Other critics of my work were not angry, but simply amused. They saw the ape paintings, not as an attack on the dignity of academic art, but as a way of scoring points against modern art. They used the ape art to enjoy a cheap laugh at the expense of Abstract Expressionism, Tachisme, and other extreme forms of the contemporary art scene. They too were missing the point. If apes were so

absorbed in making abstract patterns, this did not degrade human abstract painting. On the contrary, it meant that the human works were advanced, sophisticated examples of something so primary and basic that even the ape brain was excited by it. It strengthened the validity of what the human abstract artists were doing, it did not weaken it. And to educated eyes there was, of course, the world of difference between the simple beginnings of the apes, and the mature distillations of the human artists.

This difference was immediately clear to the artists themselves. Their reaction was neither anger, nor amusement. Instead they were intrigued and excited by what they saw. They realized they were looking at the germ of aesthetics, the first dawning of a sense of artistic control and exploration. In the pictures made by the chimpanzees they witnessed, objectively, the age-old battle of the artist to balance restraint with abandon. The ape would try new ideas, make new patterns, but only very slowly. Old patterns were repeated and only slightly altered as time went by. The war between wildness and tameness, when making lines, the war between novelty and security, between strangeness and familiarity, these were being worked out by the ape, at its simple level, just as human artists were working them out at their highly complex and advanced level. They felt a sympathy with the chimpanzee that non-artists could not grasp.

There is still much to be learned from ape art. More prolonged studies with exceptional apes are needed. It takes time to obtain the right circumstances with these volatile and highly physical animals. But once they have settled down to paint and have, momentarily, escaped into that fascinating challenge of 'making lines appear on a blank surface', they can become as intense in their concentration as any human artist at his easel.

I welcome this new study of ape painting by Thierry Lenain, published almost forty years after the appearance of my original book *The Biology of Art*. He and I have analysed the subject from very different viewpoints – I from biology and he from the humanities. As a result we stress different aspects and do not always agree with respect to our ultimate conclusions. But as he himself has said, 'this only shows how rich ape painting is, since it allows entirely different approaches'. For example, I stressed the similarities between ape art and human art, while Lenain stresses the

differences. I prefer to use a broader definition of art, he a narrower one. But we are both fascinated by the same phenomenon and by the debate which it provokes.

Oxford
December 1996

Acknowledgements

First of all, I should like to thank Desmond Morris. With his assistance, I have been able to examine a large number of documents which it would have been very difficult for me to find elsewhere. He has allowed me to use illustrations from his books and articles, and also to use unpublished material in his possession. Finally, and above all, his encouragement, his generosity and his openness of mind have helped to reinforce my determination to complete the present work.

I should also like to express my gratitude to Werner Müller, who allowed me to photograph his collection and to choose paintings to illustrate this book; he also enlightened me on various aspects of the painting behaviour of chimpanzees, and I owe to him my first close encounters with anthropoid apes.

Finally I should like to thank all those who, in so many different ways, have helped me to complete this book: B. Cooke, G. Dücker, R. S. Fouts, B. T. and R. A. Gardner, H. G. Gerwenat, M. Groenen, B. Holt, J.-P. Lang, D. Martens, S. Michalski, P. Miller, B. Rensch (†), D. Riout, I. Schretlen, V. I. Stoichita, L. Tessarolo, L. Van Elsacker, M. Vancatova, G. Wimmer.

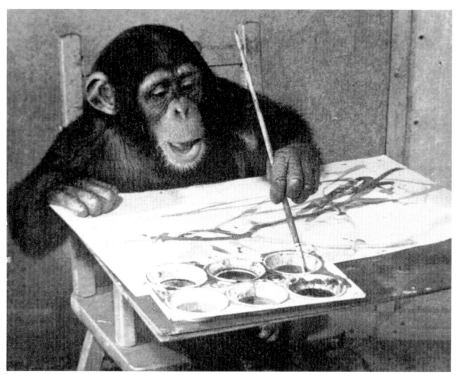

1 Congo, a young chimpanzee, at work.

Introduction

The action begins in the early 1950s in a library at Oxford University. Desmond Morris, a young Englishman whose interests are divided equally between ethology and modern painting, stumbles upon a brief article that triggers in him first disbelief and then a click of recognition. The article contained a summary of the research carried out by an American primatologist into the reactions of a chimpanzee to being presented with coloured pencils and sheets of paper, either blank or with various shapes on them.

Three years later, in 1956, the Oxford ethologist was appointed director of the unit that made cinema and television films for London Zoo. One of the animals he filmed was a young chimpanzee named Congo. In the following three years carefully controlled experiments were made with Congo and his paper and pencils. Six years after the scene in the library the ape had made nearly four hundred paintings and drawings. The best of these were shown at two exhibitions in London, where they provoked articles by well-known contemporary critics and caused a stir in the international press. At the subsequent sale, buyers fought over the little chimpanzee's work, which fetched prices rivalling those of prestigious artists of the period. The paintings entered important collections, some apparently royal.

Desmond Morris went on to write a number of books on animal and human behaviour, but his first book was on ape art, and to date it is the only book written on the subject. Entitled *The Biology of Art*, it was translated into a number of languages.[1] In addition to an account of the methods and development of the research undertaken at London Zoo, it also contains an analysis of the paintings and drawings themselves, amounting to an aesthetic theory of ape art. *The Biology of Art* also provided the first historical synthesis of experiments that preceded or were concurrent with the ones described.

The recognition of ape art as a separate scientific subject brought to light other similar experiments in the field, most of which were isolated cases. The first took place in pre-revolutionary Russia; the most recent was started in the USA three years after Congo did his

first drawings. The experiments at London Zoo, in any case, were common knowledge long before the book was published, in 1962. Other apes and even a monkey were set to work, and soon there was a blossoming of talent from the Netherlands to the United States, Germany and Austria. Desmond Morris listed about thirty painting apes and monkeys in the world, mainly chimpanzees, but there were also orang-utans, gorillas and capuchins. Other experiments were carried out subsequently, but they did not elicit the same response as those quoted in his book. What might be termed the great age of ape art lasted for about ten years. The subject was then almost completely forgotten until the beginning of the 1990s.[2]

During this short period, thanks to a strange encounter between animal psychology and modern art, an image appeared to have been introduced into contemporary history, an image that had in fact been a favourite with painters for centuries, although only as an ironical fantasy. From Teniers to Decamps, the theme of the artist as monkey was used as a pictorial fable to illustrate the vanity of art and of human nature in general. The monkey represented the poor imitation, the slavish, pretentious and inept copy of the true Creation. When Picasso was presented with one of Congo's paintings by Roland Penrose, who had brought it from London, he must have thought that reality had merged with historical fiction, reversing accepted values in the process. As if the monkey were having his revenge on the illustrators who had portrayed him as irredeemably foolish: a young chimpanzee had in a sense been promoted to the rank of artist.

The inventors and promoters of ape painting felt the need to explore the roots, the foundations or biological principles of its artistic aspect. One of the fundamental concerns of contemporary art is the deliberate regression into the primitive, in all its many forms and manifestations. Ape painting fitted neatly into this perspective, offering itself as the hitherto unwritten chapter in the history of 'primitivism'. It was presented as the opportunity for a regression that was far more radical than the movement responsible for the discovery of 'primitive art': as a means of returning to the earliest beginnings or conditions of art, earlier than could be attested to by any human culture.[3] The hope was to grasp the missing link between animal nature and culture. Or, to be more exact, to illuminate a point preceding even that link. The origins of art needed to be examined

beyond and before their earliest possible manifestations in history; a way had to be found of getting to the roots of the origins themselves, of revealing the origin of the origin; this was, in sum, the stated aim.

However, the terms in which such questions were asked were forcefully challenged by certain experts in the study of the artistic image and its history. They emphasised the fact that the basic functions of the drawing or painting equipment were beyond the reach of the animals themselves, and this meant that it was the biologists who were the primary agents of 'ape art'.

In an article now regarded as a classic of its kind, the art historian Meyer Schapiro cited ape painting as an example *a contrario* in order to establish one of the fundamental notions of aesthetics in the visual arts: the notion of pictorial field. The pictorial field is the specific visual location selected or set up to receive the contents of a painted image.[4] This location can be a flat or a convex surface, it can be regular or irregular, determinate or indeterminate, vast or minute, dominated by a vertical or horizontal axis etc. Each of these factors determining the field very closely interacts with the elements of the image as such. One of the essential acts in the creation of any artistic image is the definition of the type of visual support, which in turn conditions the fundamental scope of the image. This applies even to the great paintings of the Palaeolithic period, whose creators did not produce an artificial field but preferred the bumpy and usually unprepared walls of the caves to any other support. Instead of trying to smooth away the natural irregularities of the walls, they integrated them carefully into their paintings, occasionally modifying the colour by scraping the patina off the rock before drawing or painting on it.

Schapiro's position on the particular question of pictorial field in Palaeolithic painting needs clarifying because our current knowledge of this art does not support his view. In his opinion, the painters of the Palaeolithic period worked on supports that, from an aesthetic and symbolic point of view, were characterised solely by their negative properties: they were rough and their irregularities 'showed through the painting'; in other words, the Palaeolithic painters had no proper notion of pictorial field. In point of fact, not only were some of the paintings executed on prepared surfaces,[5] but, even more remarkably, some of the bumps on the wall had been carefully chosen to play a positive rôle in the arrangement of the pictorial representation; often this choice attests to unusual visual inventive-

ness, and the latest developments in research into Palaeolithic art clearly indicate that the rock surface itself was imbued with symbolic significance.[6] The irregularities of the wall did not therefore protrude 'through' the image, like stains emerging through the pattern of a fabric, but were an integral part of the image, both formally and from a symbolic point of view. Having raised the hypothesis that 'the unprepared background had positive significance for the prehistoric painter', Schapiro rejects it: 'I am inclined to think that the Palaeolithic surface was neutral, and was merely a support for the as yet undefined image.' We know now that the rejected hypothesis was the correct one, and that the cave wall must be regarded as a form of pictorial field in the fullest sense of the term.

Whatever his opinion on the particular case of Palaeolithic painting, Meyer Schapiro made an observation that is vitally relevant to our present concerns: apes do not set up a field for their 'painting' any more than young children do. It is imposed from outside by the enactment of a drama with which they are unacquainted. In fact, apes and monkeys accept the characteristics of the support they are given without any attempt at modification and without seeking any other type of field. They display no evidence of awareness that this basic parameter of all pictorial art can be modified. It also could be said that, unlike children, they remain eternally unaware of this possibility. This argument can be developed.

Most ape painting is done on sheets of paper of normal size (from 30 x 40 to 50 x 60 cm), similar to the size of an easel painting; this pictorial field has been the most common in western art for so long that by now this type of field seems to be the natural one. This is an illusion, however, particularly within the context of an enquiry into the origins of art, a vast field of enquiry. The pictorial field, along with the instruments (paint, brushes etc.) that constitute painting equipment, is a product of history.

Let us consider the process of painting on an artificial mobile support, rectangular in shape, smooth and of uniform texture. This apparently fairly widely established idea of the shape and size of a picture has a much shorter history than might be imagined. The 'picture' as a flat, separate and mobile image seems to have developed at the end of the geometric period in Greek art, about 700 BC, when small terra cotta plaques bearing painted scenes and designed to be hung became popular.[7] In other words, for thousands of years

remarkable cultures came and went with never a thought for any such pictorial field. If (as seems probable) there was no awareness of a pictorial field of that kind in the Palaeolithic period, then we must be talking about tens of millennia. Under the pretext of throwing light on the origins of art, the promoters of ape painting seem to have based their operation on an historical short circuit that applies to an essential attribute of painting rather than to a secondary parameter. The situation would have been completely different if the monkey had set up a rough kind of pictorial field of its own devising, but it never did. Although it is possible to acknowledge that monkey painting 'reveals impulses and reactions that are latent in its nature',[8] it is, according to Schapiro, basically nothing more than one incarnation of modern painting.

Another well-known art historian, H. W. Janson, adopted a position on the subject that was even more clear-cut than that of Schapiro. In his view, the products generally known as 'ape paintings' are in fact the work of human beings and owe nothing fundamental to the animal, even though they are 'painted' by the animal's hand. In reality, what happens is as follows: you allow an ape to daub paint on a canvas (or a sheet of paper) for a while in any way it likes (the fact that it is a canvas is of no interest to the animal anyway); when the result is beginning to look like an abstract painting you remove the canvas. All that remains to be done then is to exhibit it as an 'ape painting'. The process relies entirely on the imagination of the person carrying out the experiment. The chimpanzee, Janson writes, 'is merely a source of random patterns, more manageable perhaps and capable of a greater variety of movements than the proverbial donkey's tail with a brush tied to it, but essentially of the same order'.[9] Janson was at pains to point out that his explanation was not an attempt to imply rejection of the results as a non-artistic fabrication; he was simply trying to indicate the real significance of the results. These in fact fall squarely into an aesthetic category which, though often given great prominence in modern painting (in Tachiste painting in particular), has been with us since classical times, and was exploited quite deliberately by the great painters of the Renaissance – the lucky accident.[10] According to Janson, only the human carrying out the experiment anticipates that, by a felicitous accident, the daubed canvas will present this aesthetic appeal, today rendered even more appealing by the fact that abstract

painting has prepared us to appreciate it. The ape anticipates nothing whatsoever, and in fact is nothing more than a rather specialised piece of equipment. Janson adds that the play value of this process, which inevitably convinces you that the contrary is true, rests on the anthropomorphic character of this piece of equipment. What a good trick: the ape's hand is an illusion.

The interpretation of ape art, therefore, is based on two diametrically opposed perspectives. On one hand, there are the zoologists of aesthetics and their project, attempting a positive analysis of the reactions of the animal when the wherewithal for painting is put within its grasp. They also analyse the tangible results of the animal's contact with the painting equipment, scrutinising it for evidence of a fundamental aesthetic sense that is older than culture itself. The other perspective is that of the historians, and it hinges on the idea that monkey painting is something that has emerged from history and from the mind of man. Although these two opposing points of view define the main outlines of the problem of interpretation, they also form a barrier which the interpretative process must bypass in order to develop.

Obviously, the biologists of art were aware that their experiments depended partly on artificial input from the culture of human beings. They would not have dreamed of denying that apes do not set up their own field but borrow it lock, stock and barrel from outside, along with the equipment they need. Their main concern, however, was not to go into great detail about the consequences of this evidence, but to progress resolutely through their experiments towards the revelation of further facts. Although they undoubtedly paid some attention to the problem of the pictorial field, their perspective did not encourage them particularly to emphasise its essential rôle in the process of drawing or painting. The pictorial field, however, is not simply a passive receptacle to be filled by the artistic subject, nor is it a blank screen on which elementary aesthetic projections may appear, unadulterated. On the contrary, its particular structure plays an *active* part in determining the basic potential of the artistic act.

The same observation could also apply to the other items that make up the painting equipment, including the colours (consisting of pigments and medium), the equipment used to apply the colour to the support (brush, airbrush etc.), plus all the other instruments needed

to produce a picture (easel or stand, palette, maulstick, lighting etc.). These items, singly and in combination, are inevitably the products of a particular culture, and they have been in a constant state of change as the history of art has progressed; they are as much a constituent part of the history of art as the works of art themselves, helping to determine the possibilities and constraints negotiated by artists in order to create their works.

Because the active, historically determined rôle of the pictorial field, an essential component of the picture-making equipment, has been given such prominence, we now need to tackle the question of the meaning of ape painting in a different fashion. If the pictorial field is not an external parameter but rather an intrinsic aspect of the artistic act itself, then the study of the shapes drawn by the ape can throw no light on the real origins of art; in other words, it cannot reconstitute the circumstances surrounding the birth of art. Ape painting offers no enlightenment on the central question of the problem of the origins of art: how picture-making equipment came into being and how mankind came to set up a pictorial field to accommodate his painted forms. What we have here is nothing but a 'pre-human' reaction to the pictorial field typical of modern western painting, and it is possible that whatever seems specifically 'pre-human' in ape painting might be simply the absolute naïveté of the ape's response to that pictorial field.

If this analysis, however, leads to the conclusion that the ape does not paint, or that it receives no stimulus from the aesthetic particularity of its painting; or, in other words, if it leads to the conclusion that the hand of the ape plays no real part in the process of producing the paintings, then it goes much too far. It is a fact that when a non-human primate is given the opportunity to paint it does not do just any old thing in any old way – far from it; nor do the results of its activity stem predominantly from themes selected and imposed by the person doing the experiment. Monkey paintings present constant features and individual variations of form that undoubtedly proceed from the animal itself. Even more satisfactory to report is the fact that the configurations produced by the animal demonstrate an awareness of the pictorial field that has been handed to it: *they constitute the monkey's response to that particular pictorial field*. The phenomenon therefore has nothing in common with the story of Roland Dorgelès' donkey, quoted by Janson, nor

with any of the other well-known anecdotes about artists using animals to introduce an unpredictable element into the painting process.

Among these anecdotes is a famous episode in the life of the Japanese artist Hokusai, one of the many colourful stories that make up the legend of his life. Hokusai was known for performances that astonished his audiences, a bit like the tumblers, acrobats and contortionists he sometimes represented in his work.[11] In 1806, Shogun Iyenari organised a competition between Hokusai and Shazanro Buncho, a celebrated representative of the Chinese school. Hokusai won general admiration and the favour of the Shogun in the following manner. First he unrolled on the ground a long roll of paper and painted it with big blue loops. Then he took a cock, dipped its feet in red paint and made it walk across the paper. His audience at once recognised a river studded with red maple leaves in autumn.[12] In his text *Eloge de la main*, Henri Focillon returns to this story in order to remind the reader that the cock was, for Hokusai, nothing more than a new kind of painting tool with which he could show off his mastery of control, like a special kind of brush whose shape and way of moving (largely unpredictable) allowed him to achieve exactly the effect he was looking for: '(...) it was because his hands carried the memory of the years spent depicting life by different methods that the magician was encouraged to try this one. His hand is present, though imperceptible, and, though touching nothing, it controls everything.'[13]

This is unlike monkey painting, in which the animal appears to possess at least a basic awareness of the possible uses of the equipment supplied and thus plays an active part in the process. The results of their paint-play demonstrate this awareness and are not therefore the outcome of chance (controlled to a greater or lesser extent) in which the animal is used merely as a vehicle. On the other hand, because the animal has no part at all in the setting up of the equipment, there is always a measure of Hokusai's practice in monkey painting. But the conscious involvement of an animal capable of understanding *a posteriori* the basic functioning of the painting equipment makes the phenomenon far more complex.

Janson, it must be said, only knew monkey painting through the experiments carried out at Baltimore Zoo, where Betsy the chimpanzee manipulated the colours directly with her fingers (illus.

2). He discusses only Betsy's work in his article and says nothing of the work of Congo, who used brushes and pencils. From the point of view of aesthetics, it can be shown that brushless painting as practised by apes presents almost no structured composition, because the process of finger painting allows almost no sense of the pictorial field to develop. The situation is quite different in the case of pictures produced with the normal equipment. If painting is interpreted as an activity proceeding from a specific reaction to the pictorial field, even if the latter is imposed by an outside agency, it is perfectly legitimate to talk about ape painting (illus. 3).

The basic question that is at the origin of research on ape painting concerns the biological roots of art. Opposing the traditional humanistic conception of artistic activity as one of the main distinctive features of human in contrast to animal life, some biologists have asserted that, in fact, the very roots of what they like to call 'artistic behaviour' can be observed in the animal kingdom. Consequently, they claim that art can be regarded as basically a biological phenomenon, whose principles are already present in higher animals and which became more complex only with the advent of the human species. This notion is based mainly on the evidence of an aesthetic sensitivity in several animal species, i.e. a capacity for appropriate response to formal structures, and behavioural patterns directly related to that capacity. Let us mention for instance the remarkable 'architecture' and 'painting' behaviour of the bower bird. This bird builds an 'arch' by arranging blades of grass into a clear, regular shape, which it then paints with red berry juice, applied with a straw used very much like a paint-brush.[14] In a similar vein, one might also mention the 'musical' properties of certain bird songs.[15]

On the basis of such phenomena, some authors believe that the analysis of animal behaviour can lead to a better understanding of the basic functioning and essential purposes of human art as well. Reasoning according to the concepts of evolutionary theory, they consider that artistic activity is 'prefigured', as the semiotician T. A. Sebeok put it, in animal species, and that the specificity of art in its human forms should not be overestimated. They look at human art as the complex consequence of an aesthetic behaviour, which, in the course of human evolution, came to be covered with layers of social-symbolical extras and by-products. Since the roots of art appear to

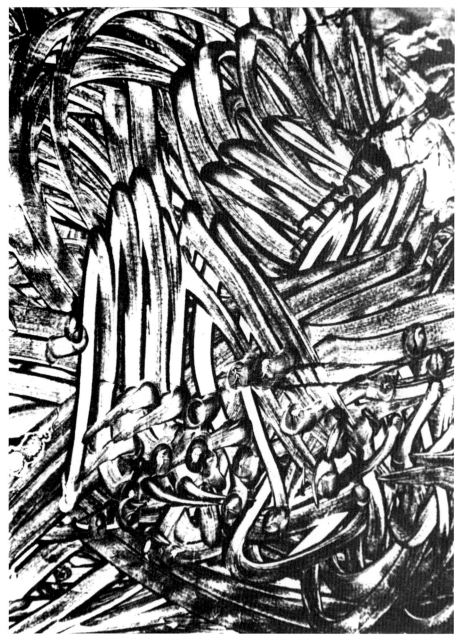

2 Baltimore Betsy, a chimpanzee, finger painting.

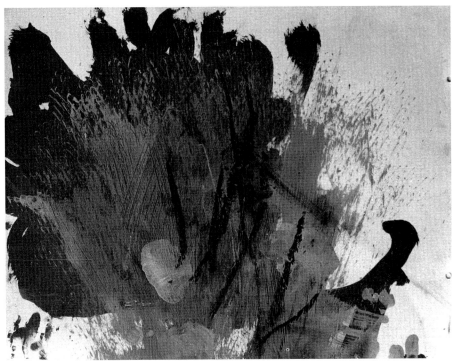

3 Congo, a chimpanzee: gouache and pastel, with lines produced with a plastic brush.

stretch so far back into the development of higher life, its origin would no longer be a problem for anthropology. This is, for example, why Konrad Lorenz, when describing the aerial arabesques delineated in flight by corvids, not only felt justified in using the word 'art', but went as far as stressing that it had to be taken in its proper sense: 'I am using the terms "creative" and "artistic" deliberately without putting them in quotation marks, for it is most likely that the processes involved here also constitute the roots of all human artistic activity.'[16] The invention of ape painting emerged from this kind of thought, with Desmond Morris among its chief promoters to the general public, and was presented as the most compelling argument for the existence of a 'biology of art'.

Although ape painting has lost some of the cultural relevance it had in the 1950s and 60s, the more general question of the biological roots of art appears to be in the air once again. In 1993, it was the topic of the 16th annual meeting of the European Sociobiological Society, held in Amsterdam,[17] which was intended to promote and discuss works in that field, either very recent, such as Eibl-Eibesfeldt and Sütterlin[18] and Dissanayake,[19] or earlier, such as Alland.[20] The general approach of the Amsterdam meeting was to investigate the socio-biological functions of human art: what are the evolutionary benefits of 'artistic behaviour', how does it work as a means for the human species to consolidate its position in the chain of life? It is claimed that the socio-biological perspective overcomes the Homeric clash between anthropology and biology by allowing the latter to include the former even with respect to art, that crucial resistance point.

The problem of the origins of art is not discussed in this book. Our sole field of enquiry is to discover, from an aesthetic point of view, what goes on when an ape is placed in contact with painting equipment. If the particular nature of the animal did not make it disposed to react to the pictorial field, the reply to the question would simply involve our knowledge of the history of painting. This is not, however, the case. It is true that in ape painting the painting equipment plays some sort of active rôle, through the intermediary of the animal; indeed, this is what gives the student of aesthetics the authority to expatiate upon the subject. But even though the ape is reacting to the enticement of the painting equipment, it is reacting in its own way and in accordance with its ape nature. The nature of the

ape must therefore be taken into account just as much as the historic combination of events that, at a given moment, made the encounter between the ape and the painting process possible. The subject of the present book is the moment of that encounter and nothing else: the book does not aim to dissolve the phenomenon completely into a historical reflection, nor to recreate a lost moment in the origin of the species, nor to throw light on the fundamental essence of art by revealing its so-called biological roots.

I hope to make it clear that once ape painting has been approached via its double nature, at once inseparably human and simian, it can no longer be regarded as a pathway to the solution to the problem of the origins of art. Careful study of the specificity of ape art will serve only to make us appreciate more keenly the dividing line between artistic activity in the real sense and the playful manipulation of painting equipment by the animal species that is closest to man in terms of biological evolution. If the process of ape painting is analysed in comparison with human painting, a break rather than a continuity is revealed: if the question of difference is explored further, then the question of origins is brushed to one side.

PART I History

This story took place at a time when the paintings and drawings done by non-human primates were considered as art, and were presented to the public as such. Whether it was to affirm the underlying relationship between monkey paintings and art (in its true sense), or to deny the existence of any such relationship, there was a time when the question of the artistic status of primates attracted a lot of attention.

When this unprecedented turn of events took place, two important historical developments coincided. The first was the evolution in artistic taste that was to lead Western aesthetic consciousness to seek out and to appreciate primitive or elementary forms. The second was the appearance of the science of primatology, which involved experiments with apes and monkeys and detailed observation of their biology and psychology.

1 Conditions and omens

The genesis of primatological difference

One important factor contributing to the creation of conditions favourable to the exhibiting of paintings by apes was the establishment of a system of primatological difference. This term designates the relationship between the human group and the simian group within the same category of beings. The concept of primatological difference as it is defined here has two aspects. On one hand it indicates the difference between the primates (including human beings) and all other animals. On the other, it endorses the well-known concept of anthropological difference, i.e. the difference between human beings and the remainder of the animal species. Anthropological difference focuses on the comparison between man and the species to which he is closest in evolutionary terms; of these species only the large anthropoid apes, headed by chimpanzees, survive today. The important point here is that the difference between men and apes assumes its full significance only against a background of their similarity: differences only exist where there are similarities. In other words, primatological difference does not imply that there is no real contrast between men and apes, but that the contrast has to be seen strictly in the context of their common membership of the same category of beings, the primates.

The genesis of this concept is a relatively recent historical event that closely fits the development of modernity. Linnaeus gave the impulse in 1758 when for the first time he named the primate group, that is to say those of first rank in the hierarchy of living beings, man and monkeys. A century later, the Darwinian theory of the evolution of species made it possible to define the precise biological proximity between monkeys and man. Since then, primatology has developed as a discipline specifically devoted to the exploration of the many aspects – biological, ethological, psychological, semiotic and aesthetic – of the relationship between the two great families of beings that form the order of primates.[1]

Linnaeus drew up the basic outline of primatological difference

soon after another event that had far-reaching consequences: the scientific discovery of anthropoid apes. The total of about two hundred species of animals known collectively as 'monkeys' includes two sub-orders: the primitive monkeys (*Prosimii*), including the large group of lemurs and loris, and the simians as such (*Anthropoidea*). This second sub-order consists of three super-families. The first is represented by the monkeys of the New World (*Ceboidea*), which include marmosets and capuchins. The other two cover the monkeys of the Old World. One group consists of monkeys with tails (like the *Ceboids*) such as macaques, baboons, etc., (*Cercopithecoidea*). The other group consists of the big monkeys with no tails, or apes (*Hominoidea*). The latter comprises two families, the *hominids* (of which Homo sapiens is a member) and the *pongids,* or great apes, which are divided into four types: gibbons, orang-utans, gorillas and chimpanzees. The *pongids* are currently called 'anthropoids', although strictly speaking modern taxonomy reserves the term for the sub-order of simians as contrasted with prosimians.[2] It hardly needs stating that the primatological difference appears most strikingly in the pongids, which are also the most recent arrivals.

The earliest description of a large anthropoid primate was provided by the anatomist Nicolaas Tulp (the central figure in Rembrandt's *The Anatomy Lesson*). It was published in 1641, illustrated by an engraving. Tulp talks about an orang-utan, but it was probably a dwarf chimpanzee.[3] No systematic description of a chimpanzee in terms of comparative anatomy was given until 1699, when it was provided by an Englishman, Edward Tyson.[4] The gorilla was not scientifically identified until 1847. Thus, the great apes were not formally identified until the eighteenth century. Fitting them into place in the animal kingdom and, most of all, forming a clear idea of their nature (biological properties, faculties, behaviour) compared with that of man came much later.

Why did primatological difference pass unnoticed before the eighteenth century? And how was it possible for mankind to be unaware of the existence of the animals exhibiting the difference in so spectacular fashion until only one hundred years before that time? To answer these questions would involve analysing the historical development of the general principles leading to the understanding of the relationship between mankind and monkeys. Most of the groundwork has been done by Janson, whose book, quoted above,

traces the outlines and implications of the history of artistic, literary and philosophical/scientific representations of the monkey from the classical era to the last century.

Building on Janson's findings, from a very varied sample it emerges that the monkey's resemblance to a human being has always stood in the way of any real understanding of its differences. One basic tendency, whose principles were never really questioned until the science of primatology was born, has dominated our concept of the monkey throughout history: this is the tendency that leads us to consider the features that establish differences and similarities between monkeys and men exclusively from the standpoint of the resemblance between the two.

Let us call 'resemblance' the relationship that follows from the proliferation of analogies. A series of common features – general physical appearance, plus some striking details of the appearance and some behavioural features – immediately link monkeys with men in the imagination. A first reaction is to exaggerate these analogies and multiply them. This is exactly what occurs when a monkey is observed without scientific intention. Numerous human characteristics are displayed in the monkey's physiognomy and movements, eliciting a reaction of the 'it almost looks' type, and the onlooker spontaneously seeks signals that endorse this reaction, ignoring characteristics and features that are particular to the animal alone. The proliferation of analogies is sheer entertainment for the visitor to the zoo. However, it can also be used to form the basis of a body of knowledge. In fact the propensity to exaggerate the human characteristics of the monkey has been evident ever since the animal first began to arouse interest, in the work of Aristotle and Galen;[5] subsequently it remained a feature of representations of the monkey throughout history.

The dominance of the resemblance can provoke an exaggeration of the differences, in the same spirit as the exaggeration of analogies. The dominant theme in works by classical authors describing the monkey was the emphasis on the physical and moral ugliness of the beast, which made it a loathsome caricature of a human being. Janson explains the reason for this theme perfectly. The two opposing vectors that constitute it form one indissociable structure: precisely because the monkey resembles man so closely it cuts an abject figure when pretending to a nature that does not belong to it.

The monkey resembles man, therefore it is only a sham. With the arrival of Christianity the negative perception of the monkey was reinforced by the metaphysical radicalism of a religion that posited everything in terms of divine will. No longer was the monkey simply a disagreeable being floating weightlessly between the status of man and beast, a grotesque simulacrum; now he became the embodiment of evil, '*figura diaboli*'. Christian authors frequently referred to the Devil as '*simia dei*': the sworn enemy of the true Creator because he is without any proper purpose, aspiring to the same status as the Creator while trying to overthrow him, deceiving with the false insignia of real power.[6] From the twelfth century on a modified version of this theme took over: the monkey became the image of the sinful soul and of human vanity.

The recognition of a positive kinship between the great apes and man does not in itself involve a retreat from the idea of resemblance. In fact, the latter remained very strong in eighteenth-century writing and was not set aside by scientific writers until the science of primatology came into being, a century and a half later. In addition, the gradual reduction in the symbolism that contrasted monkeys and men by the systematic disparagement of monkeys opened the way to an unprecedented intensification of the positive aspects of the resemblance. This new situation particularly coloured attitudes towards the great apes, whose biological level greatly impressed the thinkers of the Enlightenment. Now the resemblance began to contribute to a tendency to do away with any distinction between the great apes and man. The orang-utan aroused such amazement that Rousseau discounted the arguments put forward by those wanting to describe it as a monkey, not a man, as insufficient evidence: 'there are striking similarities in the descriptions we read between these so-called monsters and the human species, and the differences are slighter than might be found between one person and the next. It is difficult to comprehend the arguments [...] on which the Authors base their refusal to give the Animals in question the name Savages.'[7] Lord Monboddo, author of a book on the origin of language, had no hesitation in claiming that this being, mute by choice, represented a more advanced stage of development than many savages.[8]

Apart from the extreme and paradoxical forms in which primato-logical difference is almost equivalent to a failure to make any distinction, the combination of the resemblance with the theory of

evolution produced an image of the monkey as an almost-human animal. This image became a commonplace in imaginative writing in the last century:[9] the differences were toned down to give rein to various types of 'almost', and the animal nature of the ape was treated as a vein of savagery that kept the beast *in extremis* from being human. This representation of the ape is behind modern popular myths as well. The story of *King Kong* is about a monster in whom the spark of humanity, buried deep in its animal nature like a jewel in the sullen clay, is suddenly stirred; but the jewel is condemned to eternal imprisonment.

We enter a different realm if we seek concrete evidence of the 'human element' in monkeys, to be measured by observation and experiment; this is the realm of scientific primatology. For this specific science to become established, the approach has to be completely inverted: the nature of the monkey has to be assessed according to its difference from the other members of the family of primates rather than according to its resemblance to them. The starting point for the study of primates is an awareness that monkeys are fundamentally different from men, though belonging to the same biological group, in spite of their genuine proximity (in some respects) and a resemblance so strong that it sometimes blurs awareness of the difference. Instead of searching at once for similarities, then allowing these to proliferate so that distinctions can be deduced, an effort has to be made to glimpse the monkey's distinctive features behind the veil of similarities. During the observation, the idea that each apparent resemblance may hide an important difference needs to be constantly born in mind. The difference thus ceases to be the reverse of resemblance and becomes the guiding principle of the exploration of the resemblance. Posited in this way, from the standpoint of difference, the phenomenon should be seen as a totality of analogies and distinctive traits at various levels. From this standpoint we should establish first in what way the monkey seems simultaneously so close and so distant; second, to which specific observable phenomena the impression of resemblance relates and, third, how the analogies and contrasts fit into the global phenomenon.

The task is now to map out the levels of analogy and contrast which have meaning only in relation to the complex reality of the phenomenon. This would require not only a review of analogies, but

also a review of the vast number of contrasts deduced from the resemblance mode. The distinctive features that differentiate men from monkeys are no longer the obvious great categories such as reason, thought, language, culture or even aesthetic sense. Each of these criteria, from a general point of view, has been forced back from the absolute to the relative, so that the contrasts have been moved into second place. The development of the science of primatology has proved indissociable from this change in standpoint; from a qualitative concept of the anthropological difference we have moved on to a quantitative one. This means that at this point it is not so much the qualities (absolute differences) as the degrees (relative differences) that allow us to define the contrast between men and animals.

The experiments carried out in the early years of this century by Nadjeta Kohts in Russia and then by Wolfgang Köhler in Tenerife established that chimpanzees possess faculties of comprehension that allow them to handle relatively complex situations and problems, not by applying pre-programmed behavioural patterns but by 'working out an overall solution according to the structure of a field.'[10] Köhler went on to make clear that this intelligent working out of solutions could not be reduced to a simple mechanical process of trial and error, but was operated (as with man) by 'insight'. It was also by means of experimental observation of chimpanzees that Yerkes came to question the theory that the great apes partook of no cultural function whatsoever; the discovery of elements of 'tradition' in monkey communities was corroborated by Japanese primatologists working with groups of macaques in their natural habitat.[11] As for language and thought, experiments by Gardner, Patterson, Premack and Rumbaugh on communication by artificial signing systems amongst chimpanzees and gorillas have raised the debate on the difference between man and the large anthropoids to a level of complexity that is far greater than previously imagined. Not everyone in the field shares their opinion, but in any case a review of their arguments brings in considerations that are a great deal more complex than might have been expected under the old certainties of triumphant humanism.

Of course, these researchers never doubted for an instant that they were profoundly different from the subjects of their experiments. Observation did not lead to a blurring of the distinction, on the

contrary; close, practical knowledge of non-human primates had the effect of making the 'limitations' in their abilities ever more noticeable. The hundreds of hours spent patiently and with great ingenuity training them to perform the simplest (by our standards) task gives some idea of the problem. In spite of this, however, systematic research into the basic distinguishing characteristics of the monkey led to a kind of fraying of each criterion, to a point where difference appeared only as divergence or relative levels. The deeper the investigation went, the more the distinctions developed in the direction of 'more or less'. Yerkes clearly stated this principle: 'The differences between them [the large anthropoids] and us are more often quantitative than qualitative, a question of more or less rather than of presence or absence.'[12]

The question of qualitative difference between man and animal does not disappear, but it evolves in such a way that it can only be addressed in terms of 'quantity', as if critical thresholds need constant subdivision into a schema of every-increasing complexity. This is also why the 'difference' position elicits discoveries that ensure that the map showing the properties of the non-human primate as opposed to man is subject to constant revision.

Nevertheless, it must be emphasised here that the appearance and prevalence of the quantitative standpoint corresponds to a change of conceptual theory and not to the disclosure of any absolute truth. This standpoint might easily be ousted in its turn, one day, and replaced by another model that could reintroduce the qualitative element in another form. What is more, the quantitative paradigm has not been accepted by all the branches of science concerned with the problem of anthropological difference. Zoology is the principal science involved, although this does not mean to say that all zoologists accept it without question; also involved in a more general way are the disciplines in which the terms of evolutionism are used for argument. The quantitative standpoint has made no inroads, however, into social anthropology or philosophy; in these two disciplines the problem of anthropological difference is addressed in completely different terms.

In particular, the phenomenological movement and its heirs continue to insist on the strictly qualitative aspect of this difference – even if only in accordance with the conceptual development of the idea of *difference* itself, a particular preoccupation of contemporary

philosophy (especially through the work of Jacques Derrida). In other words, whatever (undeniable) progress has been made in recognising the complexity of the behaviour and psychology of the large anthropoids, it is not the case that, henceforth, basically everything can be reduced to the adage 'more or less'. The question of the qualitative flaw separating apes from human beings remains entirely relevant.

What is more, detailed study of the latest findings on the subject of the earliest human beings confirms that the qualitative did not degenerate into the quantitative, and this fixes a question mark firmly over the whole of question of anthropological difference. The few scraps of information that archaeologists have been able to provide on the subject of the life of the Australoids and other primitive humans suggest that they behaved in a manner that clearly distinguishes them from the great apes of today; they behaved like human beings and not like apes. This emerges particularly clearly from the study of their tools, their use of fire and their habitat, all of which bear witness to durable and complex ways of using space.[13]

Whatever the truth of the matter, the important notion to grasp for the moment is that, historically speaking, the relinquishment of the paradigm of qualitative difference is evidently inseparable from the development of scientific enquiry into the great apes and their intellectual powers.

Lastly, as far as real-life experience is concerned, advanced awareness of primatological difference creates conditions for a much more intense relationship with the large anthropoids. On the same principle, the resemblance no longer overshadows or exaggerates the parallels between our specific characteristics and those of the ape. Anyone who has been lucky enough to enjoy prolonged contact with an anthropoid will never forget the immediate and extraordinary rapport that springs up, much stronger than that experienced with any other animal, including monkeys as opposed to apes.[14] This is a very important point because experiments on the intellectual faculties of the large anthropoids, in particular experiments involving drawing or painting, presuppose a two-way affective relationship between the animal and the person conducting the experiment. This relationship is, moreover, quite evident in the writings of scientists who, like Morris, Gardner, Premack and others, have worked in close contact with these

animals. The first-hand real-life element is therefore of paramount importance in any research into primatological differences.

When I first had prolonged face-to-face contact with a young chimpanzee, I felt for a few moments that I was standing in front of an artificial being, a sort of animated doll. This impression, which soon disappeared, was caused by a kind of conflict of categories. The being standing in front of me seemed to belong neither to the animal kingdom nor to the world of man. Our symbolic mapping of the world of the living provides no intermediate category, therefore. The consequence of this aporia was, for a moment, a strong sense of unreality. Afterwards, the predominant feeling was an extraordinary 'mutual comprehension', which was anticipated for an instant at the exact moment of our first encounter.

The manner in which our games and our mutual exploration developed created a feeling of closeness in me that was paradoxically far greater than the closeness I have felt with very young children. First contacts with a baby or young child often provoke 'misunder-standings' and an impression of bafflement that can be quite oppressive to both parties, whereas with the chimpanzee all my gestures and actions seemed to be immediately 'understood', and the animal, in return, gave me its fullest attention and did nothing that I could not participate in to the full.

The whole gamut of simple actions that it performed seemed perfectly and immediately comprehensible, and this increased the impression of connivance. The little chimpanzee sucked its thumb, and dragged a favourite 'toy' around with it wherever it went. It studied everything attentively out of the corner of its eye and by feeling things with its hands (the texture of fabrics, skin etc.) and took a lively interest in simple mechanisms like a cigarette lighter. It looked its carers straight in the eye and watched their faces closely for changes of expression. It enjoyed doing funny walks and loved being swung by its hands or feet, or being suddenly rolled up in a rug, etc.; when tickled it produced characteristic little 'chuckles', and made half-hearted movements of avoidance, tucking its chin into its chest to avoid being tickled in the neck. In other words, it constantly anticipated segments of chains of operations. This was evident, for example, when it was offered some jam on a teaspoon and showed no great urgency about finishing the pot: it knew that it would receive the whole pot and that each spoonful would come in good time, and

it therefore did not seem necessary to hasten the process. This was very different from the behaviour of a capuchin monkey I had also observed in the same circumstances: for the capuchin the spoon never moved fast enough.

These points of contact strengthened my feeling of closeness in the most natural way, and impressed me so forcibly that I tended to ignore signals or actions that I did *not understand*. This could be expressed differently: my *first* impression was of connivance, anything unknown (for example the precise meaning of a particular facial expression) came *afterwards* and only if I concentrated fully on it; it had a hard job filtering through the overall feeling of identity.

To find oneself feeling so close to a non-human is obviously extremely unsettling. On looking back on it, everything points to this extraordinary sensation having to be interpreted *through the difference* which separates men from chimpanzees and at the same time brings them together. The impression of perfect communication hampered only by lack of speech is based precisely on this *difference*, even without making any special mention of the fact that the physical strength and (towards man) very unstable temperament of the adult ape make freedom of contact with man almost always impossible. The bafflement and 'misunderstandings' between adults and very young children, which are potentially the defining characteristics of all human relationships, are in fact the sign of intersubjectivity; they relate to the gulf constituted by *the identity of the other*, the fact that the other, in its otherness, is my exact fellow-creature – or, to express it the other way round, that my other is always another in the strictest sense of the word. The existence of this gulf, thinly disguised in everyday life by the codification of normal human intercourse, is itself a condition of *meaning* as a limitless opening-up to the world, like a moving fabric, endless and ceaselessly recreated, of relationships between things and beings. Conversely, the first impression of a communication that is direct and without pretence, such as the impression one may gain from contact with a large anthropoid, constitutes the characteristic feature of a relationship taking place *outside the realm of the inter-subjective*, with a living creature that is certainly close to us in certain respects, but also basically does not belong to the world of meaning.

Be that as it may, the possibility of experiencing and analysing a relationship of such proximity to a monkey can only exist within the

context of the notion of primatological difference. Conversely, the real-life experience of such close and affective contact is inevitably the situation in which the question of the difference between man and ape is at its most intense.

The discovery that apes and capuchin monkeys could react to a pictorial field was one of the more important landmarks in the history of primatological difference because it concerned a major faculty traditionally considered by man to be essentially the property of his own species. It is important to bear in mind that this discovery was made from the standpoint of difference.

The most striking thing about a painting done by an ape or a monkey is certainly its confusing resemblance to a gestural work of art (illus. 4, 5, 6, 24). It is impossible to disregard this resemblance: it makes an aesthetic impact at first glance, even though the origin of the painting is no secret. Even with the fullest awareness of the very distinctive way an ape painting is executed (and this situates it light years away from a gestural painting) it seems to be impossible to grasp its *apeness* just like that. This is mainly because a painting, once produced, tends to become detached from its origins and to acquire an independent existence; every monkey painting is immediately drawn, as if by magnetism, into the galaxy of artworks that constitute the '*musée imaginaire*' of abstract painting. Hung upon a wall, it becomes simply a gestural painting: the intellect and the powers of reasoning observe this transmutation but appear powerless to prevent it. With a bit of practice, however, it is possible to distinguish immediately and accurately an ape painting from any other artefact. This does not mean that what one perceives is the *apeness* itself, or that the painting belongs aesthetically at a respectful distance from abstract art. In fact, things occur in the reverse order: the very possibility of categorising the painting visually as a monkey painting leads us to recognise it implicitly as a manifestation of one particular artistic style among many others. Rather than being consigned to another planet, aesthetically speaking, the painting will be pigeon-holed in a compartment labelled 'ape', somewhere among the various styles of contemporary art.

Exploration of the extraordinary aesthetic power of this resemblance was not, however, the main objective of the primatologists who were interested in aesthetics. They were guided by the principle of difference, and their evaluation of the ape's primitive

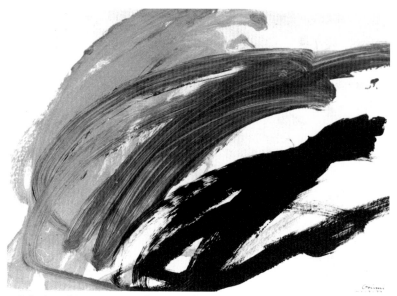

4 Grimi, a chimpanzee in the Copenhagen Zoo: a yellow, red and black gouache (colours are listed, here and throughout, in the order they were used by the monkey).

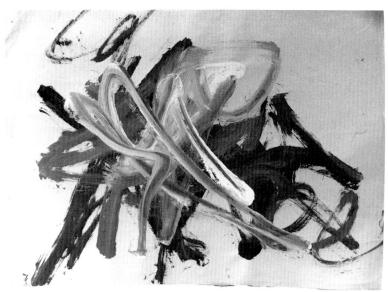

5 One of Congo the chimpanzee's last paintings, in gouache (black, brown, green, yellow). Note the two loops in the bottom right-hand corner.

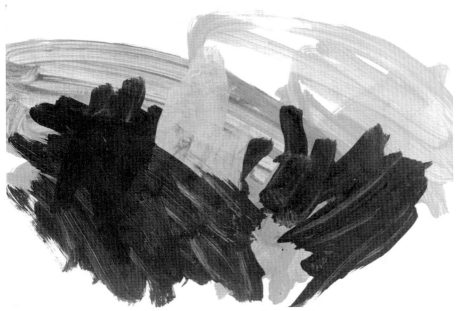

6 Bozo, a chimpanzee: an acrylic in blue, red, yellow and brown.

aesthetic sense was conducted in a sense in spite of the awkward fact of any element of resemblance. The object of their research was located behind a great veil of analogies with modern art, where there were important contrasts in the graphic and pictorial structure as well as in the execution. In the introduction to the catalogue to the 1957 exhibition, Morris writes that ape painting and Action Painting 'have certain things in common. Both are abstract and neither can be described as "geometric". Also, in both cases, the moment of action involved in the creation communicates itself very forcibly. But there the resemblance ends.'[15] Experiments in which non-human primates were brought into contact with the pictorial field were aimed at mapping the limits of the resemblance (in the area of aesthetics) between men and apes as accurately as possible. Ape paintings were the products that presented the closest resemblance, in primatological terms. It would never have been possible to reach such an advanced position in the field of analogies if the approach of non-human primates had not freed itself from the imagery of resemblance.

The theme of the artist as a monkey

The development of a principle of difference governing scientific and philosophical representations of the living creature most closely resembling man constitutes one of the two indispensable conditions for the existence of 'ape art'. The second condition for its existence is the history of art itself. Relatively recent developments in art have made possible the aesthetic appreciation of an elementary kind of painting which is completely abstract and is dominated by the gestural. The investigation and detailed exploration of the painting ability of monkeys occurred as a direct result. Previously, however, art history also played a rôle, but it was of a different order. As early as the seventeenth century, images began to emerge that seem to herald the appearance of ape art. In fact our first glimpse of monkeys portrayed in the act of painting is in museums and art galleries. What rôle should we assign to these forerunners of the phenomenon itself?

Although the images of painting monkeys in museums seem to anticipate the later historical event, they are simply works of the imagination; they do not in any sense set out to explore the aesthetic

abilities of the real animal. Scenes illustrating the theme of the artist monkey bear no relation (in meaning or status) to any real-life equivalent; on the contrary, they emphasise its absence from the purview of pre-modern culture. If an impression of anticipation persists, this is caused by the imagination shifting the subject of the original theme forward on to a different time-scale.

Janson has shown how the image of the artist monkey derives from the general idea of the monkey as a symbol of human vanity.[16] The first pictures on the theme of monkeys belong to an earlier iconographic tradition and illustrate the futility of worldly activities, in the hectic pursuit of which man loses sight of his own salvation; art represents one of these activities, which are gathered into a kind of catalogue of vanities in which the protagonists are depicted as monkeys.[17] From the seventeenth century onwards monkeys were increasingly associated with artistic activity, and the artist monkey became an independent theme; this echoed the old adage that had been present in literature since the early Middle Ages and signified the unworthiness of human art when trying to imitate the work of the Creator: 'ars simia naturae'. Within this pictorial sphere, the negative value of the figure of the monkey was to be exploited in a variety of different ways. Art was sometimes seen as slavish copying and sometimes as the skill of the portraitist, at pains to flatter his model, like an animal trained to perform tricks by popular request. Quite soon, however, what was only a pejorative symbol gained value as entertainment. The image of the artist monkey achieved a range of meanings fixed at different levels, from metaphysical reflection to simple fantasy, from satire to concealed aesthetic theory. The theme is developed throughout these various versions like a game between three broad functions: the latent general theme of the monkey as a symbol for human vanity (which can be made manifest to different degrees); the entertainment value gained from exploiting the monkey's resemblance to man; and, finally, a number of more specific references to the condition of the artist. The sum of all these is a collection of often very ambiguous images; it would be a mistake to attempt to attribute an exact interpretation to any of them.[18]

David Teniers the Younger (1610-90) was the first well-known painter to explore the theme. In addition to scenes of manners with monkeys as characters in the style of Adriaen Brouwer (c. 1605-38),

using a formula that was taken up again later by Antoine Watteau (1684-1721), Teniers produced a pair of paintings depicting a *Monkey Painter* and a *Monkey Sculptor* (Prado, Madrid). Janson interprets the second of these as an adverse comment on the custom of blind copying from antiquity: the sculptor's studio is full of plaster casts of classical statuary, and in the background can be seen a splendid brand-new, pseudo-antique sarcophagus covered in bas-relief monkeys. The painter is seen at work under the watchful eye of a fellow monkey, standing admiringly behind him with his lorgnette in his hand: his studio contains a collection of paintings, including some by Teniers (illus. 7). The figure of the monkey represents a kind of self-mockery on the part of the artist. By drawing the spectator's attention to the fundamental nature of what is being presented, the painter informs us that he is not fooled by his own tricks and has not forgotten the object that they might be making fun of. Anne-Marie Lecoq is undoubtedly correct to remind us of the entertainment value provided by the monkey in this painting, which she describes as 'much less laden with significance than we have been led to believe.' The fact remains that the figure of the monkey is often presented by Teniers in contexts where it is very obviously surrounded by symbols of vanity, for example *The Country Surgeon* (Nat Leeb Collection, Paris).[19] It should not be forgotten either that the spirit of '*vanitas*' pervades seventeenth-century Dutch painting to a high degree. In genre paintings particularly, this symbolism, even when it is neither explicit nor intentional, and definitely not unambiguous, is nevertheless an essential (if concealed) part of the picture.

Eighteenth-century art continued to present the monkey as a symbol for the artist. The variety of uses to which the subject was put was preserved, but its combinations and proportions extended. The pejorative attitude towards the monkey often persisted, contributing to the denunciation of the portrait painter (the prisoner of his model's overweening vanity)[20] and to the ridiculing of certain excesses of taste. This is how Hogarth derided the way the collectors of his day idolised the Old Masters.[21]

A painting attributed to Jean-Baptiste Deshays (1729-65) shows a monkey sketching a female nude, seen by the spectator from behind (illus. 23). The painter is staring wide-eyed at the woman while he draws the outline of her buttocks, his palette at the ready in his left hand. As if by chance, his pencil is lingering in the crucial spot of the

44

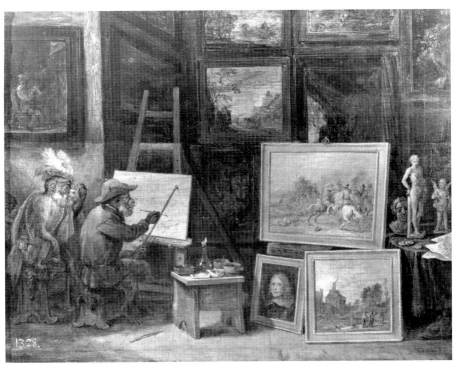

7 David Teniers, *The Monkey Painter*.

model's anatomy: the painter's instrument is in fact nothing more than the visible extension of his sexual organ, the seat of unspeakable desires. The phallic symbol of the pencil or paintbrush was already a popular favourite with eighteenth-century French artists (Boucher in particular), and its popularity was set to continue.[22] We are spared none of the trivial details of the sitting; the naked woman is required to become any one of a number of characters from Greek mythology or the Bible, an Aphrodite or a Susannah posed in a dignified position, one whose formal elegance transcends the weight of her flesh. For the moment she has not quite achieved this: her Junoesque figure is a heavy weight to bear, and in order to hold her pose she has had to rest her right knee on an armchair; her left foot is placed on the floor, on a piece of folded cloth, evidently to spare it from contact with the cold floor tiles. The painter himself wishes to be aristocratically dressed: his three-cornered hat and sword betray his desire to be perceived as a gentleman. Unfortunately his appearance reveals the futility of this desire. The three-cornered hat, derived directly from the hat worn by the monkey in Chardin's *Monkey Painter*, is frankly tatty and looks as if it is made from the same drab fur as his monkey coat. A rag, evidence of the inevitable dirtiness of the profession of painter, hangs from his pocket (there is another one hanging on the easel). As for his sword, it is lying on the ground just behind the animal's tail, and echoing its position. Finally, the inferior equivalent of the painter's hand is prominently displayed: the monkey's right paw is resting on the lower part of the easel. Deshays' painting concentrates on the meanest aspects of the art of painting, which are so much in evidence during the process of executing a painting but disappear without trace from the finished work. The pitiful ambition of the artist, the body's many constraints, the dreary routine of a profession spent doing everything possible to appear nobler than it really is. The satire rebounds eventually on to the spectator himself: the artist caught ogling and painting the model's splendid posterior is surprised in mid-concupiscence, and, by extension, so are we. Even if we fancy ourselves in the realm of the mind as we contemplate such beauty, we are looking at exactly the same thing as he is.

In the nineteenth century caricaturists used the monkey to poke fun at fashions and behaviour that bowed to the artistic taste of the day; Grandville, for example, depicted a Romantic art school pre-

sided over by a half-dressed, monkey-featured Delacroix painting with his foot.

The negative symbolism of the monkey lessened as the religious background to it disappeared; as this happened, the figure of the monkey began to be used more and more for its picturesque qualities and its entertainment value, natural concomitants. The amusement caused by the monkey since the days of the wandering minstrels of the Middle Ages was tinged with a kind of child-like wonder. In 1752 Pons-Augustin Alletz published a short book entitled *Histoire des singes et autres animaux curieux dont l'instinct et l'industrie excitent l'admiration des hommes* (History of monkeys and other curious animals whose instincts and industry excite the admiration of mankind). The work consists of a collection of odd anecdotes gleaned from literature and from travellers' tales; the idea of entertainment appears right at the beginning of the *Avertissement* (preface) and recurs four or five times in the foreword. The decorative arts at this period used the image of the monkey purely for its exotic connotations.[23]

This development brought about interesting modifications in the theme of the artist monkey. It provided Watteau and Chardin with the opportunity for changing the scenery for the depiction of artistic subjectivity. Rather than an image of the futility of painting as such, both produced a subtly ironical version of their feelings about themselves and their relationship with their art. Both played on the hidden connotations of the theme (the monkey as imitator and captive comedian) and on the expressive possibilities inherent in the subject: the monkey's face, not wholly human but able to supply resemblances at every level, can mimic the human face in touchingly convincing ways without adopting any very well-defined expression; the resulting rather generalised look is full of mystery.

Chardin depicts his artist monkey just as he is about to begin a painting, looking quizzically at the spectator (illus. 8). Anne-Marie Lecoq's seductive interpretation is based on the caption for the engraved version, which was written by one of his friends when the painter was still alive. According to the caption, all painters imitate one another, and the painting probably represents the artist monkey preparing to paint a portrait of Chardin himself. This would give us a sort of two-level self-portrait in the language of *singerie*.[24]

Watteau's monkey is sitting contemplatively in front of his

47

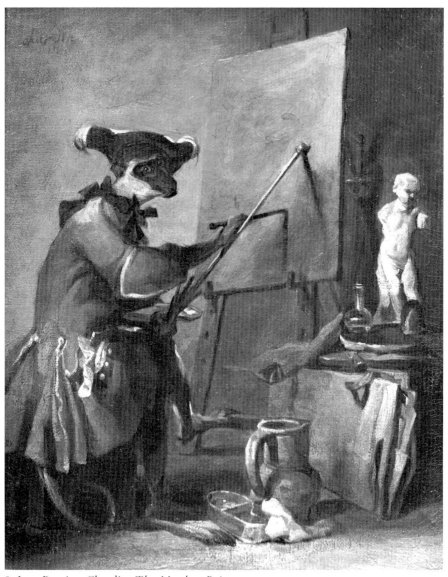

8 Jean-Baptiste Chardin, *The Monkey Painter*.

painting, as if engrossed in a thoughtful and difficult dialogue with it (illus. 9). The painting on the wall gives the impression of being a disguised self-portrait. In the style of Watteau, it depicts a Pierrot being greeted obsequiously by Scaramouche, watched by Harlequin. The painter is working from a model that is nothing more than a puppet made of rags, dressed in female clothing. On the canvas (we can only see its back) he will have to transform this miserable sham into a 'living' person, 'true to life', and this with the assistance of the equipment that is so prominently displayed – palette and brushes, bottle of turpentine, knife and painting rag – which reminds us of the material realities of the art of painting, an art which pretends to be so cerebral. With its pensive air and aristocratic dress, this monkey painter contrasts vividly with the animal on its pendant, the monkey sculptor, hammering at the stone with the innocent energy of the artisan.[25] This is Watteau's reinterpretation of the traditional contrast between sculpture, as manual labour, and painting, which was considered intellectual work, as Leonardo da Vinci stated. Watteau used the theme to make a personal statement about his own status as an artist.

In their separate ways, Chardin and Watteau use the resemblance relationship to make an important philosophical and psychological observation, expressed in the form of an amusing fancy. Both put their skill and imagination at the service of profound ideas. The figure of the monkey is no longer the miserable image of moral turpitude; now the animal arouses sympathy by adopting the human condition in all its aspects. In this way they manage to combine two sets of attributes, natural vivacity and impulsiveness on one hand and the slightly craven characteristics of an animal that is only a poor imitation of man on the other. The theme of the resemblance of the monkey to man is exploited to its fullest extent. All the traditional elements combine in a totally original fashion, giving a remarkable polyphony of references and allusions; meanings open up to the spectator and remain open.

These various versions of the traditional theme, all pointing towards resemblance, have in common one thing that is vitally important to our quest: they present the monkey purely as a symbolic representation of man. The examples discussed above show plainly that it is never the real animal that is portrayed. The postures, expressions, clothing and situations are all human, apart from the

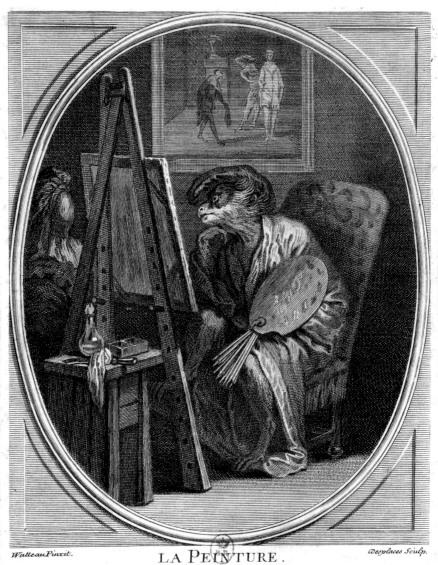

LA PEINTURE.

Telle doit au Pinceau ce qu'elle a de renom,
Qui fait horreur à voir sans fard, & sous le linge:
Et pour peindre à son gré mainte laide Guenon,
Il faut être adroit comme un Singe.

à Paris chez la Veuve de F. Chereau Graveur du Roy rue S.^t Jacques

9 Engraving by Louis Desplaces after Antoine Watteau, *Painting*.

monkey's 'mortal shroud'; in addition, Chardin and Watteau add expression to the monkey's features by giving it human eyes. Basically, this is the artist in monkey's clothing – not the monkey artist but the artist monkey – and Janson takes care to mark it correctly: 'the artist as an ape'.[26]

After an eclipse during the Neo-classical period, the monkey returned to art with redoubled force in the work of the great orientalist painter Alexandre-Gabriel Decamps (1803-60), whose popularity was to an extent based on it.[27] Decamps found that monkeys could add an excellent touch of the picturesque to painting, and he exploited this to the full, combining the natural entertainment value of the monkey's resemblance to man with the exoticism of a theme that was traditional in the work of the Old Masters. In a spirit of comic historicism, he revived the symbolism and ways of expressing the subject in works intended to entertain. The combination of his comic skills with a sophisticated cultural joke made his monkey paintings very successful; they were popular with the public and were not despised by literary figures including the Goncourt brothers, Alexandre Dumas and Théophile Gautier. Most of his paintings, executed after 1835, use the routine formula of the monkey as a travesty of man. *The Experts* (1837, Metropolitan Museum, New York) depicts typical bourgeois art-lovers (in posture, clothing, even hair style), only identifiable as monkeys by their faces, and even these belong to no particular species. *A Great Artist* (1836, Wallraf-Richartz Museum, Cologne) takes up the classic theme of the artist monkey from the comic historical standpoint: the painter is dressed in the Dutch fashion of the sixteenth or seventeenth century and is holding a palette and maulstick; he has stepped back from a canvas which we can see only from behind and which emits a dim glow, like in one of Rembrandt's famous self-portraits. There are many other examples of the re-use of this classical formula, in fact it constitutes the main subject-matter of Decamps' monkey paintings.

Another formula exists, however, and it is a novel one. A painting executed by Decamps in 1847 shows a monkey seated in the corner of a kitchen in the company of a young cat. The animals look so lifelike in this painting that we need the title to inform us that it is in fact a pictorial representation of one of La Fontaine's *Fables* (*Bertrand et Raton*, Musée La Fontaine, Château-Thierry). The same objective observation and symbolic nudity characterise *The Monkey Painter*,

exhibited in the Salon of 1833 (Musée du Louvre, Paris). This is a portrait of a real macaque, in circus clothing rather than ordinary dress, sitting in a typical monkey position on the floor (illus. 10). Of course macaques do not paint with a palette held on the left forearm, nor do they paint Romantic landscapes. Apart from this, however, there is nothing in the monkey's appearance or pose that is implausible for a real-life monkey. What is more, although the later works mentioned above revive links with fables and secondary meanings, this image based on careful observation of the monkey as an animal appears totally devoid of symbolism.[28] Janson was disappointed by this narrowly objective view. In his opinion Decamps' *Monkey Painter* displays a definite impoverishment of the theme in comparison with the way it was handled by the great masters.[29] More positive perhaps would be to consider how the artist combines, boldly and in one paradoxical vision, the artistic gesture and an authentic animal portrait; the vision is entirely original and quite disturbing if you look at it without letting your thoughts stray into the realm of symbolism. Decamps' painting leaves an even more disturbing impression on those familiar with photographs of Congo, Julia or Sophie at work: the powerful feeling of having seen this amazing spectacle somewhere before, the concentration of the animal in front of the canvas as it covers it with brushstrokes (illus. 11). When Picasso took up the theme of the artist monkey, in 1945, he retained the lifelike authenticity and simplicity introduced by Decamps but added his own type of hidden agenda. Brassaï tells how, after a stroll along the banks of the Seine, 'inspired by the dozens of amateur painters cluttering the path, with their easels firmly pointed at the "motif" ', he picked up a sketchbook and 'drew the quays full of monkeys with paintbrush in hand, some even perched in the tree-tops, busily painting Notre-Dame.'[30] He returned to the theme in 1953–4 in the series of drawings of 'the painter and his model'. The figure of the monkey acts as a vehicle for Picasso's cynical view of 'the painter'. Like Toulouse-Lautrec, who was very small and misshapen, and like the elderly Monsieur Degas, the monkey is depicted as a voyeur, pathetically fascinated by women whose too ample, too beautiful bodies are submitted to the obscure fumblings of his paintbrush. He crouches nearby, his blank expression seeming to express a melancholy awareness of sexual desire quite out of proportion with its object. The monkey, by

10 Alexandre-Gabriel Decamps, *The Monkey Painter*.

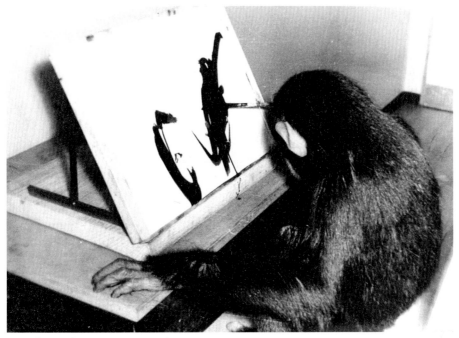

11 Julia, a chimpanzee, at work.

connotation, is related to the circus: sad clowns and pitiful dwarfs. This half-pint satyr also has a kinship with the Minotaur, that tragic hybrid, 'too human' in its own animal skin, 'prowling around the sleeping woman'.[31]

By his interesting transformation of a classic theme, Decamps created an artist monkey really looking like a monkey who could paint; it was as if the retrospectively prophetic effect had suddenly become sharper and had taken on a more positive colouring. There is more to be said, too. It may be correct to surmise that this sharper focus was closer to the real thing. According to a short story by Alexandre Dumas, Decamps kept quite a menagerie in his studio, apparently consisting of a frog, a tortoise, a young bear and a monkey called Jacques I (to distinguish it from Tony Johannot's monkey, Jacques II).[32] The monkey, which was swapped for a Greek rifle with Eugène Isabey, who apparently exchanged it with Camille Flers for a Turkish pipe, was a great favourite with the painter's friends, it seems. Dumas describes it romping freely about the studio and playing with the painter's materials, 'seated on a chair pulling the hairs out of a paintbrush one by one.' The story is a mixture, it has to be said, of reality and invention. The monkey was alleged to have been captured in 'Lower Guinea', now Angola, in an imaginary Africa where the royal tiger hunted with the hippopotamus. What is more, the animal is introduced as a marmoset, a member of the *callitricidae*, a family of monkeys that is only found in the New World. This obvious invention does not necessarily invalidate the story of the exotic animals, especially the monkey, in Decamps' studio. The use of the names and characters of living artists, and the central figure of the monkey, suggest that the story was embroidered on existing facts; this cannot at any rate be completely ruled out. There are other examples in nineteenth-century art of this attitude to the theme of the studio monkey as a cherished companion to the artist and the object of his affection. A touching painting by the German artist Gabriel Max, dating from the end of the last century and now in the Reiss Museum in Mannheim, depicts the artist, already quite advanced in years, sitting sadly by a window and holding a small capuchin monkey tightly to his chest. Gabriel von Max was the author of several paintings of dead monkeys, nailed on to wooden supports in positions resembling those of a live monkey. The painting discussed above may be interpreted as a kind of

retrospective testimony in which the painter expresses his love and support for the real live animal whose dead fellow-creatures were his models.[33]

It is easy to imagine Decamps' monkey, during its games in the studio, being presented with a piece of paper and some charcoal, or a canvas and some paints, then scribbling a few marks on it. Jacques I was not an anthropoid. It appears to have been a macaque from North Africa, the commonest type of monkey found in western menageries from the Middle Ages on, or perhaps a capuchin. The large anthropoids were extremely rare at that period; they are delicate creatures that cannot survive in northern climes without heating day and night, winter and summer, and very attentive care. The arrival of the first chimpanzee at London Zoo was a public sensation; the animal survived for only six months, and it was half a century before another chimpanzee was added to the collection.[34]

It seems, however, that the ability to play drawing games is not the sole prerogative of the anthropoid. The spontaneous reactions of a capuchin monkey were closely observed by Bernhard Rensch, and two Californian researchers elicited convincing reactions in rhesus monkeys by using reinforcements, i.e. by associating drawing with pleasant stimuli (chocolate drops in this case).[35] Similarly attentive observation might have revealed precedents in the Decamps household or elsewhere, but it is also possible that early examples of the art of non-human primates may have been produced within the studio painting tradition in which the negative image of the artist monkey first occurred and developed, and may then have disappeared without trace.

Surely a scene like this was the direct inspiration behind the pages of the story of *Manette Salomon*, by the brothers Goncourt, certainly the most amazing pages ever written on the subject of art and a monkey. Two painters, Coriolis and Anatole, inseparable friends, share a studio with Vermillon, introduced to us by the name of his species; he is a rhesus macaque. The marvellous description of his expressions and attitudes, undoubtedly taken from direct observation, is a delicate combination of fictional anthropomorphic attributions and a large number of realistic animal touches.[36] The monkey thus has a symbolic function of key importance, derived from the traditional idea of imitation, yet this does not affect the unity of the narrative. Anatole, in prophetic manner, is compared to the monkey

right from the beginning of the book: he is a whimsical character, light-hearted and much too talented as an imitator for his own good – his skill at imitation is like a basic flaw that affects the development of his art from the outset.

The symbolic status of the monkey motif and the fictional aspect of the novel do not make it possible to decide whether or not the Goncourt brothers had ever witnessed a macaque in the act of drawing or, if they had, what they would have imagined they were witnessing. Some features of the story are evidently created or dictated from the standpoint of resemblance. This is the case for example when we are told that Vermillon struggled unsuccessfully to draw 'from life'. Other features, on the other hand, can be found in authentic stories about monkey painters: eating the colours on a first encounter with painting, a 'passion for scribbling', and tremendous excitement on the part of the animal while at work: 'it expressed surprise and despair by turns, and banged the paper with little yelps of anger: the tip of its pencil had disappeared and it was not making any marks.' Interestingly, the Goncourts convey a kind of atmosphere of failure: Vermillon struggles to imitate Anatole's behaviour as he paints and realises he is not managing; it is the old idea of unsuccessful imitation. In fact, the motivation of a monkey when painting has nothing to do with imitation. It begins playing with the pictorial field with no other concern but play, and therefore with no reason for failure. This does not prevent the Goncourts' lines bearing a strong resemblance to Morris' description of the expression of intense concentration of his chimpanzee during painting sessions.[37] Other features of the description would be unsurprising if they referred to a chimpanzee, for example the gesture of the monkey who, noticing that the pencil no longer works, hands it back to his human companion. In conclusion, by a wonderful coincidence, this mixture of fiction and authentic observation contains the following portrait: Vermillon, so far, 'had only been able to draw (...) circles, endless circles, and there seemed to be a possibility that this monotonous kind of drawing might be the limit of his talent.' Congo, the best-known and most important of the monkey painters, ended his short career by discovering the circle.[38]

Whatever the factual relevance of these early manifestations of monkey art in the nineteenth century, two main points need to be retained. Firstly that it was in the art world, in painters' studios, that

the idea of the monkey exercising a kind of primitive artistic skill, though still animal, came into being. This idea emerged from changes occurring in the cultural sequence whose roots were directly planted in the classical image of the monkey as a symbol for man. The Goncourt brothers show the characteristic features of this idea at its birth: the monkey's imitative nature might lead it to the most basic scribbles or elementary patterns – the crudest, most useless approximation of any human art worth the name. The text of *Manette Salomon* presents a picture of what a monkey's drawing is or might be like. This represents a major new development. Animal though it was, Decamps' monkey painter produced perfect human paintings. In fact, none of the known representations of the subject shows a monkey producing 'monkey' paintings. On the occasions when the work is visible it is always a human piece of work. Even the four-handed Delacroix in Grandville's picture is painting battles scenes. The only 'monkey' element that occasionally occurs in the artistic output of the artist monkey is the replacement of human figures by monkeys, as in the case of Teniers' sculptor. It comes as no surprise to find truly simian drawings occurring in literature but not in painting. Those using classical pictorial language, in the broadest sense, were reluctant at that period to produce images that did not comply with its aesthetic code; the scribblings of a monkey lay well beyond its scope.[39]

The second important point has its origins in the first. The results of the drawing game played (perhaps) by a macaque in an artist's studio, under the amused gaze of some aesthetes, would not themselves have had any aesthetic relevance at the time. They would not have stimulated experimental investigation of the phenomenon; even less would they have been admitted to a salon or a collection. In fact, history shows no direct connection between the painters' studios of the last century and the development of monkey painting. The transmutation of the image of the artist monkey into real-life ape painter has come from elsewhere, from biologists, and from a quite different milieu, from laboratories and zoos. It owes its introduction to a hiatus and a sideways shift in the succession pattern of contemporary culture. Nonetheless, we should not conclude from this that the history of ape painting has no relationship whatsoever with the realm of artistic fancy. The rupture and sideways shift in the succession seem more like a cunning move

on the part of the history of art: a sort of detour without which the image of the artist monkey would not have been able to achieve its transformation by total inversion, by passing on this side of the mirror.

2 Dates to remember

Before Desmond Morris

It is almost always impossible to identify a 'first time' when retracing the history of a cultural event. The items dealt with by the cultural historian are difficult to discuss as individual entities; he will describe the progressive broadening and thickening of a sequence of categories, or the shifting of clusters of items whose alterations are often simply changes in status. At what date were the drawing games of a non-human primate elicited and observed for the first time? The question already threatens to obliterate the nature of the phenomenon. The structure and status of the various different accounts of the phenomenon are as important as the events themselves; although the factual realities of the events are obviously not immaterial, they constitute only one part of the whole.

At a certain point in the history of the last century, realist fiction took up the time-honoured theme of the artist monkey in a way that almost prefigured later events, although inconclusively. Then the story died away again. A short while later the first objective accounts of real-life cases appeared from the world of science; in the early years of this century their number grew rapidly and their status changed radically. The intersection of the fictional and the real events gave birth to ape art.

Disposition to graphic play is an inherent characteristic of the large anthropoids. It has been noticed by nearly all those observing the behaviour of chimpanzees in captivity, in contexts where the chimpanzees are in close proximity to humans. The earliest descriptions of real-life cases, dating from the last quarter of the nineteenth century, all confirm this observation; accounts proliferated as the years went by. The naturalist Henri Coupin reports the reminiscences of the director of the Zoological Institute in Berlin: in about 1875 the director's son was playing with a male chimpanzee in his office. When the monkey saw the boy writing 'he would often also pick up a pen, dip it in the ink-well and draw lines on the paper'.[1] Coupin tells a similar story about a chimpanzee that belonged to a

doctor in the last years of the nineteenth century: 'many people, on the invitation of its guardian, had been to see it (...) drawing parallel and straight lines with a pencil held delicately between its thumb and index finger'.[2] At the same period, Garner, one of the pioneers of field primatology, observed a chimpanzee in Manchester Zoo that drew with chalk on the walls of its cage and also drew with a pen on sheets of paper. In a brief account of this in his book on gorillas and chimpanzees, Garner observed that the chalk drawings were of large circular and oval shapes, but the smaller drawings done in pen or pencil were full of lines and angles. The influence of the medium employed on the shape of the drawings produced by the chimpanzee would have been of great interest in another conceptual framework, but Garner drew no conclusions from his rudimentary observations. He noted that although the chimpanzee seemed to know exactly how to handle the instruments, it was impossible to know if the shapes it produced were coincidental or whether they could be regarded as real drawing.[3]

The phenomenon introduced in outline by these occasional observations became the object of scientific research just before the First World War. In the year 1913 a crucial step was taken towards establishing ape art as a field of scientific enquiry. Nadjeta Kohts, a Russian scientist, made the first thorough, detailed investigation of the psychological development of the chimpanzee (illus. 12). Later, she compared these observations, made over a period of three years, with observations of her own child.[4] An important element of her research was concerned with perception of shape and colour, and she was able to demonstrate very close parallels between the visual perception of the chimpanzee and that of man. Sustained study of the drawings themselves was another important element. In addition to demonstrating the depth of the chimpanzee's predisposition towards drawing – Joni, the young chimpanzee, drew enthusiastically for several years – Kohts demonstrated a significant development in the manner of working at it. The active involvement of the eye in the act of scribbling was the outward evidence of this development. Joni's drawings show an increasing tendency towards the building up of an elementary pattern based on lines already drawn on the paper; the chimpanzee returned quite regularly to the printed shapes, system-atically drawing little perpendicular strokes across them. Kohts was also able to identify a critical phase when the child's drawing,

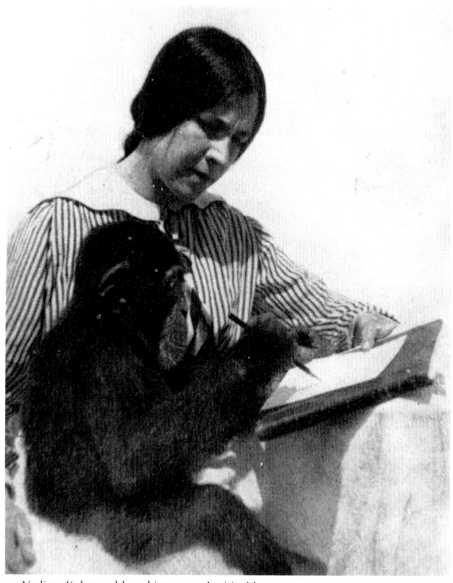

12 Nadjeta Kohts and her chimpanzee Joni in Moscow, 1913.

initially quite close to that of the chimpanzee, diverged from it decisively as it became representational. Some of Joni's drawings were published in support of Kohts' observations in the 1935 study.[5] Subsequently she studied the graphic behaviour of three other chimpanzees and two capuchins, and the comparison of the levels of skill they developed allowed her to highlight differences that significantly favoured the anthropoid. The relatively superior quality of the chimpanzee's drawing skills, plus a capacity to develop, indicates that these skills cannot be categorised as 'zero level'.

It was also just before the First World War that the psychologist Wolfgang Köhler, one of the founders of *Gestalt* theory, began his experiments on the intelligence of apes in the laboratory in Tenerife, established in 1912. The result of his research, published in 1916, is one of the classics of primatology. The book mainly deals with the cognitive faculties of chimpanzees and provides no information about their drawing abilities. Nevertheless, one of the many facts observed by Köhler has direct bearing on one aspect of the question that was not in fact investigated until the 1950s: the medium used by the apes for their pseudo-artistic activity. Most specialists favoured drawing as more practical and therefore better adapted to scientific research: drawing with a pencil is easier to control than painting and gives more legible results. At any rate, these are the reasons put forward by Desmond Morris when he returned to drawing after monitoring Congo's great success as a painter. Köhler recounts an episode that demonstrates a very definite and spontaneous liking for the basic effects of the painting activity as such, i.e. the spreading of colour over a surface, thereby completely changing its original appearance.[6] In the early 1930s Klüver also noticed the same love of painting in a capuchin,[7] but it was not until the experiments carried out by Morris and Rensch that the behaviour of monkeys with regard to paint as a medium was analysed in detail. There is also a short book on the intelligence of chimpanzees, published shortly before Köhler's study by a researcher named W.T. Shepherd, in which the drawing abilities of an individual chimpanzee are discussed.[8]

During the inter-war period the work of the pioneers of primatology, who had established a very distinctive scientific tradition, continued to develop. The comparative approach to the behaviour and psyche of the great apes evolved more or less on the fringes of the tougher trends in animal psychology and ethology, the

latter gaining stringent experimental credentials and producing systematised quantitative results. This comparative approach, however, produced a considerable literature whose epistemological style is characterised by its very accommodating standpoint; observation of the animal is based on empathy with the animal, whose behaviour has to be *interpreted* rather than being reduced to a collection of elementary diagrammatic outlines. One of the chief ways of monitoring the effects of this interpretative stance is to gather and store as many observations as possible concerning a particular piece of characteristic behaviour, in order to compare them and to identify constants and variants. It was when they realised that this was the correct technique to follow that researchers began to preserve monkey drawings with a view to publication. Soon the drawings came to be regarded as so many items to be filed away in the 'graphic behaviour' file, items that were felt to be of some future scientific value. A deputy director of the zoo in Hamburg, Alexander Sokolowski, once watched a chimpanzee scribbling in the house of a music-hall artist. He kept the drawing and used it, 'als Kuriosität', as a full-page illustration to the book he published in 1928.[9] A few years later a young couple named Kellog published (without comment) some drawings done by a young female chimpanzee brought up for ten months in close proximity with their young son – for the purpose of scientific research.[10] Finally, a couple of interesting observations were made in the early 1930s by an Englishwoman, Winifred Felce, who was director of the department of anthropoid apes in Munich Zoo from 1931-39. Nanni, a young female chimpanzee, discovered by herself the joy of drawing. What was even more extraordinary was that she also loved leafing through magazines: 'For several weeks, they [the young apes] had to have their temperatures taken twice a day. They lay on our laps for this. On the table was the book in which the temperatures were recorded. The ever-bored Nanni took up the pencil one day and began scribbling in the book. When she threatened to spoil the book with her doodlings, she was given the pencil the wrong way up; she noticed, however, that her efforts produced no visible result and, after examining the pencil, realised the reason and turned it round. When she was ill and in a cage by herself she used to fret to join her comrades, but, given an illustrated book to look at, (...) or pencil and paper for scribbling, she would remain happy for many hours.'[11]

The first systematic study of the graphical responses of an ape was not however undertaken until 1941, by a researcher in the Yerkes Laboratories, Paul H. Schiller. The results of the research appeared in 1951, after Schiller's death, edited by Karl Lashley, a collaborator who had been closely involved in the experiments.[12] The article, the first ever to be devoted exclusively to the question of the drawing capabilities of the animal, was epoch-making; in it, the basic methods for the systematic analysis of ape scribblings are laid down. Schiller's idea was to use drawing as a means of gaining access to certain aspects of the chimpanzee's faculties of perception. Having noted that Alpha, an adult female, had a relentless urge to scribble, he recognised an opportunity to apply procedures that were classic experiments in the psychology of perception. These procedures consisted of a series of tests aimed at establishing the structure of the perception mechanism. How does the apparatus of perception sort out sense stimuli, and what are the principles governing the association and discrimination of configurations? An experimental approach to such questions is relatively straightforward when the subjects are human; humans can be requested to classify shapes according to various criteria, simple preference being the easiest. Applying similar tests to animals poses problems, however. Ingenious methods of bypassing the barriers of communication and motivation that separate the experimenter from his subject have to be found. Using drawing games has many advantages from this point of view, because it allows direct monitoring of the visual reactions of the animal, faced with configurations that it will alter or accentuate. The detection of stronger or weaker constants in the type of graphical interventions made by the ape will provide all kinds of information about the way it perceives a particular configuration. If, for example, a tendency to complete incompletely outlined geometrical shapes is observed, then some consciousness of the complete form can be inferred.

These experiments on graphical interventions by chimpanzees led to the production of the first anthology of ape art, which consisted of about two hundred drawings. These permitted Schiller to identify the base parameters eliciting and governing the graphical production of a non-human primate and also to describe the fundamental characteristics of the operation and its results. The article of 1951 thus corroborated a series of observations known since the work of Kohts,

now confirmed by a significant sample: the absence of any representational element, the development of a 'style', the spontaneity and depth of motivation,[13] and finally the influence of the ape's vision on its scribbling movements. In addition, Schiller made new discoveries about the animal's visual control, and he hoped to explore the influence of this control over the ape's drawing in order to study perception as such. He presented the chimpanzee with sheets of paper on which he had stuck shapes chosen according to various formal criteria. Analysis of the marks made by Alpha on these sheets of paper demonstrated her acute sensitivity to the shapes and their variations; she perceived the shapes globally, in the same way as a human being. Although there is a marked preponderance of controlled motor-action movements in the drawings, Alpha produced extremely coherent responses to the shape perceived. She demonstrated strong awareness of the shapes on the paper (their placing and structure), making marks on complete figures on the centre of the page, often 'completing' incomplete figures and obviously favouring symmetry and balance. Schiller's study also showed that the chimpanzee's sensitivity to form went further than just a preference for certain shapes; it partook of a sense of form as such, or, to be more exact, of a response to a given formal situation. When a sheet of paper contained several figures, the chimpanzee reacted to their overall configuration (illus 13, 14, 15).

Schiller also observed that the chimpanzee's sensitivity to form was reflected in its drawings on blank paper. The free drawings produced by Alpha consisted largely of regular patterns made by the drawing motion, the to-and-fro movement of the fist and forearm. Apart from these elementary gestural shapes, Schiller observed no specifically formal elements in the scribbles. Nor did the ape's drawing appear to relate to scattered lines (like its own) drawn on the paper before it was handed over. But the drawings did show reaction to the field represented by the sheet of paper: not only was the paper regarded as the correct location for drawing games (the ape drew on it without going over the edge), but also the edges and corners of the paper were favourite areas for exploration (illus. 16). The ape's explicit aim at the pictorial field was observable even when the piece of paper contained empty outlines of relatively large shapes, or when a group of shapes was arranged to give an empty space in the middle. In these cases the chimpanzee placed its drawings inside the spaces, secondary

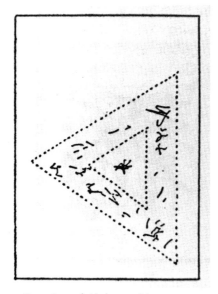

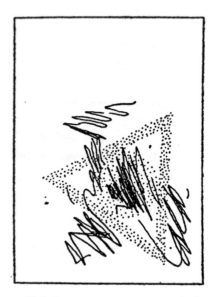

13 Reaction of Alpha, a chimpanzee, to a pre-marked shape.

14 Alpha's reactions to a pre-marked shape (a disc inscribed in a triangle).

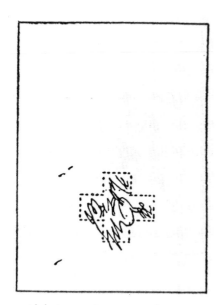

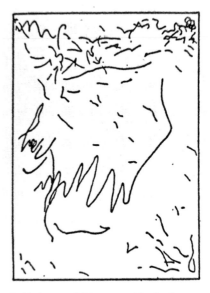

15 Alpha's reactions to another pre-marked shape.

16 Alpha: scribbles on a blank sheet. Note the marking of the corners.

pictorial fields inside the overall field constituted by the sheet of paper ('in-field').

The study concludes that the scribbles have to be interpreted according to their own 'rules' and not as a primitive stage of representation (they have nothing to do with this), nor as a disorganised activity that could only be termed 'graphical' at the risk of misusing the word. The ape scribbles, i.e. it draws with no other aim than to produce visual interplay between the lines it draws, the field and the shapes it contains, and this activity possesses its own intrinsic logic.

Finally, Schiller's observations about the sensitivity of the chimpanzees to shapes and the pictorial field had the effect of extending his enquiry beyond the subject categories of perception, towards a detailed study of the drawing technique itself. Although the drawing was not influenced by small thin lines drawn in hard pencil on the paper before it was given to the ape, it seems likely that bigger marks in definite shapes, drawn with something like a crayon or a brush would, because of their larger size, influence the final result. Schiller also noted that changing the drawing instrument caused differences in the type of line produced by the chimpanzee, who thus demonstrated its reaction to variations in two important components of the drawing equipment, the field and the instrument. Alpha usually made short marks with a hard pencil and larger marks with an instrument that left a thicker line. The adoption of another technique, therefore, could give rise to an elementary system of shapes which, overall, would be engendered in the following manner: the first marks, determined by the shape of the support, would in turn determine all subsequent marks according to the shape of the image field (a constant).

The preliminary data on the art of non-human primates was thus established. The most important innovations in the field were made fifteen or twenty years later by Desmond Morris and Bernhard Rensch, who updated the enquiry in terms of aesthetics; their studies, however, were based more or less directly on Schiller's experience.

In addition to Schiller's work, a further contribution was crucial in preparing ape art to make its public appearance: the idea of including the painting equipment in the study. This idea was born in the United States in about 1953, only on the fringes of the scientific

community. The photographer Lilo Hess owned a young female chimpanzee, Christine, that he used to encourage to draw with chalks and to paint with its fingers. He reported that although Christine enjoyed drawing, her enthusiasm knew no bounds when she was presented with a paintbox. She adored handling the colour and spreading it over a sheet of paper with her fingers.[14] At the same time two young chimpanzees in Baltimore Zoo were given the opportunity to practise the same technique, borrowed from child psychiatry and progressive educational theory. Like other monkey painters, including the famous Congo, Betsy and Dr Tom were television personalities and played an important part in the promotion of their zoo (illus. 17). Their pictorial activity brought them popularity and fame that led to the transatlantic exhibition of ape painting in 1957. In fact, a large number of their paintings was exhibited and sold even before that date. The first exhibition was held in the Little House Theater in Baltimore in 1954. The local paper published large photographs of the paintings and of the 'artists' in action.[15] Another newspaper, also copiously illustrated, carried the information that the director of the zoo was selling Betsy's work for between ten and twenty dollars a piece.[16] Unlike the Congo affair, however, these shows exploited to the full the traditional entertainment value of the monkey, particularly from the standpoint of the monkey's resemblance to man. The special technique of painting without a brush had its uses in this respect. It appealed to the monkey practising it on two counts: first, because of its nakedly pictorial quality (simple coloured daubing, more tactile than visual), and second, the appeal of drawing a network of informal lines with the fingers in the coloured paste smeared all over the paper. The informal nature of the play (which, by the way, was what caused finger painting to be excluded from the methodological arsenal of psychologists)[17] was perfectly designed to attract the public: it had analogies with the avant-garde art of the day and therefore could be seen as a simian caricature of modern painting (illus. 2). This was the ambivalent (and hidden) content of what Morris termed a heavily over-promoted 'zoological farce'.[18] The exploitation of the medium that permitted 'monkey art' to emerge as such was initially accompanied by the surreptitious return of the artist monkey.[19] Morris later had the greatest difficulty in getting rid of this farcical image – one persistent enough to dog the footsteps

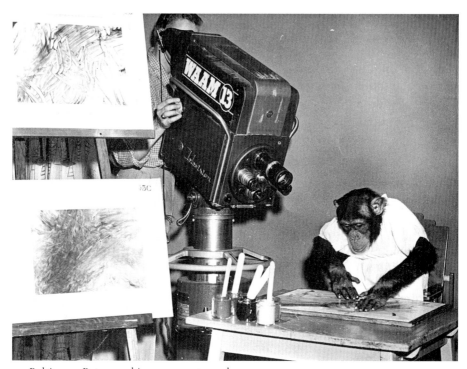

17 Baltimore Betsy, a chimpanzee, at work.

of an already quite celebrated biologist wanting to work on some fundamental scientific problems.

The biologists of art

In the late 1950s, interest in the scribbling and painting capabilities of the non-human primates intensified and became more focused. The topic that no one had previously thought of calling 'monkey art' became the subject of scientific study, conscious of its sources and its scope and integrated into the cultural life of the period by its relationship with other fields besides animal psychology.

This development was the work of two scientists who were the most important protagonists in the history of 'ape art', Desmond Morris and Bernhard Rensch. Both began their investigations at the same time, and their first publications in the field came out in the same year, 1957. Both approached the problem of the graphic and pictorial behaviour of monkeys in terms of *aesthetics*. Schiller confined his investigations into chimpanzee behaviour to the study of phenomena relating to the psychology of perception. The many fundamental observations about the drawings of apes he made as he conducted his experiments had nothing to do with the ultimate aim of his study, in which notions of art, beauty and aesthetics played no part. Together, Rensch and Morris inverted Schiller's aims: they applied the experimental methods used for the study of perception (as established by him) to the study of the graphic and pictorial behaviour of the monkey for its own sake, with a view to investigating the origins of the aesthetic sense in animals.

Bernhard Rensch

Bernhard Rensch pursued his research into the aesthetic capacity of primates with a capuchin monkey, Pablo, at the Institute of Zoology at the University of Münster. Pablo realised that a piece of chalk rubbed against the wall of his cage left visible marks. Knowing that another capuchin had already distinguished himself in this field,[20] Rensch began investigating the animal's drawing and painting abilities in 1954 (illus. 18). He immediately became interested in the aesthetic sense and its pre-cultural origins. However, he decided

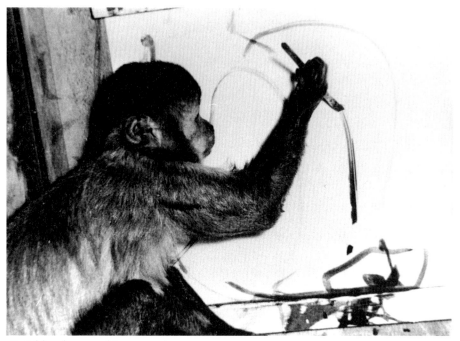

18 Pablo, the capuchin, at work.

to approach his research from a different angle. His first investigations related to the 'passive' aesthetic sense, evidenced in expressions of visual preference. Detailed study of the 'active' aesthetic capabilities of monkeys, as manifested in drawing and painting, began only in 1959 and was based on the results obtained from the first group of experiments.

Rensch's research into visual preferences was carried out with three monkeys belonging to different species, a capuchin, a member of the Cercopithecidae and a chimpanzee.[21] Later, moving backwards through the hierarchy of species, he extended his investigations to birds (Corvidae) and fish.[22] The two studies rely heavily on the classic methods of experimenting into aesthetics established by Gustav Theodor Fechner in the nineteenth century.[23] Rensch studied the reactions of the animals when presented with pictures bearing different kinds of configurations. Statistical study of the responses indicated a preference for symmetrical, rhythmic configurations in which an underlying pattern recurs; the monkeys and the Corvidae shared this preference, at least, the fish on the other hand preferring asymmetrical configurations. The study also revealed that the monkeys were subject to aesthetic 'modes', the object of preference varying under the influence of repetition.

There also seemed to be a very primitive preference for rhythmical elements in Pablo's drawing play. Often the lines drawn on the walls of his cage, from top to bottom, were repeated symmetrically, forming a kind of regular fan shape. In 1958 Rensch published a photograph of the monkey producing such a pattern, which proceeded from the repeating of a basic physical action (the arm moving back and forth).[24] Rensch was already familiar with Congo's paintings and drawings, which had been exhibited in London in 1957, and had read Desmond Morris' essay in the exhibition catalogue. He was struck by the close similarity of the fan pattern produced by his monkey to that of Congo, achieved by the same technique. He made a special study of this convergence, publishing the results in 1961.[25] In addition to Pablo, Rensch was able to study two chimpanzees in Münster Zoo, Lotte and Fips, unfortunately already aged 7 and 8 years old respectively. The investigation had to be interrupted at the beginning of the following year because the chimpanzees were reaching sexual maturity and becoming aggressive. A few years later Rensch was able to continue his research with a very talented young

chimpanzee, Julia, acquired by the Institute of Zoology of his university. Her paintings, executed over a span of more than ten years, were subsequently published in various periodicals.[26]

All the monkeys studied took to painting and drawing of their own volition, as soon as the materials were put in front of them, without having seen it done and without any other assistance than a brief initiation from the experimenter into how the pencil or brush should be handled. Like Schiller, Rensch studied the monkeys' response to blank sheets of paper and their reactions to geometric patterns. Just like Alpha, the three monkeys showed real sensitivity to the different lines produced by the various instruments, to the shape of the field, and to simple geometrical configurations (illus. 19). The published examples show lines adapted to paper of different sizes and echoing in remarkable fashion the shapes already on the paper. A circle, for example, elicited from Pablo a line from the centre which almost exactly followed a portion of the circumference (illus. 22); the chimpanzees marked the geometrical forms by following the contours, often almost perfectly. Their free painting also demonstrated the same sensitivity to form. Pablo sometimes drew parallel lines, as he had done when drawing with chalk, but more usual for him were mixtures of straight and curved lines, spread out in more or less harmonious fashion over the surface of the paper. The two chimpanzees manifested clear individual difference, in their behaviour as well as in their 'artistic' products. Several stages of painting activity could be observed in their paintings. At the most basic level there are clusters of broad strokes, oblique and slightly curved, proceeding directly from repeated to-and-fro movements of the forearm. The most sophisticated level reveals a close adaptation of gesture to form. The fan-shaped structures illustrate this, the symmetrical unfurling of the fan from a central focal point follows the shape of the page in a way that could be described as optimal (illus. 25). Rensch wanted to evaluate the rhythm and harmony of these paintings, submitting several of them to art experts without telling them that they were done by monkeys. Their reaction was mainly positive, as far as the general aesthetic quality of the artefacts was concerned.[27]

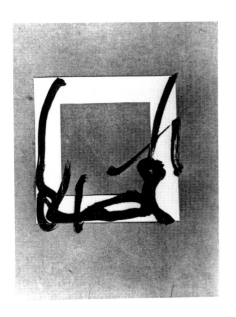

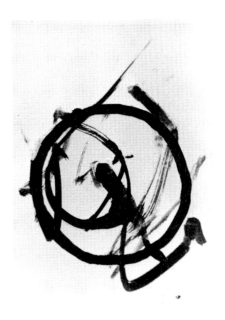

19 Lotte, a chimpanzee: painting on a
pre-marked pattern.

20 Pablo, a capuchin: painting on a pre-
marked pattern.

The second half of the 1950s was a golden age for monkey artists. They were at work in all the countries where the cultural tradition was dominated by the experimental sciences: the United States, Great Britain, the Netherlands and the German-speaking countries. Each country brought its own contribution to a large body of work, which was becoming better and better understood. In 1957 the zoo in Vienna was the scene of the artistic debut of two orang-utans and two chimpanzees, one of which (and this was to remain very unusual) was an adult male, famous for the episodes of sexual arousal that accompanied his painting play.[28] Between 1957 and 1959, five years after its predecessor at the zoo in Basel, the second gorilla painter in history made a name for itself in Rotterdam; this was a large female named Sophie, whose delicate little zig-zags are immediately identifiable as hers (illus. 21, 22). There were painting chimpanzees in Amsterdam in 1958, including Bella, a gentle female whose concentration during painting sessions was absolute; she never lost her temper, even when her sweets were taken from her, until one day her keeper wanted to remove her painting materials at an inopportune moment. Nadjeta Kohts returned to her experiments on monkeys' drawing abilities in 1958, and also at about this time the great American media stars like J. Fred Muggs and Zippy took over from the Baltimore painters, this time working with brushes rather than with their fingers.

There is no doubt, however, that we would not be talking about the 'ape art period' if Desmond Morris had not synthesised all these various experiments in his work at London Zoo. Not only did his work at the zoo with Congo, the chimpanzee, either launch or directly influence everything connected with ape art from the late 1950s onwards, but the acceptance of ape art in cultivated circles was also due to his efforts. He was also responsible for gaining international status for ape art – beyond the milieux of the laboratories and the avant-garde art enthusiasts – this time in a way that was far removed from the traditional idea of the monkey as a caricature of man.

Morris was born in 1928 and studied zoology at Birmingham, obtaining his doctorate at Oxford in 1954, under Niko Tinbergen. Tinbergen taught ethology and had shared the Nobel Prize with

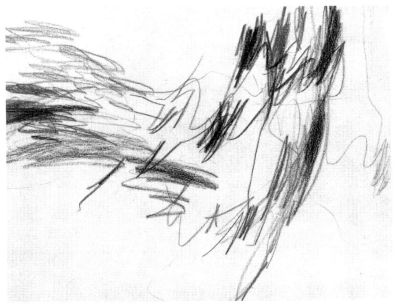

21 Sophie, a gorilla: a drawing in coloured pencils (red and blue).

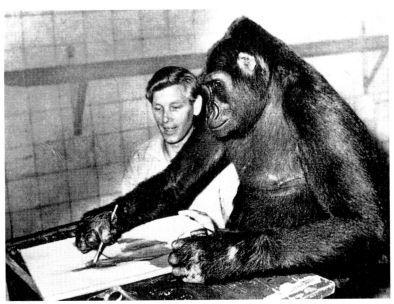

22 Sophie and her keeper, Chris Baris, in Rotterdam Zoo.

Konrad Lorenz for his part in having founded this new discipline, a hybridisation of traditional field biology and biology as pursued in the laboratory. At Oxford the young research scientist also became friendly with the biologist Julian Huxley.

As well as his scientific studies, Morris passionately enjoyed painting; he was a Surrealist. Since adolescence he had painted tiny, imaginary animal forms, in all sorts of strange shapes, no doubt inspired by what he saw through the microscope as a budding young biologist. His first exhibition was held in 1948 in his native Wiltshire, and the pictures, with their echoes of Klee, Brauner, Tanguy and, above all, Miró, caused great excitement in the local newspapers. Morris continued to paint while he was at Birmingham, where he associated with avant-garde circles, took part in Surrealist happenings and learned to make films. In 1950 he wrote and directed two amateur films, both Surrealist ; one won a prize and was shown by the BBC. Also in 1950 his work was exhibited at the gallery belonging to Edouard Mesens in London, alongside paintings by Miró, his long-term idol. It was at this time that he met Roland Penrose.[29]

Morris' artistic output diminished while he was completing his studies and preparing his doctoral thesis. This was his first experience of having to balance scientific research, his official subject, and painting, which he admitted was the great love of his life. To gain some idea of the impact of this division of vocations, we need only remember that in 1967 Morris chose to interrupt his career as a zoologist in order to become director of the Institute of Contemporary Art in London, at the request of Herbert Read and Roland Penrose, its presidents. This meant giving up the position of Curator of Mammals at London Zoo, to which he had been appointed in 1959.

Having completed his thesis on the behaviour of the stickleback, Morris wanted to extend his field of study to other species. He left Oxford, hoping to get a job at London Zoo. Helped by his experience as a film director he was appointed to the only post vacant at the time, as head of a television team that was to produce a weekly programme. The series, entitled *Zootime*, was a collaboration between the Zoological Society and Granada, one of the new independent television stations in Britain. Morris suggested having a permanent broadcasting station inside the zoo so that the behaviour of non-domesticated animals could be shown live, in surroundings

less artificial than a television studio. The idea was accepted and the programmes began appearing in 1956. However, although Morris aimed to produce a series that was of scientific interest as well as having popular appeal, he soon came to recognise the limitations of the medium. He had to be satisfied with entertaining the viewers with the many adventures and misadventures that inevitably occur when live television programmes are made with wild animals. His growing ability to extemporise only added to the boredom that he soon began to feel. One compensation for continuing with his task was the arrival of a rather boisterous young chimpanzee, born in the wild and now aged about one year old. The powerful personality of the little ape, called Congo, won Morris' affection immediately; it also won the monkey's rapid promotion to mascot of *Zootime*. Every week the public was regaled with his latest exploits. He was never filmed in clown costume, in the style of J. Fred Muggs, but was simply (and much more attractively) shown behaving like a normal young chimpanzee, exploring his environment, inventing new games to play, responding to the invitations of the large, kindly ape that appeared on the screen with him. Morris had never had the opportunity to observe an anthropoid from such close range. Surprise followed surprise, and his interest in the psychology of the chimpanzee, the complexity of the monkey's responses and tricks (often very cheeky) encouraged Morris to carry on in spite of the frustration he felt.

Shortly after he first encountered the article on Schiller's experiments, Morris suggested jokingly to his research colleagues that he should organise an exhibition of ape art in a London gallery. In 1954, on a trip to France, he had the good fortune to visit the caves at Lascaux; the paintings on the walls were then still bright and fresh, and it was, he said, 'the greatest aesthetic experience of my life.'[30] He promised himself that some day he would undertake a detailed study of the origins of the artistic impulse. He did not have to wait long, nor was the idea as eccentric as he perhaps had first imagined.

Congo arrived at London Zoo in May 1956, and he made his first attempt at drawing in November. At first Morris conducted the painting and drawing sessions off the air; later, when Congo learned to handle the paper, he took the risk of showing the sessions on *Zootime*. This went so well that the experiment was repeated four times. Following these programmes, the director of Baltimore Zoo

suggested a joint exhibition, beginning in Britain then moving to Baltimore, before touring the United States.

It was Morris' firm intention to take advantage of the exceptional opportunity now offered to him of making a long-term study of a single animal observed on a daily basis. But, as he recalls in *The Biology of Art*, the official aim of this work on Congo's artistic behaviour was not really scientific. For the directors of Granada TV the main aim was to make some sensational programmes, which would be seen by three million viewers and would provoke a reaction that would, in the long term, bring in a lot of advertising. Their predictions turned out to be extremely accurate. But the external pressures had a detrimental effect on the development of Morris' project, the main one being that the monkey was encouraged to use paint rather than pencil.

Free-style drawing was naturally the first stage in Congo's initiation into art. During a short apprenticeship Morris placed a pencil in the chimpanzee's hand and pushed the pencil over the paper, holding the monkey's hand in his. Once Congo had understood that this movement produced a controllable visible result he wanted to try again on his own, and repeated it over and over again. Morris moved on quite soon to painting, more spectacular to look at, although he felt that for experimental purposes it would have been better to stick to drawing. He did not return to drawing until much later, when he had built up a large enough stock of paintings for him to be able to return to Schiller's work on pre-marked patterns.[31] It might be said, therefore, that the use of painting was to some extent a response to public demand, and also a reply to the work of Betsy, which had satisfied public expectations so successfully that Betsy had become everyone's idea of the artist monkey. Once again the combination of a monkey and painting produced a distant, silent and (this time) indirect appeal to the historic collective unconscious.

Although the ghostly figure of the artist monkey certainly spurred on the transfer to painting, forestalling Morris to some extent at this important stage, this provided a pretext for a serious exploration of the whole matter. Morris had stated from the outset that the project was serious, not a joke, and finally this view was accepted. Once his project was underway, he sacrificed the minimum to the image of the artist monkey, which he saw as the main obstacle.[32] It could be said that, in ways to be explained later, he was right.

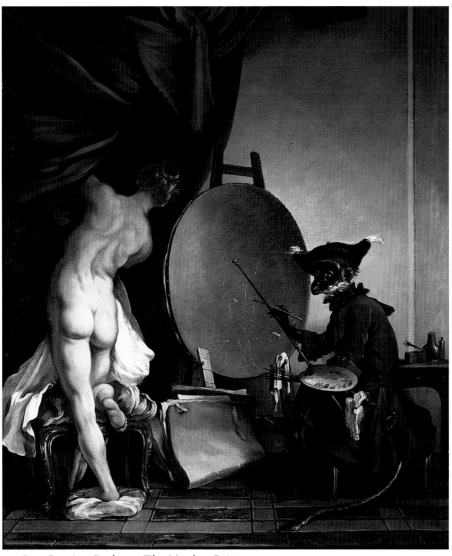

23 Jean-Baptiste Deshays, *The Monkey Painter*.

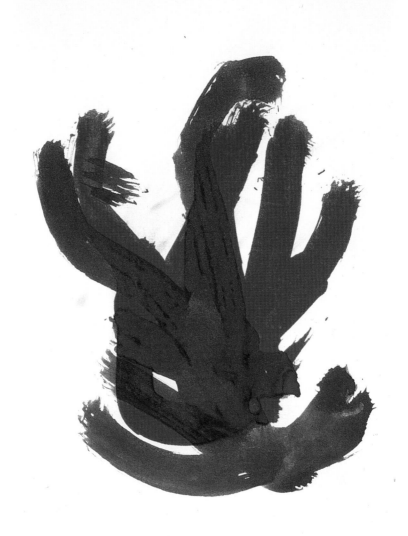

24 Gipsy, a chimpanzee: red and blue acrylic.

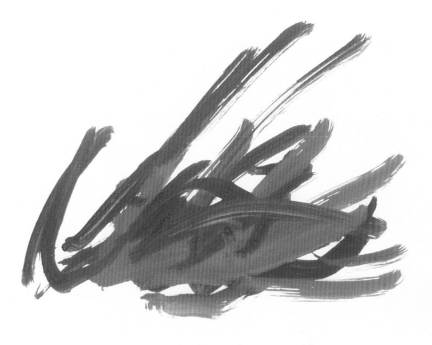

25 Julia, a chimpanzee: gouache with a leaning fan-pattern (blue, orange and red).

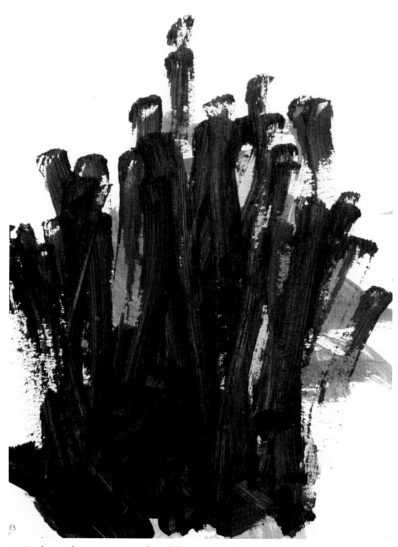

26 Lady, a chimpanzee: red and brown acrylic.

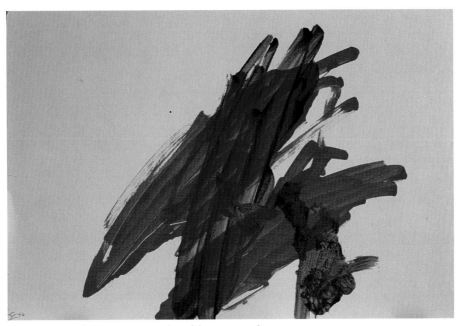

27 Jessica, a chimpanzee: a red and brown acrylic.

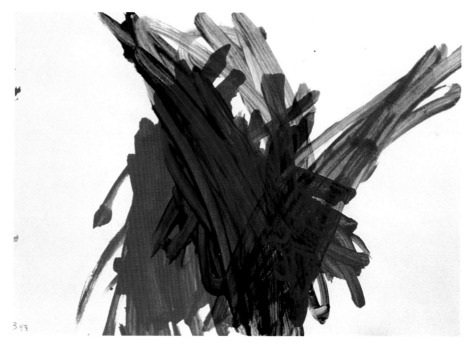

28 Bozo, a chimpanzee: a green, blue and red acrylic.

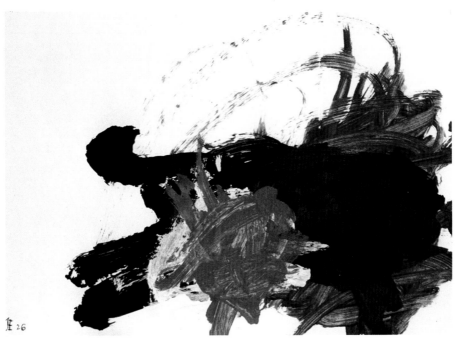

29 Jessica, a chimpanzee: an acrylic. The white area standing out from the group of black lines was next marked with a loose cluster of red lines.

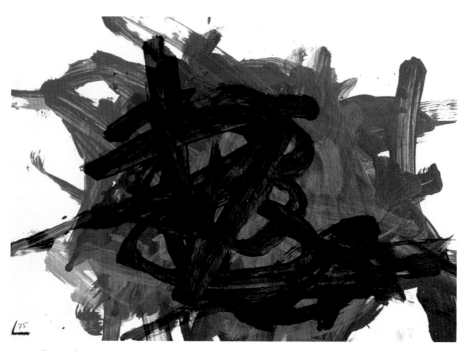

30 Lady, a chimpanzee: green, red, yellow and blue acrylic.

Exorcism of the image of the artist monkey was a *sine qua non* of real monkey painting, if it was to develop beyond the daubing of the Baltimore school. To establish conditions that would favour a more intense relationship with the painting materials was a long and difficult task, requiring serious effort. The chimpanzee understands very quickly how to make a mark, and reacts quite spontaneously to the image field and to the methods of using the materials put at his disposal. It is a different matter, however, to guide an animal to the stage where it concentrates convincingly on the exploration of composition and form when it plays with the marks and the field.

It took nearly two years of patient effort to get Congo to this stage of mastery of paint play. The main problem faced by Morris was how to give continuous encouragement to Congo so that he would concentrate, without altering his responses in any way. He had to monitor the monkey's play activities very attentively with the aim of restraining acts that were not specifically pictorial yet took place during his play with paper and paint. If, during a painting session, the chimpanzee began jumping on the paper or waving his brush at it while looking in the opposite direction, this meant that his attention was distracted by types of play other than that offered by the painting materials. Morris therefore had to develop and refine the monkey's spontaneous interest in paint play, without having recourse either to constraints or to rewards that would have falsified the parameters of the play. Morris used rewards only very occasionally when he needed Congo to keep still for a moment; he took care not to link the reward to the painting activity itself. If he had done so, the animal would have been placed in a situation where, instead of reacting spon-taneously to the painting materials, it would simply have been reacting to external stimuli, either by being conditioned, or by anticipating the experimenter's demands. Morris proved this by 'reinforcing' the artistic impulses of another chimpanzee with rewards, and the result was a dramatic loss of interest; the animal scribbled something as quickly as it could and held out its hand for its reward.[33]

The experimenter therefore had to anticipate the animal's 'pictorial thoughts' in order to encourage their free rein, and to measure out the time spent painting according to the animal's concentration span. Morris developed an efficient device to avoid distortion of the paper caused by the animal moving around. He sat

Congo in a child's chair with a table enlarged to provide a firm, horizontal support. Various refinements were added as the experiments developed. Congo's colour preferences proved to be unimportant, in fact the possibility of using all the colours at once led him to mix them all up into a uniform grey shade that was of little visual interest. If the colours were presented separately, real contrasts were achieved and these interested Congo greatly; this method also had the advantage of bringing his attention back to the same 'composition' several times, each colour change having the novelty of a fresh start. Morris also used a technique of painting by stages: he gave Congo several pages at a time, while Congo had only one colour; then he changed the colour and returned the pages to him one by one. This permitted him to break up the process of producing shapes into its component parts and to observe it as though through a magnifying glass; the chimpanzee reacted to its own marks as if they had been put there beforehand by someone else, rather than modifying them as it went along.

The move from drawing to painting won a very enthusiastic reaction from the chimpanzee. The superiority of liquid colour compared with the thin line of the pencil was grasped at once: 'Congo was delighted by this change. He revelled in the fact that much bigger marks could be made with little effort, as the paint flowed from his brushes onto the large coloured sheets I provided.'[34] He also readily grasped the interest of the paintbrush, and how perfectly it was adapted to painting play. It did not have to be forced on him like an awkward limb extension. On the contrary, not only did Congo not try to get rid of the brush in order, for example, to spread the colour with his hands, but he gradually learned how to hold it between his thumb, index and middle fingers, which allows the greatest precision in drawing. The manual dexterity of apes is often under-estimated. Their neat, well co-ordinated movements allow them to use all kinds of implements without any trouble. The structure of the monkey's hand – the thumb is shorter than the human thumb and does not meet the other fingers so easily – does not seem to be an obstacle to dexterity;[35] chimpanzees can pick up very small objects between the thumb and the tip of the index finger, and a few are capable of threading a needle. With Congo, this 'manual intelligence' found a very suitable training ground in paint play.

As time went by, Congo's concentration intensified to an incredible

degree. The length of the sessions gradually increased until they reached nearly an hour (even though no drawing took more than a few minutes); his manual accuracy grew and grew and, above all, he began to focus his attention much better on the problems of 'composition'. 'As the weeks passed, he gained in confidence and every coloured line or blob was placed exactly where he wanted it, with hardly any hesitation. He worked for much longer now, the bright colours adding an extra appeal that intensified his concentration more than ever. Nothing would interrupt him until he was satisfied with the balance of his picture.'[36]

In addition to the behaviour of the young chimpanzee during painting sessions, observed so painstakingly by Morris, who could hardly believe his eyes, the many examples of Congo's painting reproduced in the book published in 1962 show a powerful interest in the symmetrical coverage of the page, in a range of rhythmical variations and in colour contrasts. One of the most surprising characteristics of this aesthetic awareness, which surely no one would previously have dared to credit to an animal, was a sense for the point at which a painting was complete: Congo would put down his brush or hold it out to Morris when he wanted to move on to another sheet. To remove the page before the end, or to insist that he continue with a painting judged by him to be complete would cause considerable annoyance. The progress in his ability to make decisions about his work was accompanied by an exploration and invention of procedures that before long formed an extensive repertory of different strokes, dots and scrapings etc. with the brush. The taste for novelty, a typical feature of the chimpanzee's play, also led Congo to try out all sorts of variations on his spontaneous structures, the most important for him being the arrangement of brushstrokes in a fan shape. The repetition in various forms of this characteristic shape tended to give to that shape the status of a mental image preceding its being physically set down on paper; in other words, the fan pattern gradually turned into a kind of motif (illus. 31, 32). When Morris, at a later date, applied a series of tests to configurations produced by Congo and six other chimpanzees, he drew attention to the notion of formal equilibrium and pointed out some striking correlations between the character and the graphic style of different individuals. If expressive intent as such is foreign to ape painting, ape painting serves as a vehicle for some remarkably expressive effects.

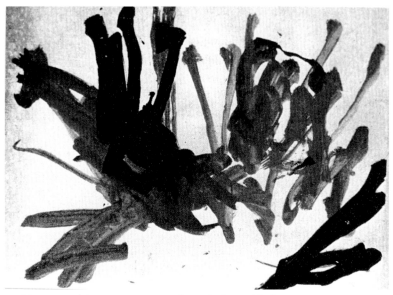

31 Congo, a chimpanzee: a gouache painting with fan.

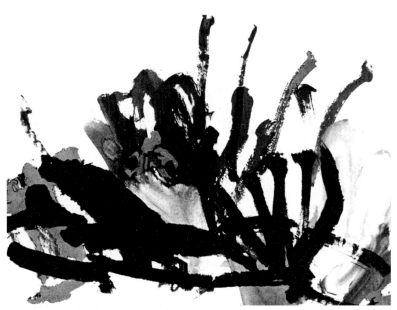

32 Congo: red, blue, green and black gouache. Note the subsidiary fan in the lower right-hand corner.

The project had to be halted at the end of 1958 because Congo had become too assertive and energetic to sit quietly for painting lessons. His two years of activity had produced a body of 384 drawings and paintings – the largest ever for a single individual. Morris assembled anecdotes about his adventures with Congo in an amusing little book,[37] wrote several articles for scientific journals[38] and published a longer description of his study in book form four years later. But it was mainly due to the exhibitions of 1957 and 1958 that ape painting achieved its prominent position in post-war culture.

Because the private galleries were wary of causing a scandal, the first exhibition of ape painting was held at the Institute of Contemporary Art, then the flagship of the avant-garde in Britain. Morris received the support of its director, Dorothy Morland, and of two well-known past presidents, Roland Penrose and Herbert Read. The exhibition was scheduled as the second half of a section of the programme of 1957 entitled 'Primitivism' (the first was devoted to drawings done by Australian Aboriginal children). From 17 September to 12 October 1957, twenty-four paintings by Congo were exhibited with twelve works by his rival in Baltimore. The whole exhibition then transferred across the Atlantic.

The exhibition met with a variety of responses. The idea that monkeys enjoy painting was not entirely new, since it had already been aired on television. On the other hand, bringing the paintings out of the zoo and exhibiting them in an official gallery gave new impetus to the surprise factor and raised tension. The matter had left the sphere of 'pop-zoology' (as one Punch journalist put it) for the world of fine art.[39] For some, it was too much. The president of the Royal Academy, the bastion of tradition, asked the public for donations to pursue the matter in court, 'for fraud or, if possible, for common theft.'[40] Above all, it was essential that the operation should not be viewed as a farce. Although some accused Morris of wanting to ridicule modern art,[41] others applauded his achievement, while others, imagining the exhibition to be an exercise in self-mockery in the Dadaist manner, were disposed to be wholeheartedly amused. The argument put forward by the adversaries of Action Painting, who felt confirmed in their opinion by the show, was as follows: monkeys paint like gestural painters, clearly therefore gestural painters cannot transcend the level of a monkey, QED. The 'monkey proof' is not in fact a new argument since it is in principle

based on the traditional view of the monkey as a caricature of a human being. A critic on the *Figaro* brandished it in 1875, in anticipation: 'The impression made by the Impressionists is that of a cat walking on the keys of a piano or a monkey that has got hold of a paint box.'[42]

Fortunately, Desmond Morris combined a genuine scientific career with experience of the media, plus an acute sense of the mechanics of farce acquired during his Surrealist youth. In addition, when still quite young he had developed the skills required for handling artistic scandal. This made it possible for him to control the comic side of his operation in order to prevent it from overshadowing the real interest of the project. It was important that public hilarity should not rule the day, but proceedings of pedantic solemnity would have been no less hilarious. Morris had to steer a nearly impossible course, past the irresistible image of the artist monkey, but without destroying the powerful attraction of ordinary simian behaviour as a resource. In order to emphasise the serious nature of the operation and to add tone, Morris asked Sir Julian Huxley to open the exhibition. The famous scientist and collector of contemporary art gave a lecture on the general interest of ape art from an evolutionist standpoint, and wrote an article about it for the *New York Times*.[43] He and his friends knew how to be conciliatory when the occasion demanded. Congo, just recovered from pneumonia, was present at the opening, to the great joy of the press. This careful approach paid dividends, and the press, generally very favourable, reported the project accurately in spite of fully exploiting its comical side.

The structure of the newspaper reports is extremely instructive. In most of the articles the text is completely separate from the photographs and their captions. The texts are generally based on an interview or on the exhibition catalogue and summarise the important facts of the story, more or less echoing Morris' terms and ideas. The photographs, on the other hand, are witty variations on the theme of the artist monkey 'exhibiting'. Their trick is to give the impression of an intentional relationship between the monkey and his 'oeuvre': Congo holding his arm out towards his painting;[44] or looking straight into the camera with his hand on the picture frame;[45] or mimicking the self-important, sophisticated pose of a great artist posing proudly in front of his masterpiece, his lips pouting and his arm folded across his chest.[46] The captions are written to support

these poses and imitative devices. The last of them is accompanied by a passage of direct speech identical to one already seen below a photograph of Baltimore Betsy: 'Just a little something I dashed off, but not bad.' The same devices were used when *The Biology of Art* was published.[47] What the composition of these messages reveals is, precisely, the mutation of the classical fictional theme into scientific reality.

The most important outcome of the exhibition was a great wave of sympathy for Congo himself as well as interest in his work, including from a number of great artists. Morris took Henry Moore round the exhibition, who was fascinated. Victor Pasmore appreciated the aesthetic interest of the paintings, which appeared to him to stem directly from the power of formal organisation. Roland Penrose gave a Congo to Picasso, who was delighted and hung it prominently on the wall of his studio. Morris describes how, when a reporter asked the great painter what he thought of monkey painting, Picasso began swinging his arms and threatened to bite his interlocutor. Penrose's present was well-aimed. A few years earlier Picasso had used the theme of the artist monkey for the second time in a series of drawings called *The Painter and his Model*. His affection for animals was well known; he loved to be surrounded by them in the tradition of the great princes of art. When he lived in penury in the Bateau Lavoir a female monkey was the senior member of his small menagerie, which consisted of a tortoise and a few dogs and cats.[48] Later Miró came to look at the few paintings by Congo still in Morris' possession. When Morris offered him one, Miró repaid it with two impromptu sketches made as they drank tea together. Salvador Dalí, who was then exploring the relationship between figurative and non-figurative forms with the aid of his celebrated paint gun, later made Dalí-esque pronouncements on the aesthetic problems of ape art. On one occasion, the American painter and collector William Copley, expecting a manifestation in the Dadaist or Surrealist style, arrived at the exhibition dressed in a top hat and a cerise tail coat and was very embarrassed when he saw the paintings and realised his mistake.[49]

Congo's paintings were not simply pleasing and interesting as objects, they were also very beautiful. From the outset the exhibition organisers were deluged with requests from people wanting to acquire them at any price. In order to preserve material that Morris

still considered as experimental, but without turning down such requests (which would have displeased Granada TV) the organisers decided to sell the paintings at prohibitive prices. This was necessary because some of the paintings had already been acquired by people including the head of Granada and various members of the Zoological Society and of the exhibition's organising committee. A few days later, to his horror, Morris realised that nearly everything was sold. The works of little Congo were now included in some impressive private collections. Herbert Read bought two,[50] Roland Penrose three (including the one he gave Picasso) and William Copley insisted on having three as well. A Congo was purchased for the Whitney collection, another for the Department of Anthropology at the Natural History Museum in London. According to one rumour (Morris was unable to vouch for its accuracy) a painting by the little chimpanzee was purchased secretly for the collection of the British Royal Family (Prince Philip was president of the Zoological Society at the time). Congo, fortunately in top creative form, had to put on a bit of a spurt to honour the undertaking he had made to his colleagues in Baltimore.

Congo's work formed the kernel of a second exhibition held a year later on the initiative of Mervyn Levy. The exhibition, entitled *The Lost Image; Comparison in the Art of the Higher Primates* (Royal Festival Hall, London), consisted of three groups of work: ape paintings (ten by Congo, one by Betsy and one by Alexander, the orang-utan at London Zoo); fifteen paintings by children between fifteen months and three years old, and a similar number of Tachiste paintings. The comparison was set up to show abstract art in an unfavourable light.

Monkey painting: survival and new perspectives

After Morris and Rensch, monkey painting became something of a commonplace in zoos in the Netherlands, Sweden, Denmark and elsewhere. Less highly-publicised exhibitions were organised in Germany and the Netherlands[51], and paintings produced during the experiments in Münster, London and Rotterdam were exhibited in the Belgian city of Liège.[52]

In publishing, nearly all the books written about chimpanzees reared in domesticity since that time instance painting and drawing

activities as part of normal play, as natural as children's paint play.[53] New collections of paintings have appeared, some of them assembled outside the worlds of art or science. Although this could make it difficult to study them, some of the anthologies contain documents of considerable value. Though compiled by 'amateurs', they go some way towards filling the gap left by the dispersal and loss of the paintings of Congo and his contemporaries. The invention of ape painting was a scientific sideline, improvised on the spur of the moment. Routine cataloguing was not carried out as effectively as it would have been for works of art in the normal sense. Neglect did the rest. The result is that almost nothing but the published paintings survives. The photographic record made at London Zoo has disappeared. Morris has only about twenty of the originals, some of them of little interest. The appearance of new anthologies at least kept the subject open to fresh enquiry. One particular collection is worth mentioning, that built up by Werner Müller, a music-hall artist who was manager of the skating chimpanzees in *Holiday on Ice*. He encouraged his chimpanzees to draw and paint over a period of about ten years, to ward off boredom in the dressing room between performances. He made a large and well-indexed collection: each item bears the animal's name and a number indicating the group to which it belongs and which way up the paper was held. Part of this collection has been dispersed today, but Werner Müller allowed me to examine the collection carefully and to photograph it when it was still virtually complete. The illustrations below with the names *Lady*, *Bozo*, *King*, *Gipsy*, *Candy* and *Jessica* come from this collection.

Monkey painting did not remain the burning topic of interest it had been between 1956 and 1962. The gradual petering out of gestural abstraction meant that monkey painting no longer coincided with current developments in art. The scientific interest that had prevailed when the biologists of art were conducting their experiments also tailed off. Desmond Morris turned rapidly to other subjects and did not return to ape art until many years later. A number of authors wrote up their research, long after the event, but without introducing new elements.[54] Others attempted to introduce more rigour into their analysis, with the addition of sophisticated methodological refinements.[55] Interestingly enough, the explicit purpose of some of these analyses set out as factual scientific records is to challenge the notion of aesthetics in this field. In the end, ape art

was marginalised by important innovations in the field of primatological science itself, which developed in fascinating directions where aesthetic capabilities seemed unimportant as the object of enquiry. They were passed over in favour of systems of communication by artificial visual symbols, and these have opened up perspectives undreamt of in the 1950s. The most interesting new work in this different context was carried out in America by the Gardners, whose research has demonstrated the possibility of the acquisition of sign language by chimpanzees, something that no one previously had thought possible, in fact it was implicitly assumed to be impossible. Morris himself was very cautious on the subject: the use of signs represented for him a distant hurdle that had never so far been crossed.[56] The Gardners opened the way to a fascinating and largely unexplored branch of research, whose links with aesthetics do not seem to have attracted much attention. That said, even though the conclusions they thought they had reached remain open to question, they deserve our gratitude for having tackled so new a subject.

The widespread use of drawing and painting as an additional play activity produced some very interesting observations and anecdotes connected with the study of systems of non-verbal communication, independently of the study of the use of sign language. One of the best of these anecdotes was told by the journalist Franco Capone in the magazine *Sciences et Nature/Natura Oggi*.[57] The occasion was a 'conversation' on the subject of paintings and the pleasure of painting which magnificently corroborates all the comments made previously on the intense motivation displayed by chimpanzees regarding painting play.

Capone had gone to 'interview' the chimpanzees being studied by Roger Fouts, following the Gardners, at the psychology laboratory of Central Washington University at Ellensburg. Included in the group of apes was the famous Washoe, the first chimpanzee to have been taught American Sign Language by the Gardners at the University of Reno, Nevada, and Moja, discussed later in this book, and others, all trained in the use of ASL. When Capone had been introduced, Moja turned her full attention on him and signed the following message several times: 'Give! give! give!', adding at once 'brush! brush!'. Moja had noticed the brush used by the photographer accompanying Capone for cleaning his camera. According to Debbi Fouts, who was

acting as interpreter, the chimpanzee wanted to use the brush to groom itself. Tatu, another chimpanzee who was there suddenly had another idea: 'painting, painting!' Debbi Fouts asked: 'Tatu likes painting?' Without waiting to reply, Tatu rushed towards the 'painting room', a room reserved for this activity and reached by a small door at the back of the cage. As transcribed by Capone, the conversation continued as follows:

'What colour do you like best, Tatu?'

Tatu: 'Black, black!'

'And you, Washoe. What colour?'

Washoe: 'Red, red!'

'Why?'

Washoe: 'Beautiful, beautiful!'

'Do you prefer to paint or to eat?'

Tatu: 'Eat/paint, eat/paint, painting good!'

Although the final 'declaration' may be open to interpretation, Tatu was evidently establishing a relationship between two activities that gave the keenest enjoyment. The idea was certainly not 'painting to eat', since painting is appreciated by chimpanzees for its own sake and is used as a form of reward (in the same way as sweets or a walk).

'Monkey art' fell into relative neglect, but there was a surge of interest in it a few years ago, probably linked to the rediscovery of the 1950s and 1960s as well as to the increasing influence of environmentalists, who have a tendency to dispute man's pre-eminent position in the living world. The ideological atmosphere established by such arguments favours the increasing recognition of the dignity of animal life in all its richness. In fact, although this attitude can lead to major philosophical deadlocks (the claim to a sort of 'right to be different' leads inevitably towards anthropomorphism, generally considered inadmissible), it undoubtedly creates an ideal climate for the continuous sense of wonder aroused by the mental abilities of the higher mammals such as the great apes.

In 1991 the documents collected by Bernhard Rensch were extricated from the archives in the department of zoology at the University of Münster and were put on public display in an exhibition held at the Westphalian Museum of Natural History in Münster. In the same year a selection of paintings by Werner Müller's chimpanzees was exhibited in London, at the Circle Gallery

(Lyric Theatre, Hammersmith), with proceeds going to two societies for the protection of great apes. Four years later the same group of paintings was exhibited again at the Réserve Africaine in Sigean (near Narbonne, in the South of France). This exhibition was held to welcome Müller's chimpanzees to Sigean, where the director, Jean-Jacques Boisard, had built a specially-designed house to accommodate them in the game reserve. The aim of this enterprise was to provide conditions that were as close as possible to the animals' life in liberty, replicating the autonomous structure of the group as far as possible; the building was designed to avoid the animals having direct contact with man as far as possible. This explains why Werner Müller's chimpanzees will not be painting any more. There has been an exception, though. The story of how Jessica, the senior member of the group, resumed painting after her arrival in the reserve, several years after she had stopped, is interesting. She arrived exhausted, suffering from a range of symptoms and in a state of prostration; something had to be done quickly to help her out of this very bad state. According to Müller and Boisard, the psychological stimulus of paint play contributed to the improvement in her health, and she was soon completely better.

Similarly, there have been some notable resurgences in the art of non-human primates in the scientific world, oscillating there also between *survival* and *revival*. Drawing, for instance, is at present being extensively used in a very large-scale project on the ontogeny of the primates, started in 1994 by Marina Vancatova's Group for Primate Research at the Research Institute for Pharmacy and Biochemistry, Konarovice (Czech Republic). The experiments being carried out in collaboration with a group of Russian scientists, distant heirs to Nadjeta Kohts, concern four orang-utans, four chimpanzees and a gorilla being studied at the Institute, plus some other apes raised in different zoos in the country. So far almost a thousand drawings in pastel, pencil and marker pen have been produced, and some have been exhibited in the Czech Republic, in Western Europe and in the USA. The sessions are strictly regulated in terms of the size of the drawing sheets, the preliminary markings on the sheets to which the apes are invited to respond, the drawing implements used, the position of the subjects, etc. In addition, because all the sessions are filmed, the experiment is being carried out in optimal conditions for the interpretation of the results.[58]

Mention also should be made of the work of Ignace Schretlen, a Dutch physician who, since 1990, has been investigating the relationship between scribbling activity in young children and in apes; he has organised three exhibitions on the subject, entitled *Kijk op krabbels* (Look at Scribblings), shown in several cities in the Netherlands and abroad.[59] The originality of his approach resides in his use of a piece of equipment, invented at the University of Nijmegen, that makes it possible to record all the movements involved in the act of scribbling: variations in the speed of the strokes and in the pressure exerted on the pencil were recorded, as well as the strokes themselves. The different movements, recorded by a computer linked to the drawing instrument, are then translated into a series of curves, which make it possible to visualise the variations recorded.[60]

Almost half a century after conducting his first research, Desmond Morris himself recently returned to the question of painting by apes, in a series of programmes made for the BBC (*The Human Animal: A Personal View of the Human Species*, 1995). He wanted to fill a void in the general overview of our knowledge of the drawing and painting ability of the large anthropoids. This overview, well-stocked with orang-utans, gorillas and common chimpanzees (*Pan troglodytes*), contained no information on the bonobo or pigmy chimpanzee (*Pan paniscus*).[61] This species is much rarer and more narrowly localised geographically (pigmy chimpanzees are only found in a very restricted area on the south bank of the River Zaire), and it differs from the common chimpanzee both morphologically and in its behaviour. A comparison of their reactions to drawing with those of their close cousins was therefore of great interest. Morris did his investigation in the game park in Planckendael (near Brussels in Belgium), where there is a group of nine bonobos, a tenth of the world population of the species in captivity. This group is cared for and closely studied by a team of researchers under the direction of Linda Van Elsacker, an ethologist working at the Royal Zoological Society of Antwerp.

A number of experimental drawing sessions was held in Planckendael between November 1993 and January 1994, to a very carefully organised plan; all the observations made during these sessions were kept together in a separate file (Morris' documentary does not draw on this body of research).[62] The low number of drawings obtained makes it difficult to draw substantial conclusions,

but the indications are that more extensive research would yield valuable information.

One of the drawings, reproduced here, which was done by an adult female named Dzeeta, has a surprising appearance, differing very substantially from most of the drawings done by common chimpanzees. As we have seen, chimpanzees are strongly influenced by the shape of the page, either meticulously marking the corners and central area, or covering the whole of the image field with big, energetic strokes. In the majority of cases also their lines possess a very characteristic rhythm: overall they are usually of the same size, all drawn at comparable speed and with comparable pressure, and thus they represent a sequence of movements that are closely linked. Instead, in Dzeeta's drawing we find an accumulation of groups of lines, long and short, thick and thin, some quickly executed and some less so, scattered over the sheet of paper without any apparent 'overall logic'. The diversity of graphic forms is really astonishing, from small, complex flourishes, delicately unfurled, to clusters of much more energetic strokes produced by the to-and-fro movement of the hand, and including some straight lines of different length and thickness, either isolated or in groups, plus some ellipses, complete and incomplete, some short strokes and some dots (illus. 33).

This interesting drawing by a pigmy chimpanzee is distinguished by its relative independence from the constraints of the field as well as for its rich repertory of marks, giving the impression of a fevered exploration by the animal of the possibilities offered by this elementary drawing play. These statements must however be read in the context of the conditions so clearly described by Linda Van Elsacker in her report on the research. Firstly, the drawing in question was one of the earliest done by the subject. During the first session, when the materials were being explored for the first time, Dzeeta scribbled at length on a single sheet of paper, while during subsequent sessions she drew just a few very visible lines. These later drawings, in pastel, are composed of thicker, more energetic lines and more closely resemble the normal products of a chimpanzee. Secondly, she moved around the sheet of paper during the session, which negates some of the properties of the field (it loses its top-bottom, left-right layout). Moreover, Dzeeta and the other members of the group had some very destructive reactions to the materials, tearing up the paper and, often at the outset, breaking the sharpened

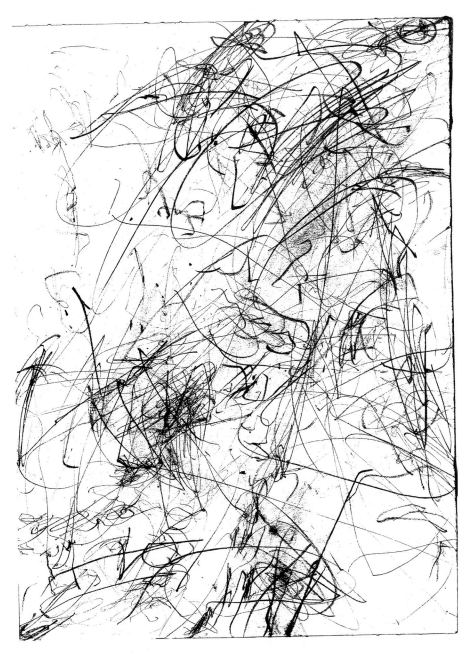

33 Dzeeta, a pygmy chimpanzee from the animal park in Planckendael, Belgium: pencil scribbles on plain paper.

points of the pencils and then reducing the rest to small pieces. In most instances the scribbling was done partly with scraps of lead extracted from the broken pencil, rubbed on the paper with the fingers. The results visible on the few sheets that could be salvaged have to be regarded as the outcome of an exploratory game that hardly focused on drawing as such.

Another important factor contributing to the spread of 'monkey art' to a wider public has been the extension of experiments on picture play to other mammals, including elephants and dolphins. This type of experiment has been carried out in the USA, in particular by David R. Henley, an art teacher who, after teaching art to mentally retarded children, ended up working in zoos.[63] The press has covered similar enterprises with great thoroughness, pleased to have the opportunity to print some sensational photographs, always popular with the readership. Zoos are usually very willing to co-operate because 'animal art' has a promotional impact that they cannot afford to neglect. However, as far as I have been able to judge, the artistic skills of dolphins and elephants cannot compare with those of the great apes: although they may play quite convincingly at spreading the colour over a surface with a brush, I personally do not consider that the formal structure of the image field is taken into account at all. And no wonder. Without enumerating the particular characteristics of their visual and mental equipment, these animals do not possess the physical equipment required to wield the painting implements effectively. In the case of dolphins, this is self-evident. As for elephants, however, although the elephant's trunk is remarkably prehensile, it certainly does not permit the same degree of control as the arm and hand of a chimpanzee, which closely approximates the physical equipment for which painting materials are designed.

Monkey painting continues to play a rôle in the promotion of zoos in Europe and in America. Among examples are the zoo in Fréjus, in France, and the *Tiergarten* in Vienna, where a female orang-utan named Nonja keeps up a steady output of paintings; her work has been sold for high prices in aid of the zoo. The European press has not denied itself the pleasure of publishing photographs of Nonja at work, brush in hand, or posing nonchalantly by one of her paintings, like a self-important and celebrated artist.[64]

The absorption of 'monkey art' into the realm of popular culture

also demonstrates in its own way its peaceful integration and acceptance as a normal phenomenon. Writing and illustration on the subject is often identical in content to what might have appeared half a century ago. Most of the time the mass media (and the public to whom it is addressed) give the impression of having discovered 'monkey art' for the first time, never appearing to realise that the same images are being repeated and that the whole subject is in fact old hat. The same old images, the same old visual tricks and the same jokes are repeated as if they were brand new. The only thing that may be said to have changed is the general tone of texts and images. Whereas monkey painting was born on the battlefield where supporters of modern art and their opponents were tearing each other apart, and whereas it represented an obvious challenge in this highly polemicised context (the fate of modern art was supposedly sealed at this level too), it is seen today as only a harmless bit of fun with no long-term consequences.

The relaxed attitude prevailing today towards monkey painting seems a typical feature of post-modern culture, a culture without conflict, in which anything seems possible and in which nothing in the art world seems to threaten the foundations of society. In this melting pot of subjects, attitudes and images drawn from the past, there is still a niche for the good old reactionary stance, ready to savage but lacking the venom that made it so feared in the past. A right-wing newspaper might still latch on to the story of Nonja in order to pour a bit of bile on 'modern art'.[65] Such an attack would pass unnoticed among the daily outpourings in the same vein, like a harmless sequel to the time when modern art had the strength to bring about its own destruction. Nothing could have illustrated this more clearly than the media coverage of the exhibition at the game reserve at Sigean, granted the honour of inclusion in the news bulletin of one of the major French TV channels (FR3). It was just like the old days. Experts were called in, including a psychologist specialising in mentally retarded children, and the origin of the paintings was concealed from them. The experts were obviously unaware of the trap, and viewers could be entertained by the judgements and diagnoses based on factual ignorance. One member of the panel, who had no connection with the subject, declared that she loved the chimpanzee paintings as much as she detested modern art. All these opinions, which seemed to have emerged unaltered

from the past, fitted seamlessly into the prevailing tenor of a report designed to show the event in a positive light, to conform to the expectations of a public more in favour of animals than inimical to modern art.

During this guileless rediscovery of monkey painting, mass culture was not satisfied with the recycling of themes typical of the period in which the phenomenon was born. Sometimes elements that were superficially 'contemporary' were mixed with much more archaic components. One example was the film *Congo*, produced by Paramount Pictures in 1995, a straightforward adventure story in which the special effects were far superior to the narrative quality.[66] The setting is the University of California at Berkeley, in a gorilla research centre. Amy, a young gorilla educated in the use of ASL, is a painter, and the walls of the laboratory are hung with numerous examples of her work. Amy's favourite colour is green, and it dominates all her paintings, most of which have large vertical strokes in black or brown, in a sea of green. To the young researcher in charge of Amy it is clear that these paintings represent the half-remembered jungle of her childhood, returning in flashbacks. The distant memory of her childhood home obsesses this unfortunate young gorilla, inspiring her nostalgia-filled paintings. The film pays lip-service to the experiments with communication by signing and the pictorial ability of the great apes, but these very topical references are enlisted in the service of an age-old myth that has animals struggling like Romantic poets to tell us about their innermost feelings.

Mention should be made here of so-called cat painting. In quite a different way, this affair is just as enlightening about the amount of ground covered over the past fifty years. The book published in 1994 by Heather Busch and Kenneth Silver, *Why Cats Paint: A Theory of Feline Aesthetics*,[67] belongs in the category of the hoax. The book's argument, developed in broad sweeps of fake erudition, false documents and phrases inspired by scientific literature and the history of art, can be summarised as follows:

Cat painting has been known since the earliest times. Evidence of it can be found in Ancient Egypt, and it has been practised continuously since then, as some of the important illuminated manuscripts of the Middle Ages or the popular prints of the nineteenth century show. However, it was not until very recently that a scientist (now deceased) discovered the key to the interpretation of feline art: in

fact, cats paint figuratively but, after the fashion of the Neo-Expressionist painter Georg Baselitz, they always represent their subjects upside down. Once this crucial discovery was made, it at last became possible to interpret cat paintings correctly, as portraits, still-lifes or scenes with figures illustrating various aspects of feline life. Today, cat painting has developed and divided into various quite distinct schools; these include 'Spontaneous reductionism', 'Expansionist formalism', 'Essentialist fragmentism' and others. These developments have been promoted and brought to the attention of discerning art lovers by a number of feline art societies in various parts of the world.

The book by Busch and Silver begins with a historical section filled with fake documents (including a picture of a mummified cat holding one of its paintings between its forepaws, with captions in very explicit hieroglyphs), and continues with a 'behavioural study'. This informs us of biologists' reluctance to accept the evidence of genuine artistic impulses in cats; they were looking for more down-to-earth explanations. The second part is illustrated with photographs of cats at work, some painting from life and others engaged in works of Expressionist tendency.

The book ends with a most convincing analysis of the other forms of art practised by cats, revealed to us at last thanks to our improved comprehension of their painting. We learn that the tears cats make with their claws on upholstered chairs are the result of a highly complex aesthetic approach and contain extremely precise symbolic meanings. Nor are cats strangers to avant-garde modes of expression, as we learn: they produce 'installations' of dead mice, evidence of very sophisticated thought processes.

The bibliography at the end of the volume bears witness to a growing interest in feline art. It is a list of titles as fantastic as the documents used to illustrate the book, and it is scattered with broad winks at readers familiar with the literature of modern art. For example, we are introduced to a book by A. Ciacometti, *Forget the Cat, Save the Art. A Reappraisal* (Raspail, Schwitters & Prat, Lyon, 1989); or the book (obviously a seminal work) on the deep psychological links between cat painting and their urinary activity, whose author is not completely unknown to us since his name is written on Marcel Duchamp's celebrated urinal: R. Mutt, *Ornamental Retromicturition. Urinary Finishing Touches: A Major*

Problem in the Conservation of Cat Art, Journal of Non-Primate Art, vol. XV, 1991.

There are a number of obvious clues to the butt of this hoax: an introductory note informs us that the book was published with the support of the ' British Society of Non-Primate Art'; in addition, the section on the 'behavioural study' contains a reference – genuine this time – to Desmond Morris' book on the biology of art (the authors dispute the theory that cat art, like ape painting, is a play activity). Obviously, the main target is ape painting and its extension to other animal species. A secondary target is contemporary animal worship and the anthropomorphism it entails, man's inordinate passion for cats being one of its most significant manifestations. A passing swipe is taken at the contemporary art market, in which anything can be sold, including paintings by animals; some galleries even specialise in animal painting, just as twenty years ago others survived by selling painting by mental patients. Modern art itself emerges remarkably unscathed: perhaps a few scratches from the pretentious names given to the leading movements in feline art, but it has nothing to fear from such superficial attacks.

Entertaining and revealing though this business of cat painting may be, I hope I may be permitted some scepticism on the subject, especially as regards the logic of the hoax. In my view the aspect that sticks in the throat is the profile of the victims: the obvious forgeries (any art historian looking at the 'old' documents must smell a rat) and the shameless winks at specialists in modern art put them out of reach. The biologists too are comfortably shielded by the enormity of the claims made. However, the general public is not so well protected; they will have read press accounts by journalists who have fallen into the trap; anyway, why should anyone be surprised to learn that an aesthetic sensibility has now been added to the multiple attributes of our elegant velvet-pawed friends, while monkeys, common elephants and even dolphins have learned to wield a paintbrush? While the educated minority shares the joke, sitting in noble isolation on the promontory of their superior knowledge, from which they can observe the amusing spectacle of the common herd falling into the trap of fiction, isn't it true that the value of a hoax is measured by the level of awareness of the person being duped?

So while art critics of the last century or their successors were able to turn monkey painting into a total caricature of modern art, now it

is monkey painting itself that is being parodied. And, in the same way that a politician or a show-business personality reaches the top only after cartoonists and imitators have turned their attention to him, Busch and Silver's hoax testifies to the ascension of monkey painting to the firmament of legitimacy. A chapter of history has come to a close.

The calm acceptance of monkey painting into the bosom of contemporary western culture does not mean in fact that the story ends there. This integration serves as the basis for new transformations: monkey painting as a cultural reality is continually renewing and reinventing itself on the basis of its status as a *locus communis*, acquired over the past thirty years. Through the eyes of a contemporary cultural historian it might be viewed as a thick emulsion made from something light – the elements of novelty – bound together by something heavy, namely the repetition (conscious or unconscious) of former patterns.

Among the elements of novelty, probably the most significant has been the appearance of single painted works produced by the collaboration of an artist and an ape. Such a collaboration was tried for the first time at the end of the 1970s by the Austrian painter Arnulf Rainer. The work consisted of two separate items placed together on the same page: a painting done by the chimpanzee and an 'imitation' produced by the artist. I shall discuss this enterprise later; the outcome was important and deserves fuller treatment.

The approach of Lucien Tessarolo, a Frenchman, has been quite different. An animal painter who became fascinated by great apes, in 1972 he produced a series of 50 variations of a portrait of a chimpanzee reared in the private zoo of Prince Rainier of Monaco. Contact with this animal made a lasting impression on him, and this led directly to an astonishing collaboration in 1987 between him and Kunda, a female chimpanzee then aged 14 from the Fréjus zoo (illus. 34); Kunda was described as having particularly highly developed intelligence and powers of attention. Tessarolo emphasises the precision of her drawn lines and the harmonious use of colour in her superimpositions and juxtapositions. During the sessions in which they both painted, he left the initiative to Kunda and then completed her clusters of lines by the addition of figurative elements. These frequently included birds, one of which is adorned with brilliant plumage created from a vigorous fan-shape of coloured marks made

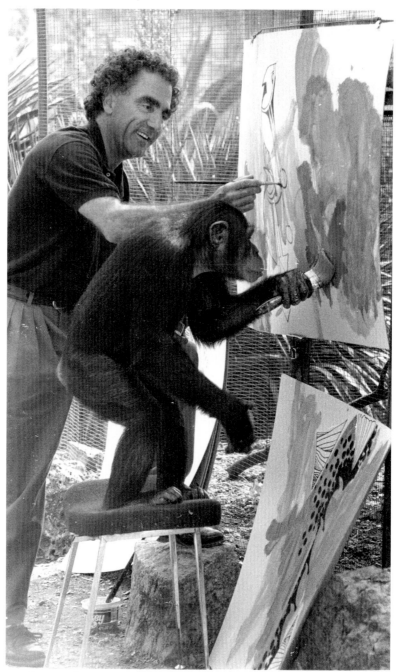

34 The French painter Lucien Tessarolo working with Kunda, a chimpanzee.

by the chimpanzee. Tessarolo says that at times, Kunda would accept his additions with enthusiasm, at others she would rub them out and wait for him to draw something else.[68] Once the pictures were finished they were signed by both artists, the painter putting his name on one side and Kunda a handprint on the other.

Nothing demonstrates the assimilation of monkey painting into post-modern culture more clearly than works like these, conceived without irony by painters eager to use the products of the paint play of chimpanzees for artistic purposes, and in such a way as to give full recognition to the part played by the animal.

PART 2 Aesthetics

There was once a naïve painter who was depressed and penniless. He had just been turned down by a gallery. A friend, remembering the story of the 'chimpanzee painter whose work fetched such huge prices a few years ago', devised a scheme to help the poor man out of his gloom. He advised him to dress up in a gorilla skin and to be seen painting in this outfit. If he could make people believe that his paintings were the work of a very original ape, he would gain celebrity at last. The painter took his advice and all went smoothly. He could feel himself becoming more and more like an ape every day. His paintings, hideous daubings, much more simian than anything ever painted by a monkey, won great acclaim at a well-attended private view in the very gallery that had rejected him. But then a real gorilla escaped from a nearby zoo. He entered the painter's studio by a skylight and made short work of the painter. Then he hid the painter's body in a wardrobe, slipped the gorilla's skin over his own and began painting pictures. He was completely unrecognisable in his ape-artist disguise.

This stirring episode from the adventures of *Achille Talon*,[1] a character well known to readers of French comics, is a kind of parable; it tells the whole story. Real non-human primates insinuated themselves into the artist-monkey's imaginary cast-off skin which was already in the process of metamorphosing gradually into the skin of a real monkey. Nobody, including the original instigators of the substitution, was aware at first of the change when flesh-and-blood monkeys took the place of the impersonators. Baltimore Betsy, although a perfectly genuine chimpanzee, could not divest herself of the simian persona of an avant-garde artistic hack, so that no one recognised her ape quality because it was imprisoned inside the trite, distracting image. Congo took her place as the complete ape artist, and it required the tenacity of a Desmond Morris to stop the caricature, rip off the monkey mask and reveal the animal as it really was, in primatological nakedness, seen now against a background of aesthetics.

The image of the artist monkey was finally effaced by the

intellectual approach of the art biologists, who promoted and appreciated monkey art as an expression of primatological difference; otherwise it would never have emerged into reality. The image of the artist monkey remains indelible, however, at one level, and this is at the level of the paintings themselves. Although it is quite possible to avoid anthropomorphism in the description of the various inherent characteristics of the monkey's method of playing with painting equipment, it is impossible to escape from the influence of resemblance at one particular level: we cannot look at the results of the painting process without conferring on them the status or the aesthetic presence that is identical to that of a *work of art*. What is a work of art? It is a thing created by a process whose aim is to confer on it a special aesthetic presence. Monkey painting, however, has no connection with this creative dimension; it is not aimed at creating a tangible object that will have a continuing visible presence after the act of producing it is over. Monkeys are totally indifferent to their paintings the moment they are finished. From a human point of view, the act of studying one of these paintings is equivalent to conferring on it, *ipso facto*, a visual value of its own. The moment you *look at* a monkey painting it *resembles* something produced for the purpose of being looked at, like works of art produced by artists.

Assessing the aesthetics of monkey painting requires measuring the distance on the paintings themselves between the simian processes by which they have been created (and their particular visual attributes) and our spontaneous recognition of them as artworks. To start with we need to find out what constitutes the simian contribution to their existence.

1 The game of the disruptive mark

The question of the 'sense of order'

According to Morris and Rensch, monkey painting provides evidence that aesthetic sensitivity, common to all primates, has a biological root; the basic component of aesthetic sensitivity seems to be a marked preference for rhythmical, balanced forms. The importance of rhythm and balance is evident in all areas of human art. In the case of monkeys, it appears that in almost all the varieties of painting and drawing activities that they perform their preferred mode of expression is also in symmetrical structures, with variations. In support of this interpretation, the biologists of art have used the evidence of their paintings to show that monkeys tend to centre their marks on the sheet and to counterbalance decentralised shapes.

Desmond Morris was able to identify two distinct stages in the creation of balanced shapes, and to show that, for the chimpanzee, it was a question of establishing a fully symmetrical effect. When he presented Congo with a marked page containing a configuration that was off-centre, towards the left or right, the chimpanzee's response was nearly always to place marks on the other side, in the empty area (sometimes marking the de-centralised shape as well), whilst a shape placed in the centre would be individually marked itself.[2] This type of response, already observed by Schiller, could in fact simply have been the result of a general tendency to place marks in an empty space if the space occupied quite a significant amount of the page. To his amazement, however, Morris noticed something else as well: the placing of the marks varied according to where exactly the off-centre shape was located. Often, as it turned out, the added marks were not right in the centre of the empty space but were the same distance from the centre of the pages as was the de-centralised pre-marked shape. If the form was closer to the middle than to the edge, the marks made in response would be placed in the other half of the page but equally close to the centre. If the shape was nearer to the edge, the graphic response would also move farther from the centre towards the other edge. In both cases, therefore, it appeared that the

desire to establish symmetry in relation to the configuration already on the page prevailed over the more straightforward tendency to make marks right in the middle of the empty space. Morris called the second method of achieving symmetry 'true balancing', because the sense of balance seemed to be unadulterated (in contrast to those cases in which it could not be distinguished from a generalised impulse to fill an empty space). He also noticed that the percentage of 'true balancing' responses plummeted when conditions for concentration were less favourable, particularly when Congo was being filmed.[3]

The undeniable formal properties of drawings and paintings by apes, the candour of their symmetry and the very distinct rhythms that they present make them exceptionally suitable as material for aesthetic analysis based on *Gestalt* psychology; *Gestalt* underpins many of the theoretical principles adhered to by biologists of art. Ernst Gombrich, who applied *Gestalt* to art history, gives Congo's drawings a special place of their own in the introduction to his book *The Sense of Order*.[4]

There is no doubt, moreover, that a perceptible sense of order within apparently spontaneous gestural painting was a determining factor in the great success of Congo's paintings with the public and collectors. Not everything can be attributed to the eccentricities of admirers of modern art. Congo's paintings would not have fetched such high prices if they had not impressed people as a kind of breath of fresh air, combining some of the basic formality expected of classical art with an underlying abstraction. It was precisely for this that Mervyn Levy made use of ape painting in the battle he waged against gestural art in his exhibition held in 1958 in the Royal Festival Hall. His intention was to show the low level to which, in his view, the regressive, primitivist movement had dragged modern art, below the level of aesthetic value. Levy argued that if chimpanzees possess an awareness of the demands of formal order, then artists who challenge formal order are obviously pronouncing a death sentence on art as a whole, as evidenced by the growing obsession with monochrome, empty canvases and other fads of the time. It should be remembered that the exhibition of 1958 comprised chimpanzee paintings and drawings by young children – the products of an unformed but authentic aesthetic sense – and paintings by 'a group of Tachist painters', presented to prove that abstract art was nothing

more than a morbid flight towards a pre-animal void, 'a regression more primitive than the scribblings of an ape, for the desire to annihilate all co-ordinate expression is a desperation well beneath the dignity of a chimpanzee or a child...' Of course, Levy's controversial argument presupposed that the hidden objective of the Tachists and other gestural artists was to destroy the form and content of all works of art. To represent the movement he was attacking, he asked students at the Ipswich School of Art to produce some Tachist paintings for the occasion. In the exhibition catalogue their tutor states that none of the students had ever attempted a non-figurative painting before, and none of them had any clear knowledge of the real aims of the Tachist movement. The results were conclusive: only one of them enjoyed the experience; the rest soon got bored and went back to their life drawing for the rest of the session.[5] However specious Levy's argument, ape painting provided the perfect support for his rhetoric.

In truly Dalí-esque style, Dalí readily perceived the aesthetic content of ape painting, so much more 'classical' than Action Painting, and he wanted to highlight this difference in favour of Congo and his colleagues. When he was interviewed by Mervyn Levy (who knew perfectly well what he was doing when he initiated the conversation by showing one of Congo's drawings), the Master of Port Lligat declared, in oracular fashion, 'the hand of the chimpanzee is quasi-human, the hand of Jackson Pollock is almost animal.'[6]

My intention here is not to contest the evidence of the rhythmic qualities of drawings and paintings done by non-human primates. The interpretation of the evidence, however, has to begin by addressing a fundamental question. Does the fact that these products present distinct rhythmical structures imply that a 'sense of order' constitutes the true principle of ape painting? Can we be sure that aesthetic activity as practised by apes and monkeys owes its characteristics to the animal's rudimentary urge to exercise its sense of form and balance, or to a primitive wish to express its taste for symmetry and order? Does ape art really conform, by some basic biological stroke of destiny, to what it is tempting to define as a rough kind of neo-classical ideal?

The analyses that follow make two things clear. Firstly, that the thesis that lays claim to a sense of order is not the only one relevant to the very strong formal properties of monkey art. Secondly, that

challenging this thesis makes it possible to take another look at the aesthetics of ape art, and to reflect on its ultimate status, without losing any of the definite discoveries made by the biologists of art.

The mark and the field

From the point of view of its general underlying principle (and disregarding any intentional or symbolic dimension), the act of the painter or draughtsman consists primarily in disrupting the state of a field. Well before any visual order is established, the drawn line assails the visual integrity of the support that receives it. The genesis of a painting or a drawing is the initial broaching of the image field; the construction of an aesthetic world is always preceded by a moment's disruption. The idea of disruption needs to be understood here in its most general sense. Disruption is constituted by an intervention that disturbs a space or an object taken as the location of the intervention. In the case of what is here named 'ape art' or 'monkey art' (purely indicatively), the field is an empty space, regular, remarkably neutral and uniform in colour, relief and texture and of very well-defined shape.

These formal properties determine a visual location that is particularly striking, and the non-human primate possesses the sensory equipment needed to see them. All biologists are agreed in defining the prominence of the visual apparatus as one of the fundamental specificities of the primates.[7] The importance of visuality is not related only to the conformation of the organ of sight, although this is in fact highly developed. It is also a function of the cluster of physical, mental and behavioural faculties that define the animal in its totality. In the case of the monkey, this cluster of faculties makes it a creature whose relationship with its environment is powered by acute attentiveness: it examines and explores the objects around with a view to interaction. This alertness, involving the eyes, the hands and the mouth, can be observed very clearly in captivity, when the animal is living in an environment that is much poorer than its natural habitat. The poverty of the environment in captivity makes the smallest things interesting; nothing escapes the animal's gaze and almost everything provokes an active response. The monkey handles each object, feels it, then pulls it apart with

hands and teeth whilst examining it minutely from every angle, peering into every orifice to find out what it conceals or, simply, to what extent it can be manipulated. This treatment of the object is functional – the primate obtains its food by tearing and dissecting things that comes to hand – but it also functions as an exploratory game, independently of food needs. The triangular structure consisting of the eyes, the hands and the mouth is used in an interesting way in cleaning activities and the social ritual of 'allogrooming', grooming the coats of others.[8] In other words, feeding is not the only activity that exploits the operational systems of the primate's faculties; the animal performs a variety of play activities as part of its general comportment. It is therefore easy to understand why, when presented with a white page and an instrument capable of disrupting its uniformity, most apes are unable to resist the invitation.

Simply to acknowledge the power of disruption in painting play allows us some notion of the complex, rich and subtle operations that may follow. Varied possibilities present themselves even at quite an elementary level, when the subject is satisfied simply by disturbing the empty whiteness of the page with a few rough marks. Or the disruption can develop into a succession of marks that build up to form elaborate structures. The line or mark destroys the neutral plainness of the field and some of its formal features; subsequent marks alter the first mark or its relationship to the field, or both. In this way, the game of the disruptive mark is neither simply destructive nor constructive, the game is played below the level of this distinction. Although a line has no alternative but to disrupt the field, in disrupting it it is obliged in some way to assert its structure – if this were not the case the disruption would not concern the image field itself but the page as an object. This explains why, played in a certain way, such a game can present us with impressive analogies with the skill practised by painters in the name of 'composition'.

Elementary systems

Let us first examine the simplest systems, in which the marks disrupt the field but do not disrupt each other. It must be established right away that such simplicity does not represent a more primitive stage in

either the development or the aesthetic value of the game. Some of the systems of disruption that belong to this first degree suppose an approach to the field that is more sophisticated than when the resultant structure has several layers. Moreover, the simple systems have various levels of complexity and subtlety, as well as a multiplicity of different methods and applications.

A primitive stage, objectively speaking, might be identified as one when the subject produces visible marks whose shape is governed by simple movements. These genuinely elementary systems include, first, spots produced by hitting the instrument against the page. First attempts at painting often produce simple constellations of dots on the white paper – there are many examples of this in Werner Müller's collection (illus. 35). Apes and monkeys enjoy repeatedly banging objects against hard, smooth surfaces. It allows them to verify their weight and solidity, which is useful in the wild when the animal may wish to crack nuts, for instance. This is also the way that many apes discovered the amazing power of the pencil. Sometimes, when the pencil is applied with great vigour, the dots appear like small 'V' shapes.

Another elementary system involves the production of semi-circles by the movement of the forearm with the elbow as a pivot (illus. 36). Such lines are one of the principal elements of more complex systems. Often drawings and paintings produced by monkeys proceed from games played on clusters of lines obtained by the animal sweeping the page with its hand, to and fro, often without lifting the pencil between strokes. If the subject is facing the paper and holding the drawing instrument in its right hand,[9] the strokes are oblique, following an axis from the lower left-hand corner to the upper right-hand corner. In a slightly more complex variant, the to- and fro-movement is aligned horizontally with the paper's edge (illus. 37). These clusters of lines deriving directly from bodily movements are in no sense aesthetically neutral. Their production very evidently observes the structure of the field. Clusters of lines are often well centred, occupying the space available generously but without going over the edges. In some cases this can be seen to cause the line to be broken off in mid-sweep: the line suddenly leans over or doubles back on itself to remain inside the field comprised by the page (illus. 38). In addition – and this distinguishes the groups of rough lines from the basic dots – they are created by the continuous movement of

35 Candy, a chimpanzee: a
black and yellow acrylic.

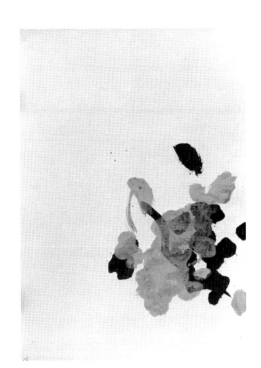

36 Bozo, a chimpanzee: a
wax crayon drawing.

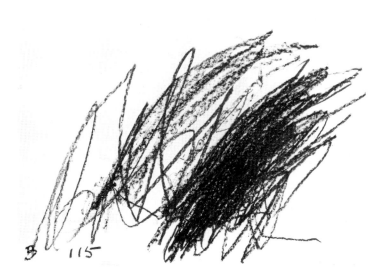

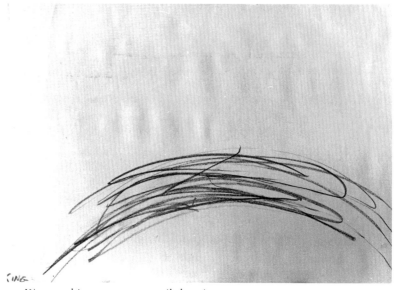

37 King, a chimpanzee: a pencil drawing.

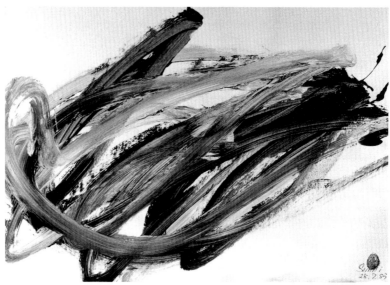

38 Grimi, a chimpanzee: pink, yellow and black gouache.

the drawing instrument over the paper and therefore presuppose an active appropriation of the visual field by the subject, to the extent that the gesture works within the confines of the field. This explains why, unlike the dots (which have no real structure), these clusters present elementary rhythmical forms created simply by the repetition of the movement: lines are drawn one after the other, in parallel. The horizontal variant proceeds from a slightly more elaborate process, requiring the adaptation of the movement to the main axis of the field, which assumes a slight twisting of the original movement. Another variation of this formula produces elliptical lines, the lines spread apart between the back and forth movements, giving a structure that is slacker and a line that has greater freedom than the straight lines, in fact the line now begins to play games with itself within the space of the page (illus. 39).

Another difference lies in the subject's approach to the parameters of the field. There are many different ways of interacting with the field in an apposite manner, according to the elements that the subject perceives or chooses as the most essential. For some apes the principal pole of attraction is the centre, the nerve centre of the field in terms of symmetry. They will start work by choice in the central area and will organise their marks accordingly. Other animals are attracted towards the corners. Unlike the centre, the four corners have very well-defined formal attributes which themselves give material weight to the structure of the field. Chimpanzees often select the corners for their marks on account of their shape, which sets them apart as exceptional areas.[10] Schiller recounts how Alpha folded her page after having marked the four corners, evidently in order to obtain more corners; the attraction of the corners was ruined by the presence of a pre-existent shape, the shape being perceived as an object urgently requiring to be marked. The attraction of the corners can be influenced of course by the position of the body in relation to the image field and the motor structure of the forearm. In the case of Congo this influence induced a particular interest in the lower corners. In some cases, finally, attraction towards the corners combines with interest in the centre. This was evidenced by a chimpanzee in the zoo in Copenhagen, Binger (illus 40, 41). Some of Binger's paintings contain lines which start from the left side of the paper and spread towards the right, where they are imprisoned by the bottom right-hand corner (unlike most chimpanzees, this subject

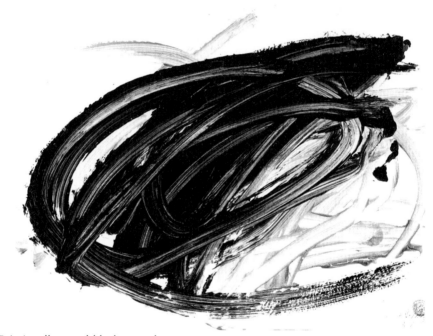

39 Grimi: yellow and black gouache.

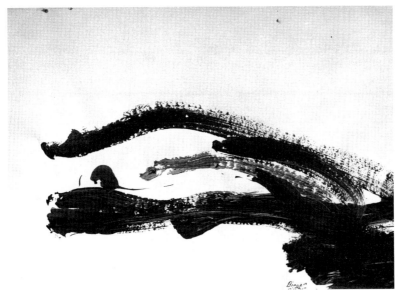

40 Binger, a chimpanzee in Copenhagen Zoo: a red and green gouache.

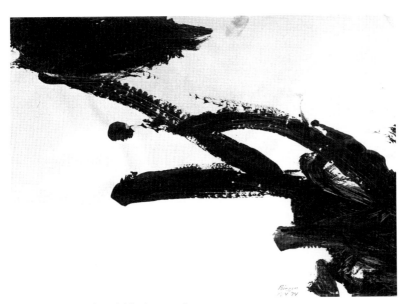

41 Binger: a red and black gouache.

allowed its marks to extend considerably over the edge of the paper, particularly in this example).

Finally, the general appearance of the field can condition the placing of lines in accordance with the principle that holds that marks shall be made where there are none. This represents a negative response to marks already produced, in compliance with their relationship to the image field: the marks multiply, avoiding contact with each other, and the maximum vacant space is covered. Some of Bozo's paintings develop a sophisticated version of this tendency (illus. 42). The subject begins by painting a cluster of semi-circular strokes on one side of the paper; then he marks the other (empty) half with an identical cluster in reverse. The cluster produced by the to-and fro-movement of the hand is reproduced by means of a change of axis, so that it occupies the field on the left and the right-hand sides, starting from the central area. The result gives the impression of a form reflected in the mirror.

The category of elementary systems also includes the bundles of brushstrokes applied in a fan-shape; this is the most elaborate of the schemes in the first group. It was Congo's 'theme tune', and it also appeared amongst Bernhard Rensch's apes; Werner Müller's chimpanzees produced fan-patterns as well (illus 26, 43). The shape evolves from the frequent repetition of vertical and oblique strokes, so that, progressively, they cover the field. The evidence of the flattened brushstrokes (due to the pressure of the brush on the paper) indicates that the hand starts at the top of the page and comes back towards the middle of the lower edge. Considered as a whole, the fan-pattern achieves a kind of compromise between the vertical lines, which cross the dominant horizontal of the field quite violently, and the dominant horizontal itself. As the strokes get farther from the centre they gradually join the horizontal axis. The radiating lines as a whole echo the shape of the field, evoking the tension between the two axes of symmetry, caught at the lower edge of the sheet of paper. When the paper is presented lengthways the strokes often straighten up and are repeated as parallel lines: the tension between the brushstrokes and the main axis is thereby mitigated and there is no need to unfurl the fan. This phenomenon shows up very clearly in paintings by Lady (illus. 26), exemplifying the coherence of what Rudolf Arnheim might have called the 'visual thinking of the chimpanzee.' In the normal fan-pattern the angles vary progressively

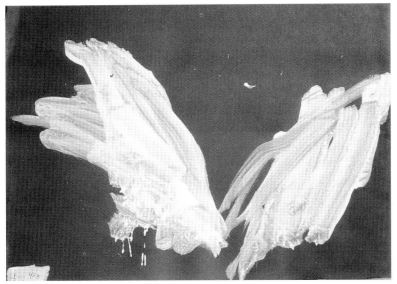

42 Bozo, a chimpanzee: a white gouache on black paper.

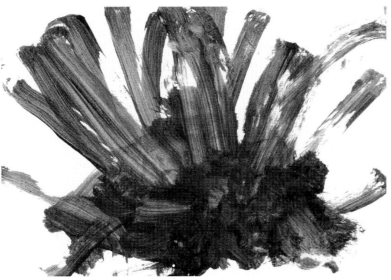

43 Lady, a chimpanzee: acrylic.

to create the compromise, and this means that each stroke of the fan is characterised according to its position in the field. There is a notable difference here from the schemes built up of rough strokes, much less interesting because the repetition operates across a single axis. Moreover, fan-shaped brushstrokes only mark the field as a whole progressively and intermittently. If the sequence were brought to a halt before it was finished the result would be asymmetrical and incomplete. It is the completed series, as a discrete whole, that constitutes the pictorial act. The discontinuity of the process is probably one route by which the chimpanzee might reach the threshold of the idea of a 'motif' (if not cross the threshold).

The fan-pattern presents one important individual feature, namely that it presupposes a view of the image field based on the position of the subject in relation to the support; in other words, the pattern reveals the vertical orientation of the support, the top not being equivalent to the bottom. Let me emphasise in passing that the fan-pattern shows how important it is to have the kind of experimental equipment that Morris used so that the support remains in a fixed position in front of the subject. This methodological precaution is an indispensible aide to the analysis of painting by monkeys. If the monkey can move freely around the page or change the direction in which it faces, as it inevitably will unless constrained in this way, the analysis of the relationship between the painted shapes and the field becomes impossible. The only alternative is to film each session, preferably without the cameraman being visible to the animal, so that the various stages of each 'composition' can be followed, and any modification of the position either of the monkey or of the paper be recorded.

Developed systems

Drawing or picture play involves first a consideration of the structure of the field, some parts of which exercise a particular attraction. Any stroke, however, that disrupts the field itself becomes an element that can elicit further marks. More precisely, it is a complex visual ensemble, formed by the stroke and by the relationship of that stroke to the field it has disturbed; the ensemble will be the object of the secondary marking that follows. Some of the essential principles of the process have been demonstrated using tests on paper bearing pre-

existing marks. These have shown that the attraction of a shape on the paper distracts attention from the attraction of the field as such. When he did his very first drawing Congo made an effort to mark a spot of ink that was visible on the paper.[11] Alpha only marked the corners or the middle of the field if there was nothing there – except for tiny strokes done in hard pencil, too light in tone to distract her. Finally, let us recall here the experiments carried out by Schiller and Rensch to show that an empty shape of a considerable size is generally preferred as a secondary field.

Awareness of shapes already present in the field manifests itself also when drawing or painting is carried out on blank sheets; the marks already made by the ape play the part of pre-existing shapes. This awareness is therefore the source of some of the most spectacular and most characteristic products of ape art; it advances the game of disruptive marks to levels of accomplishment and subtlety such that the results sometimes appear, to the human eye, like real compositions or remarkable exercises in calligraphy.[12] It must be added, however, that the dividing line between simple clusters and marks at the second level is often blurred. Are clusters provoked by the influence of the field exerted equally on all the strokes, or by the reciprocal attraction of the strokes? The two effects combine without difficulty, in fact, and in many cases it would be impossible to distinguish them.

The basic principle of these secondary interventions is therefore the same as for the elementary shapes: the condition of the first strokes is disturbed, i.e. with regard to their position in the field. In some cases, second-degree interventions do not take place in convincing fashion until the monkey has gained experience of the game – as with Joni, Nadjeta Kohts' first chimpanzee. But they may also occur immediately. All the earliest paintings by the chimpanzees Gipsy and Jessica consist of a few preliminary spots joined by strokes that merge them into one, removing their independent existence.

One of the commonest and most important of the secondary structures is comprised of strokes, or groups of strokes, that cross (illus. 27). A drawing on blank paper published in Schiller's study consists of two large series of zig-zags, more or less in the centre, the second of which crosses the first at right angles (a phenomenon that the text fails to mention). We have already seen how Joni drew long lines and then crossed them, across their whole length, with short

strokes at right angles, and Congo also occasionally did the same thing.[13] This process is also encountered in painting. Crossed clusters were Bozo's favourite pattern, and his oeuvre presents a remarkable set of variations on this fairly straightforward secondary scheme (illus. 28, 44). In the best of his paintings each bundle of lines is laid across the previous one, at a contrasting angle, so that his work consists of a succession of layers of crossed clusters. This method of 'crossing' groups of lines one with another represents maximum visual disruption. As has already been noted, Bozo relished this conflict between axes and used it in the painting with two clusters mirroring each other from the left and right side of the field. The logical explanation of this is as follows: if the first bundle of strokes is off-centre, then the second will be also, otherwise the second crosses the first. Sometimes the two schemes partially merge. The position of the initial marks on the field provokes a succession of marks and determines their position. One of Congo's fan-patterns also illustrates this phenomenon (illus. 31). Instead of descending to the edge of the paper, the brushstrokes stop two-thirds of the way down; on the left there is the beginning of a group of lines moving downwards towards the bottom, as if the fan were opening slightly wider than 180 degrees. Finally, it is noticeable that the formal vigour of the strokes crossing one another weakens when the action is motivated by the general tendency to mark a shape that is already present.

The general system of marking is worth lingering over for a little longer. It is one of the commonplaces of ape painting and can adopt very definite shapes. Jessica's paintings present a succession of coloured areas of decreasing size. The first group of brushstrokes occupies the field quite generously, the second group is painted inside the first and so on. Frequently a light-coloured area is used as a secondary field and attracts a cluster of darker strokes which often fills the area almost perfectly (illus. 45). Notice also that although chimpanzees will sometimes obliterate a coloured area, they will often avoid it, preferring to *inscribe* their marks inside a shape, so that the succession remains visible as a series of contrasting containers and contained. If apes painted principally by total obliteration, the effect of the lines would be lost in the action of marking, and the disruption activity would be reduced to a simple succession of two-stage operations. Marking the surface by

130

44 Bozo, a chimpanzee:
red and brown acrylic.

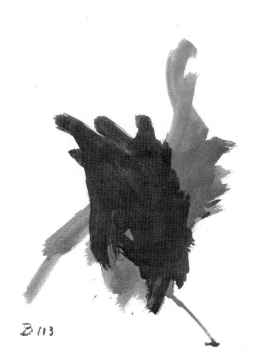

45 Lady, a chimpanzee: an
'inscribed' fan-pattern in
red, yellow and brown
acrylic.

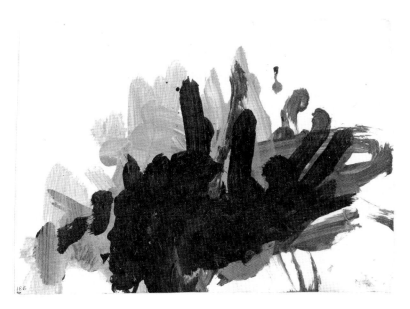

inscription, on the other hand, allows complex manipulation of the picture to develop, over a number of stages: each stage is affected by its predecessors (illus. 29, 30, 47, 51, 52).

The attraction of pre-existent brushstrokes is evident in a variety of situations, but it often proves almost impossible to identify their influence. It is possible, for example, that it plays a rôle in the fan-shaped structure; it may work in combination with the formal compromise between the two axes that constitute the symmetry of the field. At the outset, at the top of the page, each stroke tends to move away from the next in order to occupy the whole surface, but is then drawn back towards the next as it covers the page. Often the critical spot where the two strokes join is the object of supplementary marks, and there seems to be a desire to reinforce the effect of the attraction by 'sealing' the lower ends of the lines. The same phenomenon of gravitation probably explains some of the occurrences of overall asymmetry: if the painting begins in a corner – by chance, or to vary the game – the strokes cluster progressively from the corner, and the final 'composition' will reflect the initial departure from the norm.

Finally, the attraction also may be exercised by a stroke towards itself. Many chimpanzees enjoy ellipses and circles, often drawing them with great assurance (illus. 48, 53). The source of this interest may perhaps be found in what we might term the ideal economy of disruption structures: a single movement allows the line to open up the field, at the same time marking the initial line (itself) as well. These different instances of attraction illustrate the principle of aesthetic gravitation. After three years of experience as a painter, Congo discovered the ellipse and the circle, and soon afterwards the painting materials became inadequate to occupy the brimming vitality and enjoyment of play of the young male chimpanzee, by now a very assertive personality. Congo drew ellipses with ever-increasing ardour until he lost concentration completely. Intoxicated by circular forms, Congo's painting regressed into pure gesturality.

With apes as with men, scribbling often produces an energetic proliferation of elliptical and circular shapes. What is more, instances of attraction combine with other operating principles related to the formal consideration of the image field, producing 'calligraphy' that sometimes bears an uncanny relationship to a signature (illus. 49). We should not regard this as a product of 'chance': if we consider the

46 Jessica, a chimpanzee: scribbles in black pastel inscribed in a red painted shape.

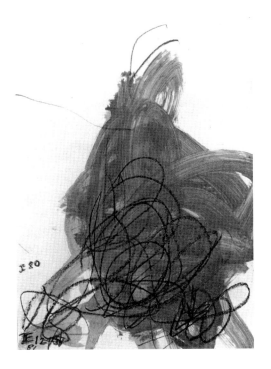

47 Jessica: a black, grey and yellow acrylic, with wax crayon.

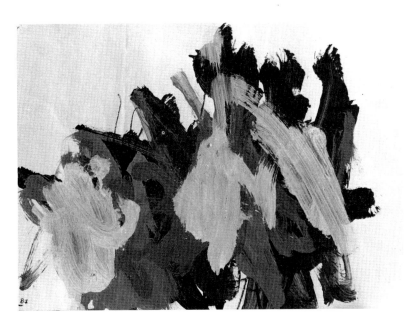

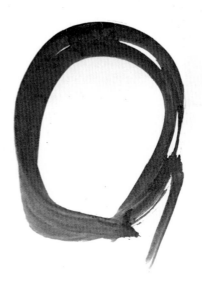

48 Julia, a chimpanzee: a gouache.

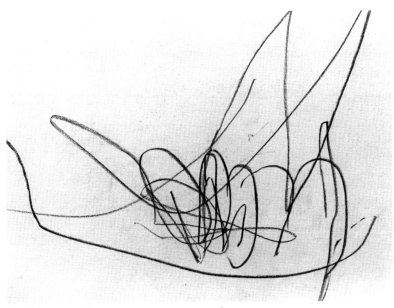

49 Congo, a chimpanzee: a wax crayon drawing.

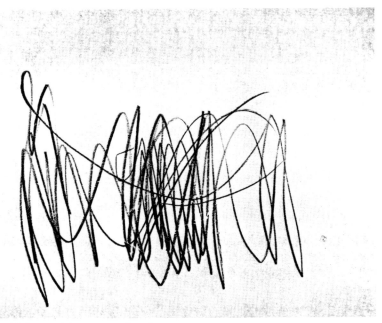

50 Alpha, a chimpanzee: drawing.

'laws' governing graphic or pictorial intervention, based on visual control of gesture and the structure of the field, it is obvious that they are neither human nor simian. They apply equally to monkeys and to men, but achieve different levels of realisation. In elementary activities like scribbling or writing signatures, convergence phenomena may occur and will not be purely coincidental (illus. 50).

Order and disruption

Monkey art is primarily an aspect of play. It provides a classic example of those activities termed by Desmond Morris as 'self-gratifying', and characterised by being triggered without any very definite stimulus and ceasing without the achievement of any particular goal (beyond the play activity itself). Ethologists have highlighted the importance of play as a component of the behavioural patterns of mammals, closely linked to other ranges of activity such as sociability and exploration.[14] Play is particularly important to the primates.[15] The painting and drawing activities indulged in by apes in captivity involve the artificial transference of the operational systems connected with exploratory play, in which the eyes and the hands play the leading rôle; in the photograph reproduced on the cover, Congo's face bears a tell-tale expression: he is wearing the 'play smile' of the chimpanzee (mouth open like a crescent moon, upper teeth covered), worn in social games to signal that the activity is 'for fun'.

Conditions for these activities do not exist in the natural environment: neither painting nor drawing is a normal part of the behavioural pattern of apes; although they are able to perform these activities, man has to act as an intermediary. Ideally, drawing or painting play can be defined as an activity in which the eyes or the hands are indispensable adjuncts (one does not function without the other) to the three components (field, colour, implements) that form an operational cell. The means for painting and drawing exist in a kind of sealed container from which operations not concerned with visualisation of the gesture are, in principle, excluded. Conditions for such exclusion do not exist naturally in the ape world, where anything capable of providing the substratum for play is available to a range of faculties. A branch or the end of a creeper are toys that

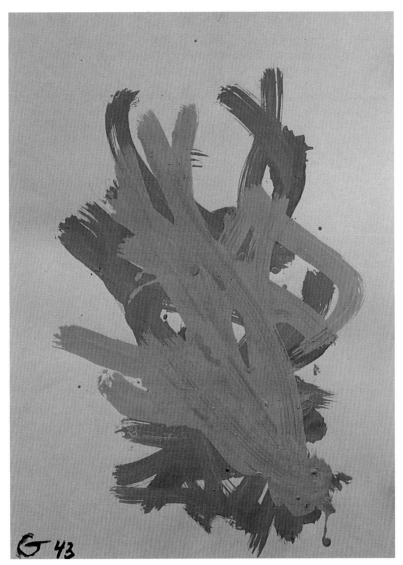

51 Gipsy, a chimpanzee: green and yellow acrylic.

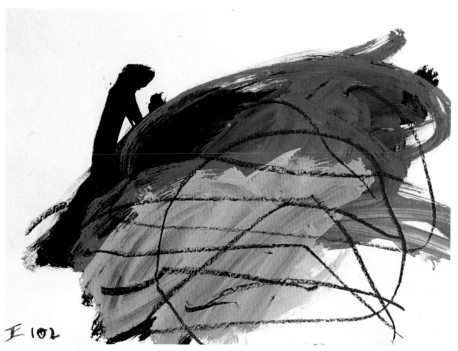

52 Jessica, a chimpanzee: black, pink, red and white acrylic with wax crayon.

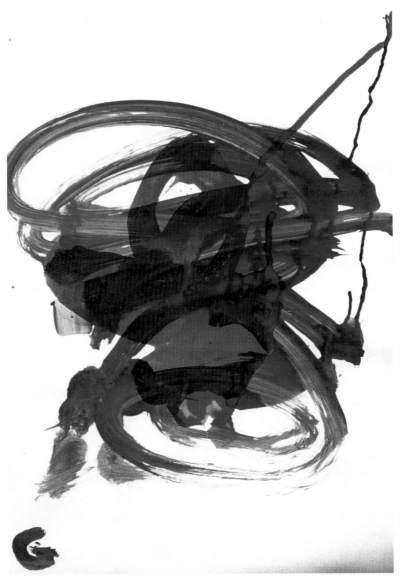

53 Gipsy, a chimpanzee: blue and red acrylic.

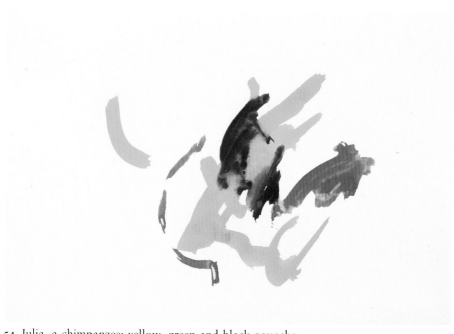

54 Julia, a chimpanzee: yellow, green and black gouache.

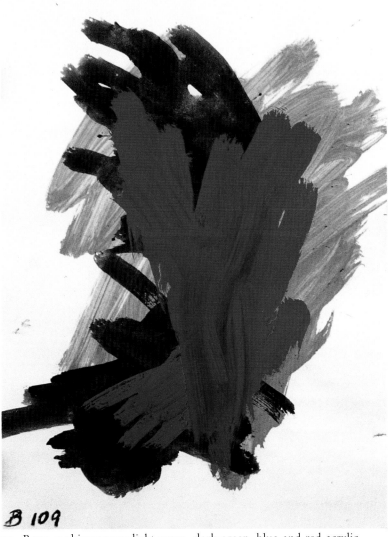

B 109

55 Bozo, a chimpanzee: light-green, dark-green, blue and red acrylic.

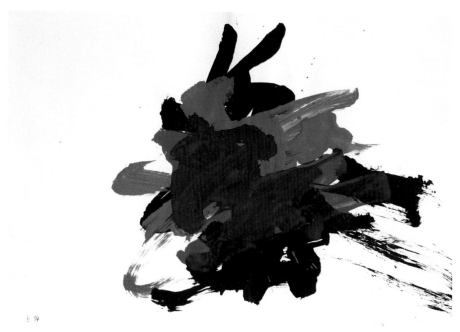

56 King, a chimpanzee: black, blue and red acrylic.

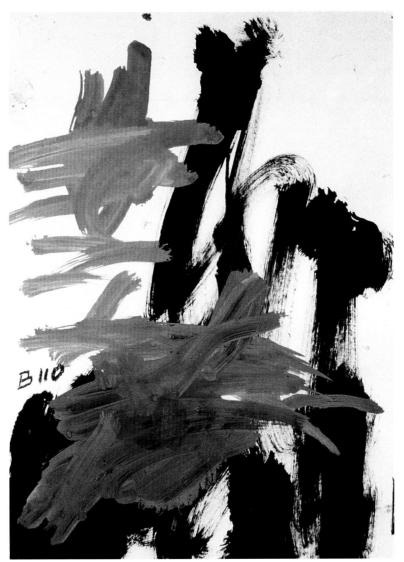

57 Bozo, a chimpanzee: black and yellow acrylic.

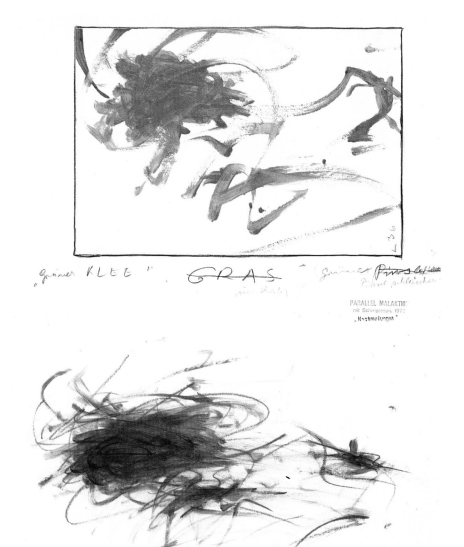

"Grüner KLEE" GRAS Grüner ...

PARALLEL MALAKTION
mit Schimpansen, 197?
"Nachmelungen"

58 Arnulf Rainer, *Grüner Klee*, mixed media on paper, 1979. The painting in the upper part of the picture is by a chimpanzee, Lady.

require participation from the hand, the eyes and the mouth as well as the sense of balance, the strength of the four limbs and so on. The great apes, in spite of everything, are able to experience a strong fascination for this artificial game from which other systems not pertaining to the co-ordinated action of eye and hand are excluded.

It must be stressed, however, that the axis that links the eyes and hands also includes the mouth, not only the jaw but also the lips, the latter constituting a highly efficient and useful prehensile organ. We should not therefore be surprised if exploration of the painting or drawing materials involves 'parasite' activities that bring the organs of the mouth into play: tasting the paint, biting the crayon (even sometimes breaking it), licking the paper and spreading the colour with the lips, tongue etc. Marina Vancatova's team have been observing an orang-utan that frequently manipulates the brush with its mouth, somewhat like the human artists who have lost their forelimbs.[16]

It should also be stressed that the operational exclusion means that the act of painting or drawing cannot be carried out by the ape on its own. The intervention of the experimenter is generally of crucial importance at this stage: it is he who – patiently and on the basis of the spontaneous but spasmodic interest taken by the ape in exploring the materials – concentrates on keeping the subject's attention on the visualisation of the gesture within the field by means of coloured lines. Getting used to the game is an important factor as well: it has often been remarked that the degree of concentration increases as the drawing or painting sessions continue. Very often, in fact most often, particularly in the early stages, the ape has to be artificially enclosed with the painting materials. From then on only the most 'gifted' or experienced subjects can gratify their thirst for exploratory play within the confines of the enclosure.

It would be a simple matter to demonstrate the importance of disruption in play in general, and in the case of primates in particular. Disrupting situations or objects forms a basic part of their method of experiencing the environment. The play activity of monkeys in their natural habitat resembles continual disruption: everything in their surroundings is 'tested' endlessly. Frenzied swinging, with no apparent motive, tests the strength and flexibility of a branch, the weight of the animal's body and its balance. The various forms of playful aggression – apes love teasing their fellow-

creatures in a thousand different ways – also represent disruptions, this time with another individual, who is forced to react, as target. Any object small enough to handle will be picked up and demolished as thoroughly as possible. Concentration on manual tasks and disruption go hand in hand. If you leave a domesticated monkey in an apartment, in about two minutes it will push over, move, dismantle, set in motion or rip apart everything within reach – including things that we would never think of as worth handling. We soon pay for our indifference! Man, by the way, is always outclassed by monkeys as far as pure handling attention goes; to experience this in one's sitting room is perhaps the best way of becoming aware of our own basic apathy towards objects as things to be handled. This apathy is one of the essential features of the way that humans experience the world.

In captivity, monkeys have plenty of opportunity to gratify their enjoyment of disruption, which gives us humans a chance to observe the process at close range. Lilo Hess noticed, for example, that when young Christine was playing with her blocks, her greatest pleasure was to knock down the towers she had built, with no apparent aim but to see them collapse;[17] such observations are not unusual. We have already seen that scribbling and painting play a large part in these artificial games. The principle of disruption, however, has never been observed, or at any rate examined, in ape art. It allows us to reassess a number of features, at the point where the aesthetic of the sense of order is limited to statements of facts. Let us examine, for example, the tendency to score outlines in the manner of Nadjeta Kohts' chimpanzee.[18] The action of drawing a line and scoring a number of short perpendicular strokes across it was also observed during Congo's painting play. In a general way, such a performance demonstrates the animal's visual control; more importantly, however, it represents an act of formal disruption that is completely characteristic. This manner of disturbing the integrity of a straight line is reminiscent of the typically disruptive game invented one day by little Gua, and it throws light on her behaviour as well: 'one of the experimenters was engaged nearby in marking out the court for an outdoor game with powdered slaked lime. The chimpanzee was apparently attracted by the fresh lines, or by the clouds of white dust which she soon discovered could be raised by disturbing them. Presently she stood upright on one of the lines and shuffled along it

for a good 2 metres scraping and kicking at it with her shoes. She was dissuaded from this play only by vehement objections from the linesman, and she went back to it like a rowdy boy as soon as his back was turned.'[19] In this example the game was made even more attractive because it achieved two goals: not only did the white line disappear in a cloud of dust, but also the unfortunate human companion detailed to maintain the tennis court was put out. A similar observation was made to me by Linda Van Elsacker about Dzeeta, the pigmy chimpanzee mentioned above: 'She distributes the fine debris that falls from the woodwool on the floor. Then she moves this mass with the side of her hand until it forms a line which she then cuts. She repeats this like a child playing in the sand.'[20]

Experiments with drawing and painting very often produce 'destructive' aesthetic behaviour. A whole repertory has been observed (illus. 59). Congo enjoyed covering a shape that he had just produced with 'savage' brushstrokes; the best examples of circles produced by him were saved by removing the paper before he had completely finished. Some chimpanzees, including Congo and Bozo, would score lines across the shapes painted on the paper by scratching with their nails (illus. 60). Morris had the idea of adding a rigid plastic hairbrush to Congo's painting equipment so that he could score lines on the paint while it was still wet (illus. 3). Sometimes the pencil lines drawn on top of painted shapes have the appearance of scratches. Alpha would often 'finish' her paintings by tearing the paper to shreds. Dzeeta used to like to pick up a pencil and demolish it; she would do the same with a sheet of paper, reducing it to pulp if it was not removed in time.

This raises the question of whether the disruption principle might not itself be the origin of the sense of order studied by the biologists of art. It has been described as being more basic and comprehensive than the contrast between structure and chaos. It is perfectly conceivable that a kind of 'sense of disorder' reigns in the image field so straightforwardly that it may manifest itself mainly *in the guise of* a sense of order. The clear shapes and the characteristic rhythms of monkey painting can be identified as phenomena of the same nature as the ones apparently drawn from absence of order, disorder or disruption. In fact, effects of order can easily be the result of disruption of the structure of the field. Before we explore this idea, let us look carefully at the fact that seems to gainsay it most

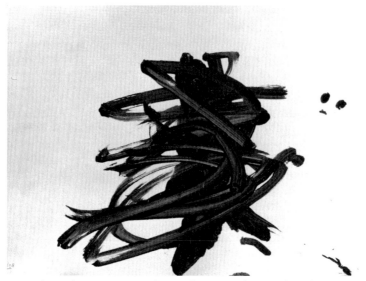

59 Lady, a chimpanzee: acrylic, with group of vertical strokes crossed by strokes of the same colour (red).

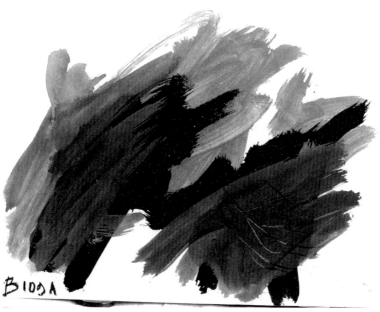

60 Bozo, a chimpanzee: red, black and blue acrylic. Note the scratches done with the fingernails, lower right.

categorically, namely the tendency towards balance in the literal sense.

My first observation is that this tendency is unusual. Many chimpanzees take pleasure in drawing, and particularly enjoy marking pre-marked shapes, but they do this without producing real equilibrium. Unlike Morris, Rensch observed no single occurrence with his subjects. Two more recent studies of the drawings of chimpanzees also concluded that it was non-existent.[21] Their authors even appeared to be suspicious of the cases of 'true balancing' observed by Morris: they regarded them in fact as pure coincidence, with no real basis in the intention of the chimpanzees. Statistics are the major argument against Morris' observations, but here we should not rely on the evidence of statistics. In a field as complex and as variable as the drawing of great apes, the scarcity of a particular type of response does not prove that its appearance is due to chance. The administration of negative proofs comes up against a major methodological barrier here: as in the experiments carried out on the acquisition of artificial communication systems, the affective links between the subject and the experimenter, on one hand, and on the other hand the rôle played by previous experience, often invalidate attempts to demonstrate the absence of abilities on the evidence of a limited range of experiments. It is obvious that there will be considerable variation in performance between a chimpanzee trained daily at painting or drawing play (or in the use of ASL), for months or years on end, and a second animal put through the same training for two or three weeks. If the Gardners had not found the time and the patience to teach ASL to their subjects, over several years and with daily play sessions, driven both by a research project and also by a genuine affective relationship, no one would ever have imagined the level of two-way communication that a chimpanzee was able to achieve with a human. The same observation applies to the pseudo-artistic behaviour of a subject like Congo: the affectionate tenderness and almost continuous attention paid by Morris to the chimpanzee for two whole years constitute a parameter that a straightforward objective scientific record would have great difficulty in reproducing.

The author of one of the studies mentioned above, D. A. Smith, recognised that the responses most closely approaching 'true balancing' as contrasted with simple filling of the empty space were produced by the subjects with the best concentration. Also

worth noting is that one of the drawings by Alpha published by Lashley with Schiller's study shows a case of 'true balancing' identical to those published by Morris (Schiller and Lashley had not in fact identified the phenomenon). As it happens, Alpha – Smith notes this as well – had been drawing for ten years before Schiller undertook his study (which was pursued over a period of six months).

Whatever the critics say, the only conclusion to be drawn from these observations is that the propensity towards balancing does not invariably manifest itself. It occurs only in isolated cases, remarkable enough and certainly relevant, but too rare to be a constituent of the graphic sense of anthropoids in general. Considered from the standpoint of the theory of the sense of order, this rarity could be taken to mean that the propensity that so beautifully expresses the essence of the aesthetic behaviour of monkeys occurs only exceptionally – a conclusion that is awkward.

Perhaps it would be better henceforth to interpret 'true balancing' as a very sophisticated type of disruption aimed at modifying the asymmetry of a field containing an off-centre shape. The monkey would be destroying asymmetry rather than creating symmetry. This interpretation is not simply a dialectical conceit. Firstly, because it denotes a different type of basic motivation; secondly, because 'destroying disorder' can produce the same result as creating order – but will not necessarily do so in every case. With regard to the rarity of 'true balancing', this probably arises because the individual is less spontaneously aware of asymmetry than of an empty space. If it chooses to mark the empty image field in preference to an asymmetrical configuration, it is doing nothing 'wrong', in terms of the logic of the operation. It has simply chosen something less sophisticated to disrupt. On the other hand, the fact that pre-marked, centred shapes attract marks to them can be explained as follows: the animal is alerted by the presence of the shape, clearly visible in the field. It intervenes directly on the shape itself; the shape is the focal point of the field and the most noticeable feature of the situation. The marking of centralised forms cannot be interpreted as an endorsement of centring as such, however. It sometimes happens that lines scribbled on a shape go well over its edges. When a pre-marked shape is used as a secondary field, therefore, the scribbling may be a graphic disruption of this field rather than an endorsement

of its structure. There are sometimes perceptible hesitations in this respect. The tendencies respectively to cross out shapes and to inscribe lines inside them (as in a secondary field) can sometimes be in competition, if the shape is considered simultaneously as a visual object and a secondary field (illus. 61); this type of hesitation would be meaningless if it were only a question of endorsing the structure of the shape.

This new interpretation, positing as it does the game of the disruptive mark as the main principle of ape painting, in no way challenges the observations made by the biologists of art. Nor does it gainsay the awareness of order in non-human primates, who do have a sense of order to the extent that they readily grasp the formal specificity of clearly organised structures. If this were not the case, they could not be sensitive to the structure of the image field and would take no interest in games of aesthetic disruption. It could be considered also that the further elaboration of compositions of disruptive marks assimilates at some point with the general preference for symmetrical structures, as described by Rensch. This general preference, however, cannot be the sole principle guiding the painting process, itself too complex and too frequently in conflict with so-called mandatory symmetry to provide a complete answer. Nothing compels us to believe that the aesthetic play of monkeys is primarily motivated by a deep longing for symmetrical structures. In fact, it is more clearly associated with a 'sense of disorder', which, by definition, implies an awareness of order.[22]

Let it be stated here that the fundamental motivation of a non-human primate playing freely with painting materials resides in its fascination with the act of marking. Let it also be stated that the animal's interest lies essentially in experiencing the way in which a gesture produces strokes that broach the whiteness of the paper and are subsequently modified or modify each other within the framework of the paper surface. If the playful fascination with the brushstrokes develops in total innocence, without ulterior motive, without the intention to represent anything and without any preconceived idea of what will result from the game, then the process of pictorial disruption can reflect very closely the structure of the field that it occupies. If each stroke blooms spontaneously on the page, with no thought other than to provoke clearly visible marks within the outline of that page, the succession of marks will automatically

61 Lotte, a chimpanzee: painting on pre-marked pattern.

62 Congo, a chimpanzee: a chalk drawing (pink and white).

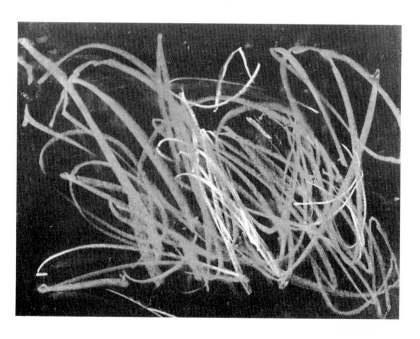

pay tribute to and echo its structure (illus. 62). This is the way in which monkey painting produces ordered forms and rhythmical compositions: by playing totally innocently at the game of visible disruption of a regular image field.

The various destructive tendencies that apes manifest are not necessarily antithetical to what Desmond Morris terms a 'sense of composition', in fact they partake of the same principle. To cross the circumference of a circle with energetic strokes, or to etch lines in paint that is still wet seems perfectly reasonable from the animal's point of view. There is also the activity of tearing up the page when it is so filled with strokes that there is no space for further visual disruption; this does not cancel out the game – on the contrary, it is a way of prolonging it to a further stage. From the ape's standpoint this is just as reasonable as simply to request a new piece of paper. The play principle in non-human primates no more includes taking pleasure in destruction for its own sake than it does satisfaction in a 'sense of order'. In social games, the continual teasing represents the means by which the hierarchy of the group is established and maintained. In games played with painting materials brutality of movement is always controlled. If it is not, then, like Congo, the ape leaves the domain of painting. Formal disruption is almost never purely violent or chaotic; on the contrary, it is sometimes produced with astonishing delicacy. Some ape paintings are composed of just a few brushstrokes, calmly and decisively placed (illus. 54). Congo seemed to understand how to 'enhance' a whole composition: what better way of disrupting a fan spread to occupy almost the whole of the paper than to add three spots of white paint? The drawing by the large, gentle Sophie is composed of two series of zig-zags, one horizontal, the other vertical. Sophie preferred to keep the blue secondary markings away from the first strokes in red, but they share the same axis (illus. 21). In both of these cases disruption destroyed nothing, it simply varied the regularity. With apes and monkeys, brutality and delicacy go hand in hand, and it is only human observers who seem unable to desist from separating them. There is roughness and aggression in play, plus overwhelming physical strength, but extreme delicacy and concentration in ritual grooming, plus permanent alertness to small mood changes in others, and shyness and sensitivity to the slightest variations of temperament. This synthesis of two kinds of attribute, perceived by us to be

antithetical, is inherent in the temperament of non-human primates. It is what has given monkeys their reputation for unreliability, and what makes them so comical to humans. Their resemblance to humans is found in the unexpected combination of thoughtful delicacy and unrestrained disruptiveness in play. Although brought about by human artifice, ape painting is nevertheless very simian in the way it demonstrates (magnificently in our view) the effects of this synthesis. Finally, the resemblance of ape painting to certain forms of human art stems from the effect of order and harmony of the disruptive marks with compliance with the form of the image field. In this way, by a strange kind of pseudo-morphosis, chimpanzee's paintings sometimes call to mind Chinese calligraphy, in which, however, the clear markings, produced simultaneously with the gestures, are the outcome of a powerful cultural awareness (illus. 55, 56).

The problem of 'motifs' and the symbolic stage

The principle of disruptive marking determines both the unity and the diversity of monkey painting. Each particular manifestation depends on what the subject deems necessary in the situation facing it, according to its own aesthetic nature and its choice at that moment. Morris saw apes' painting play as a competition between various urges, some stronger than others; the outcome varied according to the situation and the individuals involved. In the case of Congo, five 'rules' directed his graphic work. These inherent principles, not all equal in influence, and some at odds with one another, governed the graphic process in various combinations and permutations. In order of importance, they involved, respectively, remaining in the field, marking where no mark had been made before, marking where a mark had already been made, concentrating the strokes in the centre of the page, and, finally, spreading the strokes in a series of radiating lines.[23] One might add that these different actions, or combinations of actions, constitute as many different modes of working, all of them conforming to the principle of aesthetic disruption, but some more developed or more sophisticated than others.

With the anthropoid apes, previous experience is one of the great parameters governing variation in activity in general. The ability to

innovate cannot be separated from the process of auto-apprentice-ship, when the anthropoid gains in skill and moves through a number of elementary stages towards a broader range of possibilities. This applies also to drawing and painting. The disruptive process conceals potential operations that are more advanced than just a playful line drawn with a pencil, and the anthropoid ape can discover these operations for itself as time goes by.

One day, while he was observing Congo painting variations on the fan theme, Desmond Morris saw something that astonished him. Instead of drawing his lines from the top of the page, moving his hand towards his body – as he had always done, and as do all chimpanzees when they paint fan-patterns – Congo suddenly opted for a change. With great concentration he began his brushstrokes from the bottom of the page. The direction of the fan did not change, it radiated towards the top as usual, but Congo drew it upside down.[24] An interior image of the fan must therefore have preceded the act of drawing the shape: the chimpanzee had, in fact, used the structure as a 'motif'. There were other, less spectacular demonstra-tions of this transformation whereby a structure from a visualised gesture acquired, through repetition, the status of a preliminary mental representation. One of Congo's paintings (illus. 32) consists of a large fan with a small subsidiary fan in the bottom right hand corner. On another occasion, Morris tried removing the page before Congo had finished the fan: when he returned it to him, Congo carefully completed the pattern.[25]

The same apparent inward consciousness of an oft-repeated pattern has been observed in other chimpanzees, when a series of similar 'compositions' has been produced. The paintings by Binger (illus. 40, 41) seem to have influenced each other by repetition. Two paintings by Bozo, one painted immediately after the other, using different colours, show the chimpanzee repeating the same formula. These are the only examples of long vertical bands in his oeuvre, and they suggest that the chimpanzee had the first painting in mind when he was painting the second (illus. 63, 64).

On the subject of cases like these, Morris spoke of 'fixed visual units', when the shape was emancipated from the movement used to produce it.[26] It was primarily Congo's repetition of the 'fan pattern' that provoked Morris to formulate this theory. The analyses put forward here, however, suggest that the theory should be accepted

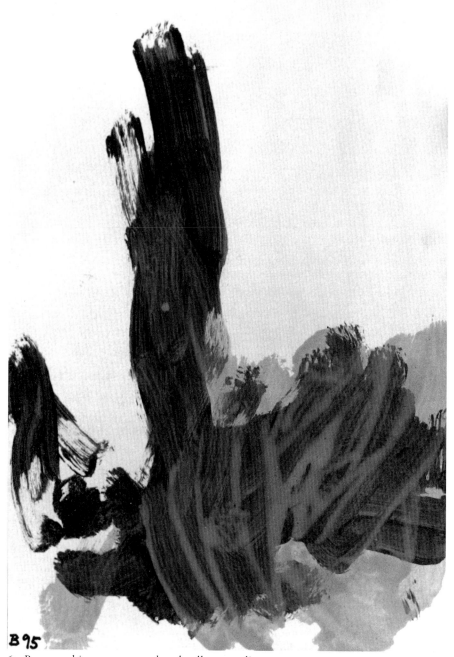

B95

63 Bozo, a chimpanzee: a red and yellow acrylic.

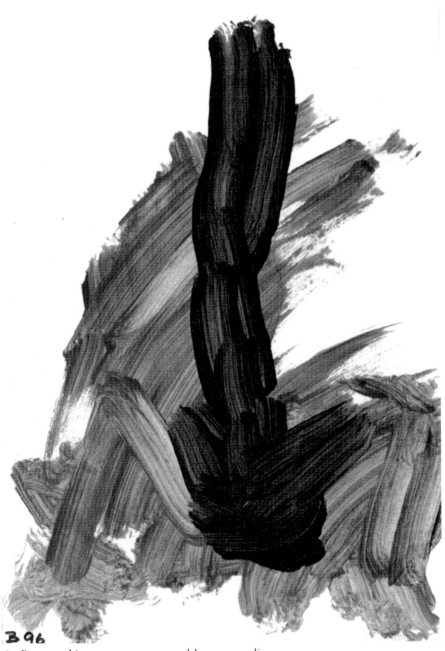

B96

64 Bozo, a chimpanzee: a green and brown acrylic.

only with the greatest reservation: the configuration is evidently emancipated from the operation that produced it, but with relation to the disruptive structure of that operation. The fan gradually achieved the status of an independent form and Congo took pleasure in varying its appearance. But Congo did not gain a sufficient degree of independence to enable him to break free of the original manner of placing the form inside the image field. Congo could reverse his movements, but not the fan-pattern itself. He did not start drawing fans lying on their sides, or head to tail, or fitting into each other head to tail, or anything of the kind. Throughout all the variations that helped to fix the structure of the fan-pattern in the consciousness of the individual producing it, it remained the disruptive formula that it always had been.

In one of her books on the drawings of young children, Rhoda Kellogg makes a very perceptive observation. She states that apes, unlike young humans, never produce complete radial structures: their fans only ever radiate through 180 degrees.[27] I should like to add that, in the case of apes, this is because the principle of the disruption of the field does not allow it to open any wider. Children often draw radial structures that open the full 360 degrees. Children's drawing can escape more easily than that of apes from the parameters of the image field.

In ape painting, variants cannot break the link between formal structure and the disruption system to which it corresponds. Even if the marking impulse is at times marginalised by an interest in new methods of repeating marking formulae, the form produced has no independent identity that allows it to exceed the original value of the intervention in the field. This is why ape painting cannot exploit the possibilities offered by combinations of different shapes. The example of 'diagrams' and 'combines' confirms this. The structures thus described by Morris (following the terminology used by Rhoda Kellogg)[28] represent the most advanced stage of chimpanzee painting play, and are most frequently paintings (or drawings) interrupted by the experimenter during the process of visual disruption which develops over several stages. It was only by withdrawing the page neatly at the appropriate moment that it was possible to obtain, for example, a drawing consisting of a single line curving round upon itself.[29] A long vertical line with several short horizontal strokes across it was reproduced in Morris's book only after being extricated

from a mass of scribbles that was progressively blocking it out.[30] Finally, the drawing recognised by Morris as Congo's most advanced piece of work consists of an imperfect oval marked with two crossed lines (illus. 65).[31] Although such a pattern may involve the theory of secondary fields, there is no reason to think of it as any more than a 'ritualised' disruptive intervention. Neither Congo nor any other chimpanzee has had the idea of leaving that or another combination intact in order to play around with it in as many ways as possible, or combining it with others and then varying the secondary combinations, as humans do in their decorative art. The chimpanzee is not interested in combinations of diagrams, nor in combinations of combines. This also explains why non-human primates, including chimpanzees, have only a very slight tendency to imitate patterns. An ape has virtually never been observed spontaneously to copy a pre-marked pattern, and the literature only mentions one or two exceptional cases.[32] The examples reproduced by Alland[33] are the work of the celebrated Nim Chimpsky, a chimpanzee, like those trained by the Premacks, the Rumbaughs and the Gardners, 'denatured' by being apprenticed to a system of communication by artificial symbols. There is no reason to think, therefore, that for apes a 'motif' is anything more than the conscious repetition of a disruptive formula. Repetition can give rise to an image that is independent of the act that produces it, but the image inevitably remains linked to the disruptive system behind the act.

Another important thing to realise is that ape painting manifests no evidence of any *spatial concept of field*, i.e. no transformation of the physical area of the support into an imaginary space (known to aestheticians as 'pictorial space').[34] When humans paint, such a transformation inevitably occurs. The spatial concept may operate in two different ways, which in practice are generally combined. It can be internal and transcendent, when the painted forms suggest a deep volume of space opening behind the support and defined by it; this is the manner of classical figurative painting in which the field is treated as a window opening on to the world represented in the painting. The spatialisation can also be external and immanent, as it frequently is in abstract painting, in which case forms do not imply a deep volume of space but maintain a conflictual interrelationship with the shape of the support. This is what occurs when, for example, the painted forms suggest a *Gestalt* that spills over the frame, inviting the

65 Congo, a chimpanzee: oval form marked with two crossed lines (chalk).

spectator's imagination to extend the forms beyond the boundaries of the field, itself now reduced to the status of an arbitrary template in a two-dimensional space much larger than the parameters of the support. In these two concepts of space the painted shapes take possession of the field through the imagination of the spectator, and this transformation of the field by the imagination demonstrates the basic independence of the visual intelligence with regard to the location constituted by the support itself; moreover, it is easy to understand that the possibilities of establishing a field and of transforming it into an imaginary space are mutually inclusive and interdependent.

Ape painting thus presents no visible evidence for the existence of a spatial concept of the image field, either according to the first mode (which presumes representation) or the second. Forms painted by apes and monkeys do not go over the edges of the support; on the contrary, most of the time they observe the 'frame rule' absolutely and, in the majority of cases, there is no visual discrepancy between the forms and the structure of the field – generally the former complies with the latter as closely as possible. The painting practice of non-human primates therefore does not involve taking possession of the field *as such*. The field is imposed externally and remains external to the painting process. Ape painting concerns a strictly formal awareness of the field, and does not involve the faculty, specific to man, of interiorisation of the field to make it into an imaginary location.

This inherent passivity, moreover, is manifested towards all matters concerning painting, and not only the field. For instance, it has been observed that if 'compositions' vary greatly according to the thickness of the brushstrokes, the ape does not try to influence the lines by adjusting the amount of paint on the brush, for example, to obtain particular effects. Still less would an ape attempt to alter a painting implement to adapt it to the production of an 'artistic project'. As for the choice of colours, when it is left to the animal, the freedom of choice operates within the constraints set by the human agent. Chimpanzees, for example, never try to mix colours in order to obtain a shade that they particularly like. Their choice is made from a limited range of possibilities, not only with regard to colour, but also with regard to the other properties of colouring matter; according to their consistency and the time it takes them to dry,

coloured lines will smudge to a greater or lesser extent. If colours are very fluid and dry slowly, the shades will have a tendency to blur; if, on the other hand, the colours are compact and dry rapidly (as does acrylic paint), it is possible to obtain layers of colour that do not merge. Thus, the nature of the colouring matter, which has nothing to do with the ape, pre-determines the possibility of painting series of strokes in more than one colour which will remain visible beneath a succession of further strokes. The human artist will choose colours or adapt his materials to suit the effects he hopes to obtain. In ape painting the range of choice is limited to a series of possibilities that are *fixed* by a human being; there is no question of innovations being brought about by the animal to modify the act of painting. Ape painting is *captive painting*, in complete submission to its equipment. The functional liberty of the animal allows it to choose only within the constraints or incitements that are inherent in the materials, as they are imposed from outside.

The fascinating problem of the anthropoid's progression towards graphic symbolisation must be considered in exactly the same terms. For years apes were considered incapable of symbolisation, but the work carried out by the Gardners and other researchers involved in two-way communication with apes makes it necessary to re-examine this opinion. It has been known for years that chimpanzees could read simple photographic images with great fluency, and indeed they evince great interest in doing so.[35] An exhaustive study has confirmed the existence of this remarkable ability,[36] and this throws further light on a number of other observations, recurrent in spite of not being the outcome of scientific studies, on the rôle of the imagination in the behaviour of chimpanzees. Cathy Hayes devotes a whole chapter of her book to the description of a curious behavioural sequence: one day she surprised young Viki in the process of going through all the gestures she usually made when dragging behind her the object she had chosen to play with, but that day there was no object. When Viki noticed that Hayes was watching her she immediately stopped her game. As far as could be seen, Hayes decided, Viki was playing with an imaginary toy.[37] A chimpanzee named Austin was also observed on many occasions pretending to eat imaginary food from a bowl, or holding an imaginary bowl and spoon.[38] Winifred Felce suggested that, in tense emotional situations, one way the chimpanzees could immediately establish links between

the members of the group was to call out in unison against 'some imaginary foe, perhaps the keeper, or just a ghost'.[39] The author does not develop the idea any further, but it would be very interesting to verify the hypothesis that suggests that demonstrations of hostility towards an imaginary subject play a rôle of some kind in the social behaviour of chimpanzees. Whatever the truth of the matter, the ability to recognise objects represented photographically presupposes, in the terms used by Davenport and Rogers, a 'mediative/representational process' which certainly appears to be functional in the intellectual life of the higher primates. This surely suggests that observations relating to imaginary objects and subjects deserve to be taken extremely seriously. Finally, various essential studies have also proved that anthropoid apes are born with the facility to attain artifical communication by conventional signs.[40] A. J. and D. Premack have established the fact that training for this system of communication can to a certain extent increase the spectrum of the chimpanzee's psychological performance.

One of the subjects studied by the Gardners, a female named Moja, may possibly have *drawn something*. One day, the experimenter witnessed her drawing in quite a different way from the scribbles she usually produced. He asked her to finish it, but Moja signed 'finished' in deaf-and-dumb language. The experimenter then asked her what it was and Moja made the sign 'bird' (illus. 66). At another time he asked her to draw a cherry, which she did (illus. 67)[41]. Strictly speaking, there is no way of proving that there was any real graphic symbolisation in either case. It is also impossible to be clear about the modality of this possible symbolisation. This having been said, however, even if the content of the response was formed in Moja's consciousness in reply to the question, it would still be most unusual for a chimpanzee to accord a referential value to one of its drawings. This claim does not, however, appear totally impossible if these observations are taken in the general context of the discoveries made by the Gardners about the unsuspected complexity of the mental processes of their subjects. The very unusual appearance of Moja's drawing lends weight to the Gardner's hypothesis; they emphasised the close similarity between the sign 'cherry' and its referent. Moreover, unlike most drawings by chimpanzees and unlike Moja's usual scribbles, this drawing occupies only a tiny area of the space available.

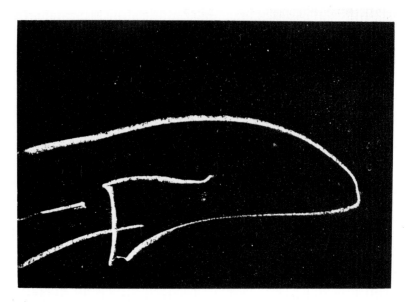

66 Moja, a chimpanzee: 'bird' (chalk).

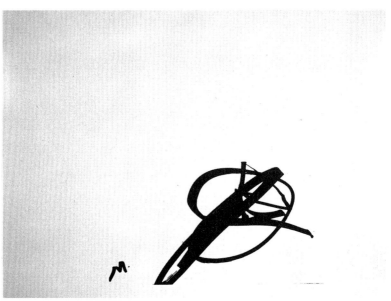

67 Moja: 'cherry' (red felt-tip).

It is possible that training might develop the capacity for graphic symbolisation in apes. It might enable them to produce more convincing figures than Moja's 'bird'.

Recently the team led by R. S. Fouts has continued experiments with Moja on a more scientific basis. She was asked to draw a number of objects and was questioned about the drawings afterwards. The experiment seemed to confirm the Gardner's observations: the chimpanzee responds to the request, and it is possible to find the beginnings of a 'visual concept' in the drawings. However, judging by the published examples, the graphic system is subservient to the principles of elementary graphic motion. All the published drawings consist of groups of vigorous strokes, drawn with a to-and-fro movement of the hand; they are in fact very similar to the usual chimpanzee scribbles, executed without any referential aim. If Moja is sketching a 'visual concept', the formal content is very weak indeed compared with the urgent strength of the movement. As a result, the drawing of a cup is a little fan-shape of lines. The researchers also reported that the 'schemata' were never modified when further information about the objects to be drawn was provided. Finally, Moja only indicated a drawing corresponding to the name of an object 5 times out of 26. The other responses, with variations, all used the word 'colour' – the word generally used by Moja to designate the activity of drawing, or 'scribbles', or drawing materials.[42]

In order to develop the capacity for graphic symbolisation in an ape a means would have to be found of diminishing the animal's instinctive enjoyment of the game of visual disruption. This would entail organising subtle diversions of the ape's spontaneous enjoyment in order to break the powerful grip of self-gratification, as this has the effect of holding the subject fast to its game of disruption. During a test in which a chimpanzee had to mark a series of letters, Premack initially gave the subject a coloured pencil to use. This had one big disadvantage: the chimpanzee began scribbling freely all over the page instead of doing the test. The process was adapted: the chimpanzee was given little pieces of black sticky tape to stick on to the chosen letter. The test could then continue as planned.[43] The possibility of expressing meaning is not the primary motivation of the pseudo-artistic play of apes; the animals do not think of using drawing as a means of communication – although theoretically they have the means, given their manual dexterity, their ability to read

stationary images and to use a system of communication by sign (an acquired system). For them, the act of marking is the important thing. The awakening of an interest in graphic symbolisation appears to be possible only if the fascination for disruptive marking is appeased. To do this would add yet another layer of artificiality to the usual quite artificial pictorial device.

The preponderant influence of the principle of disruption defines the specificity of 'monkey art'. It cannot be observed in young humans. It is true that between the moment children discover the pleasure of scribbling (at about eighteen months) and the moment when they reach the stage of graphic symbolisation (at about two and a half), the unalloyed pleasure of co-ordinated movement is an essential element of their drawing play, as demonstrated in most of the psychological studies of children's drawing.[44] But their motor control and their muscular strength, both considerably less than that found in chimpanzees of the same age, confine them at first to a repertory of far clumsier shapes than the ones usually produced by apes. Rather than a 'sense of composition', the first drawings executed by very young children consist mainly of irregular lines, hesitantly drawn. The reason why their early experiments at painting seldom present the immediate aesthetic attractiveness of a painting by a chimpanzee is that a child is unable to play the game of the disruptive mark as wholeheartedly as a chimpanzee. At about the age of two and a half, children begin to be able to recognise their own drawings as representing such and such an object. Next comes the stage when they express the intention of depicting objects or people, and begin to organise their strokes with this representational plan in mind. The drawing game then becomes a game of symbolic construction based on the combination of combines of drawn lines refined according the formal scheme desired. In the time elapsing between the discovery of drawing and the discovery of graphic symbolisation, the psycho-motor development of the child would not have given it the chance to practise the marking game for its own sake: this may be because the child does not yet have sufficient control over its movements to interact appropriately with the shape of the support, or because it is already constructing symbolic messages by combining independent forms.

Rhoda Kellogg established a catalogue of basic shapes used by children in drawing. If she had not been limited by *Gestalt* theory,

she would have been able to see that these shapes were classic disruptive marks – for example, the cross, or the circle with scored circumference (which can become a sun, a flower or a face, once the principle of representation has been grasped). The development of graphic representation, drawn from the basic repertory of diagrams, suggests boredom with the simple marking process, which gives visible form to the gestures from which it proceeds, disturbing the state of the field. If the case arises, man only returns to his fascination with pure marking after lengthy cultural detours – such as those that gave birth to Japanese art or Action Painting – and this return will take place within a project meaningfully related to a definite symbolic horizon (a project without which it would be impossible to use the term 'art' in the proper sense).

According to the biological theory of art, the very root of all aesthetic behaviour, including art in the narrow (human) sense, would be a 'sense of order', i.e. a basic tendency to organise sensorial data following basic cognitive principles, and to prefer visual situations corresponding to these principles.[45] The action of this 'sense of order', rooted in the biological identity of higher animals, would explain the aesthetic properties of ape painting, in which we actually recognise some basic components of human artistic pro-ductions, such as balance, rhythm, harmony. This putative common ground should lead us to assume that the specificities of human art simply derive, by constantly increased complexity, from those functions found in ape painting. Investigating the limits of pictorial play in apes, Desmond Morris and others showed that those animals never cross the threshold of graphic symbolisation (except those animals trained in ASL). But, within that limit, their paintings appear to be so aesthetically coherent that one might think that the symbolic and expressive functions of human art constitute just a second layer, a mere superstructure emanating from the core. From ape painting to human art, the difference would be of quantity rather than of quality, and the passage would take place by continuous transformation based on the common ground of the 'sense of order'.

Nevertheless, this way of reasoning overlooks an essential aspect of the question: the role of the painting equipment itself in the generation of forms. Ape painting proceeds from an interference between animal intelligence and an artificial set of means provided by human subjects, and the possibilities accessible to the ape are too

dependent on that set of means to be considered independently, as some kind of completely natural expression. In fact, as I tried to demonstrate, ape paintings constitute only passive responses to the pictorial field, or *articulated echoes* of it. In other words, the aesthetic properties of ape painting are generated in a very significant measure by the whole painting equipment rather than by the ape himself. And if we develop the consequences of this remark, we are led to reject the concept of a 'sense of order' as a good explanation of how ape painting comes to be what it actually is, hence to reject it as a valid foundation for addressing the question of the origin of art.

The chimpanzee's way of practising painting only shows a formal conscience, and no creative conscience, of the field; it is easy to see that this passive attitude is part of a general passivity towards the pictorial equipment taken as a whole. True, one of the most striking characteristics of the phenomenon lies in the fact that apes adapt their operations to the artificial set of means they are given to play with: Morris has observed how his chimpanzee Congo taught himself the best way to handle a pencil or brush, which appears to be the one used by humans: holding the instrument between the thumb, the index and the second finger. But even the most gifted chimpanzee will only adapt *himself* (quickly and quite efficiently) to those means as they are given to him, in a *one-way exchange* between the painting equipment and the painting operation. The operative structure of human painting, on the contrary, is that of a *two-way* exchange: the painting equipment, including the field, always conditions the practice it makes possible while being itself conditioned by the course of this practice. Acting on the set of means which makes the pictorial practice possible is as essential to the art of painting as exploring its constraints, and the evolution of the painting equipment is to be seen as part and parcel of the history of painting.

This, however, could easily be taken as a truism. Of course, chimpanzees did not invent painting. But, after all, they might have – painting must indeed have been invented at some point – or one day one of them might get the idea of tracing lines on a flat stone with a stick dipped in whitish mud; moreover, why not try to short-circuit Prehistory, and see what kind of paintings early ancestors of man would have produced? Such reflections can be easily dismissed, however, since we can establish that, in all its *positive* characteristics,

ape painting turns out to be a fundamentally *non-establishing practice*. This means that the ways in which apes respond to the painting equipment appear intimately dependent on the fact that they take it purely from outside, without trying to act on it. And it is the positive analysis of the products of their pseudo-artistic play that leads to that conclusion.

Even the chimpanzees who show the best mastery as well as the strongest concentration during play, and who introduce the most relevant formal variations, always follow extremely rigid rules when including a pattern in the field. And their combinatory capacity never goes beyond the two-level operation of marking a shape (which itself can be complex) by another shape made out of a few brush-strokes. In other words, the patterns in ape paintings do not show any kind of autonomy with respect to the pictorial field, taken together with the patterns already present in it. The variations may be indisputably relevant in terms of form, but they do not reveal any conscience of the form *in se*. This means that the forms always remain *linked to an active intervention* in the pictorial field. They never appear to be independent from the structure of the disruptive operation consisting in inscribing them in the field. This is why they cannot properly be combined *as forms*.

This is also why ape painting never involves giving a spatial character to the pictorial field, whereas this is one of the most basic operations in human art. Since the patterns do not become forms in the proper sense, they cannot be picked up by the imagination so as to be perceived as 'things in space'. And the indissoluble link between the patterns and the operative structure of the painting action also explains why apes do not show any interest in their own paintings once they have done with them: the patterns exist only insofar as they are the opportunity for an active visual intervention.

Because they never gain formal autonomy from the operating structures of the action that generates them, the patterns of ape painting are not available for meaning effects: they do not become signifiers, at least not spontaneously. This is, of course, a crucial difference with the pictorial activity of children, in which the exploratory ludism rapidly combines with communicational and expressive purposes – even if, originally, scribbling and playing with colouring matters are largely independent from a will to communicate.

Ape painting proceeds from sequences of free and intelligent operations, which however never escapes from the 'now' of the present and never gain any independence from the device which makes them possible. Let us put it the other way around: since the patterns generated by apes have no autonomy and thus no value as forms, they can be nothing but *echoes of the painting equipment*, intelligently articulated by the subject.

Now, the 'sense of order' theory can no longer be considered as a valid explanation of the aesthetic properties we find in ape paintings. This explanation could only be accepted as conclusive if the regular and balanced patterns that appear in chimpanzee paintings were the products of the subjects themselves rather than the effects of the painting equipment, produced through them. But this happens not to be the case, judging from the fact that these patterns strictly abide by the structure of the field, whatever their variations may be. In fact, it is much more reasonable to think that they are, in a sense, the products of the device itself made via the painting subject, rather than the opposite.

The explanation based on the 'sense of order' theory mistakes the form-generating action of the painting equipment, set up in the course of human culture, for the aesthetic capacity of the chimpanzee. That mistake proceeds from a hidden confusion between two different things: a capacity to respond relevantly to ordered forms, on the one hand, and, on the other hand, what might be called, in a Nietzschean paraphrase, a 'will to order' – that is to say a kind of expressive desire to create aesthetic order, to call ordered forms into being precisely for their order's own sake.

Chimpanzees certainly do have a 'sense of order', but only in the first sense. To explain the conspicuous aesthetic properties of their paintings, there is no need for an implicit metaphysics of expression. They can be explained fairly well by the agency of a ludic-exploratory drive that leads the subject to disrupt the state of a field by means of brush-strokes. Because apes do recognise the formal structure of that state, and since they have no conscience of the aesthetic form *as such*, their disruptive intervention in the pictorial field will always tend simply to reverberate its shape in various ways. Hence those effects of balance and harmony, which we ought to consider as echoes of the regular structure of the operative unit consisting of the subject and the equipment; these echoes are

articulated by subjects whose aesthetic motivation does not reach possibilities beyond the co-ordinated disruption of the field.[46]

So, it would be far more appropriate to explain the phenomenon of ape painting by speaking of a 'sense of disruption' rather than of a 'sense of order' – provided we understand that the former is not simply the opposite of the latter, since the act of disruption involves a consciousness of the order to be disrupted.

The capacity to respond to the possibility of painting in a non-establishing way does not exist in animal species other than apes and capuchin monkeys. It does not seem that dolphins and elephants can integrate the formal parameters of the field in the pictorial play; they only show a consciousness of the support as such: they put colouring matters on the sheet or panel, but do not respond to its geometric structure according to their position in front of it. The play of sheer disruptive marking does not exist in man either: for human beings, there is always *a priori* something more in painting or drawing than the pure and simple present alteration of the state of a field. For human eyes, the painted form always exists in itself – and thus exists as a bearer of meanings. To put it otherwise, the patterns produced by the act of painting have an aesthetic life of their own, independent from the action of producing them and linked to the symbolic functions inherent to 'artistic language'. These patterns are, of course, conditioned by the painting equipment, but always so as to allow the painter to play with that equipment at the same time rather than just obey it. A painter does not content himself with passively reflecting the shape of the canvas or sheet; he always draws the pictorial field into the image itself, so to speak – either as a pure form of its own (think of abstract painting), or as a sign (for instance, in all classical painting, the field becomes an opening through which the beholder discovers the scene).

In human art, the productive action is always diverted towards its results and consequences; it never has this absolute operative self-sufficiency that only animals can experience. This split between the action and its traces is precisely what, in the first place, makes the emergence of culture possible. It is the very condition of any symbolical relationship to the environment, implemented by language and other instituted sign-systems. In other words, the possibility of a symbolical network necessarily goes hand in hand with the conscience of form as such, along with the setting-up of

operative devices. Human art is wholly rooted in what I would like to call the 'operative split', meaning the severance between the action and its traces, which allows us to institute the latter as a product or a creation in the proper sense. Human art cannot be generated by simply adding some symbolical functions upon a primitive stratum made of a purely aesthetic capacity of the kind we find in apes.

The existence of a 'sense of order' in higher animals is a fact, proven by observation and experimental work, and there is no doubt that it was passed on to the human species, which 'invented' art as a domain where that sense was called in to exercise itself under its purest forms. But it is in no way sufficient to point to the 'sense of order' to solve the problem of the origin of art and culture in any way. In fact, that problem deals with the birth of at least four intimately intertwined phenomena: a sense of form *as such* (related to the capacity of transforming a given field into an imaginary space), a notion of the 'operative split' (that is to say, a creative conscience), a capacity to set up operational devices and an ability to symbolise within a symbolic network. None of these four phenomena can be approached apart from the three others. Conversely, subjects who can experience the pure and simple possibility of responding to an operative device in a non-establishing way can have neither a conscience of form as form, nor a creative conscience, nor a spontaneous capacity to convey symbolical meanings within a network of meanings.

With regard to proto-symbolic thought in chimpanzees that have learnt a system of communicating by artificial signs such as ASL, it is extremely important to recognise the limitations of their development. Even if it has been shown that these subjects can operate punctual transfers from an idea to a sign, and are capable of linking several of these transfers together, they do not possess the *symbolic network* revealed by human language. A symbolic network can be defined briefly as a body of significant vectors by means of which the world (objects, things in general) is globally endowed with meaning. Such a network, in which each signification is in a more or less explicit relationship with all the others, allows meaning to extend well beyond any immediate situation. For example, it permits us to talk about things that do not exist, or to develop meta-languages – neither of which is possible for chimpanzees.[47] This absence of a

symbolic network (or, if you prefer, this absence of culture) means that, in a completely general way, chimpanzees have no access to the principle of the 'second degree'. If a more positive, less anthropocentrist formulation is preferred, then it could be held that the non-human primate is not (as we are) a victim of the inner split that transfers the value of an act to its consequences, thus depriving it of its own original intensity. This is why chimpanzees cannot learn to make objects that would enable them to make others, with the idea of attaining a particular goal. This is recognisably the same limitation as the one preventing chimpanzees from combining independent graphic forms.

Studies of two-way communication between apes and humans have sometimes concluded that the great apes possess an authentic 'capacity for language'. This notion, a partner to the 'quantitative' theory of anthropological difference, rests on a fairly primitive functionalist concept of language, which pays no account to the existence of a symbolic network: 'First and foremost language is a means of communicating information. As such, it is composed of two component systems. One is a set of abstract (and usually arbitrary) symbols, each used to represent a specific 'referent' (an object, state, event, etc.); and the second is a set of rules for interrelating those individual elements in order to express more complex meanings.'[48] A definition of language such as this has the merit of being easy to understand, but it is not so easy to see how to move from this to a system in which all significations are interrelated and which *gives meaning* to the world in its totality and to each particular object as well. Only the functionalist view authorises discussion of 'degrees' of symbolic function: 'The acquisition of words, we have learned [through ape-language research], should not be viewed as "all or nothing", but rather in degrees of wordness and of symbolic functioning.'[49] The functionalist view of symbolism runs counter here to the structuralist view. The latter, in as much as it considers the sign as dependent on a symbolic global structure, implies precisely that – 'all or nothing' – and therefore implies a clear division between animal behaviour and human culture.[50]

We need to accept the fact that the structuralist theory of language (and this is also valid for the phenomenological view) has not yet permitted reflection on the phenomenon of 'proto-symbolic' behaviour in apes trained in ASL. Seen from this standpoint, the

problem is a philosophical minefield. On the other hand, the functionalist concept demonstrates characteristic weakness when the parameters rendering this behavioural pattern a *proto*-symbolic pattern are conceptualised: *proto*-symbolic means capable of appropriate substitutions but lacking a global symbolic network, lacking meta-linguistic capacity and also lacking an externalised collective memory of cultural creations. Functionalist ideas have led to the underestimation of the problem of *establishing* codes of meaning; they have glossed over the fact that, for example, in chimpanzee painting the process of production is not guided by any goal beyond the process itself; nor are the materials understood as an integral part of a whole project. Only a theory that prioritises the dimension of the network of meanings (more important for providing a convincing definition of the symbol than straightforward referential substitution) can make sense of the fact that, although painting apes take the image field into account, this does not mean that the field appears to their eyes as a place designed for painting, where necessarily the painting operation will take place. It is interesting to note that, although apes avoid going over the edges of the support once they have identified it as the appropriate place for painting, their painting activity is liable to slip off course at any moment and to fix on some other neighbouring object. This happened during a television report on Nonja: viewers had the entertaining experience of seeing the orang-utan suddenly turn towards the camera and start painting the camera lens.[51]

We may assume that ape painting constitutes the example of a ludic-exploratory practice as complex as possible without getting beyond the level of the 'operative split' (that is, without departing from a condition in which the action has an absolute self-sufficiency as a pure, actual intervention in a given environment). Chimpanzees may well anticipate the visible results of their co-ordinated disruption of a given field, and they may be able to generate complex 'compositions' with multiple stages, which bear testimony to a true visual intelligence. But ape painting remains wholly on the other side of experience, where there is no conscience of the principle of endowing the traces of an act with a value of their own. This is precisely why, when considering the pseudo-artistic practice of our closest animal cousins from a critical point of view, we must conclude that it does not contain anything that could lead to a better understanding of

how the 'operative split' and its consequences appeared in the history of life. Consequently, it also does not offer an opportunity to solve the problem of the origin of art.

2 What is a monkey painting?

Monkey art as a myth of origin

Sir Julian Huxley, observing a gorilla at the Zoological Society, suddenly noticed that the animal, fascinated by its shadow projected on to the wall of the cage, was tracing its outline with its finger. The gorilla repeated this gesture three times, after which Huxley tried unsuccessfully to make it do it again. Although a shadow projector was later installed in the cage, the gorilla refused to take any interest in it and never repeated the gesture before its death. The observation was carefully written up and published in the well-known journal *Nature*, 'for its intrinsic interest as well as for its relationship to the possible origins of human graphic art'.[1]

Huxley claimed never to have come across a description of an anthropoid performing such an action anywhere in literature. However, in Book XXXV of his *Natural History*, Pliny the Elder tells a similar story (although it is not about an ape), in fact in his account of the invention of drawing. According to the myth, graphic art was born on the day when the daughter of Butade, a potter of Corinth, found a way of recording the face of her lover just before he set off on a long journey: she had the idea of tracing round his profile on the wall. From the 17th century onwards, the myth of Dibutade (as the young woman was called) became a subject for history painters. The myth became particularly prevalent during the Neo-Classical and pre-Romantic periods, when art began to look inwards with increasing intensity; at that time, the myth of Dibutade became a frequent theme in iconography. The myth of the invention of drawing later provided ideal material for rhetorical developments on the origins of art in the language of classical scholarship.[2]

Obviously, it would not be sensible to suggest that a scientist of the calibre of Julian Huxley could have interpreted the behaviour of a gorilla by recreating it from a museum picture. The event itself, which was confirmed by another observer, is no more implausible, in fact, than the failure of Huxley's attempt at persuading the gorilla to repeat the performance.[3] But would the notion of linking this zoo

story with the debate about the birth of drawing have surfaced without the memory of the mythical Dibutade, or, at least, without the entire body of creation myths springing to mind?

The history of monkey painting was motivated by a glimpse of man's origins; the art biologists were chiefly motivated by a desire to examine man's origins through animal behaviour, in the light of the aesthetic freedoms offered by modern art, and from the perspective of evolutionary theory. The mainspring of the enquiry was the idea of the sense of order. The origin of art was considered to be an aesthetic function inherent to perception. It was thought that monkey painting would permit the basic characteristics of this innate function to be defined.

The theory of the disruptive mark posed the problem of the origins of art in negative terms alone. Why do non-human primates not paint or draw in their natural environment? This question has been raised on various occasions, but no serious attempt to answer it has ever been made. The answer is less problematic if the positive rôle of painting equipment is taken into account.

Monkey painting undoubtedly shows characteristic signs of an elementary level of aesthetic sensibility. The elementary aspect of it, however, emerges only if we place it beside a highly advanced parameter, the image-field typical of modern painting in its broadest sense. When the animal is encouraged to play with the painting equipment, it is being subjected *artificially* to formal disruptive play conditions. The fact is that apes display no tendency themselves to procure materials to help them play at gestural visualisation. It is true that Alpha tried one day to draw on a dead leaf, but this action turned out to be nothing more than a desperate attempt to compensate for the absence of some of the equipment. Wolfgang Köhler observed a painting session that appeared to be more spontaneous. He placed a pot of paint in front of his chimpanzees. The apes had never seen such a thing before and began by tasting the colour, noticing its ability to stain when they wiped their mouths. They then began smearing the paint on some posts and a beam, using their mouths at first until they realised that it was better to use their hands.[4] It is an interesting episode, although, as Köhler points out, the paint play produced only a series of large, white smears; the chimpanzees had the colour but not the field.

The reason why apes make no attempt at creating painting

equipment is that they are uninterested in the product of their acts of deliberate disruption. In their natural environment, disruptive play has enough outlets to make the invention of art unnecessary. The apes therefore have no need for equipment that would produce durable marks on a background. There is nothing in their system of relations with the outside world that would encourage this. Let us suppose that one fine day a group of chimpanzees came upon a supply of white clay and had fun smearing it on the trunks of the surrounding trees; this would simply be play like any other. They would soon have forgotten it, even sooner because its execution would not deliver the same rewards as the creation of disruptive marks in a structured field. One problem of the origins of art is to know how the intense satisfaction produced by pure disruptive play could have been dulled to the point where the value of the play is dependent on the quality of what is produced. Art is born when a field for the making of marks is set up. The work of the biologists has not led us to a positive understanding of this process. Nothing truly resembling ape painting can have existed at any point in history or prehistory: as played by apes, it is a game that presupposes the existence of its equipment while being absolutely extraneous to the setting-up of this equipment.[5]

Pure marking and artwork fallacy

The natural reaction of a spectator when faced with a monkey painting is to try to understand it through an aesthetic value system constructed from his experience of human art. Such constructs are produced by a tendency to regard the marks on the paper as in some way representing a preliminary mental 'drawing', an aesthetic project or an 'idea', to borrow the terminology of the classical theorists. For us, the process of painting inevitably involves a certain anticipation of the final result of the pictorial act. By its nature, the act has to materialise into something concrete, the painting, which preserves the aesthetic charge of this act.

In this sense, however, ape art has nothing to do with form. Its forms are basically built up progressively by gesture made manifest and organised while it is being put on the paper. It is true that apes' painting play does not consist solely of a series of momentary visual catastrophes. Apes often avoid painting over areas that have already

been painted, and produce shapes which, like the fan-pattern, are built up by a series of operations. This suggests that 'ape art' might to some extent imply an awareness of the principle of the durable nature of what it produces. When they are well in control of what they are doing, chimpanzees will make an effort to keep their brushstrokes visible at every stage. If they did not do this, their 'sense of composition' would not exist, and monkey paintings would simply be a succession of layers of colour applied one on top of the other. Nevertheless, this attempt to make each stroke durable is pursued within very narrow confines. The marks present the correct weight and substance for as long as the painting is being executed, no longer. The minute the succession of new marks ceases to disrupt the canvas in any significant way, the entire painting dies in the eyes of the ape. The ape is not interested in what happens when you look at a painting some time after it has been executed. The long-term consequences of the pictorial process, whereby the development of the painting is preserved in the finished work, and continues to be a living entity more or less for ever, are all lost on the ape: once the painting is completed, it does not look at it again.

Nothing could be more alien to non-human primates than the work of the gestural painters, whose aim is to render visible the live action of the pictorial gesture, although this is bound to be aesthetically fossilised by being captured on canvas. They are struggling to invent a type of painting in which gesture does not stop or become inert after it has been transferred to the canvas. The ape is unaware of such preoccupations. This is why, unlike the gestural artists, a chimpanzee does not look for the most 'dynamic' ways to escape from static form and to divert the spectator's gaze to the trajectory of the gesture. In ape painting the opposite is true: disruptive gestures unwittingly increase the static structure of the field twofold, giving the painting the 'form' that caught the attention of such a painter as Victor Pasmore; the Action Painters, for some reason, seem never to have had anything to say on the subject. The extraordinary unselfconsciousness of monkey painting can *never* be found in gestural art, which is obsessed above all else by considerations (even if they are negative ones) of the finished work and of form.

The Austrian painter Arnulf Rainer experienced first hand the separation between 'the art of painting' and monkey picture play. His

experiments at disrupting images with rough lines led him to an astonishing confrontation. About fifteen years ago he approached Werner Müller after a show and asked him to borrow some of his chimpanzees' drawings and paintings. He also asked to watch the animals at work, offering to imitate their finished work. He claimed to be looking for examples to follow – as he had looked for examples at the art school where, years before, he had spent only three days. His choice fell on the chimpanzees, whose 'sovereignty' impressed him (illus. 68).[6] It emerged after the experiment that the aesthetic sovereignty of the ape could never be that of an artist in the normal sense. Man is congenitally excluded from it and can therefore only imitate it from outside. When he saw the products of the confrontation Rainer must have been aware above all of the essential inability of an artist to produce 'pure' marks. Because an artist always has the finished result in mind, he can never attain the total independence of line to which monkey paintings appear to attest.

If it was a question of going back to the fundamental beginnings of art, man would imitate the ape. 'Ars simia simiae' might be the motto of such a venture, which, though paradoxical, makes perfectly good sense. The monkey is the only producer of pictures who imitates nothing and nobody and recognises only the unadulterated pleasure of the disruptive mark. Rainer was filmed during his working sessions. We see him in the grip of a kind of trance, banging the paper, spitting on it, waving his brush nervously, throwing it down. The chimpanzee by contrast paints peacefully to start with, but is gradually influenced by the agitation of its imitator. It stops drawing, starts jumping about energetically and chases Rainer across the room. Thanks to Müller's timely intervention, Rainer managed to accommodate these shocks to his artistic life. Painting is not a violent activity for chimpanzees. They have other means of expressing their brute strength (which should never be underestimated). The fruits of the joint venture give a hint of the great gulf that was glimpsed. Each of the fifteen works presented consists of a chimpanzee painting fixed to the sheet on which Rainer painted his imitation. The chimpanzee's compositions are straightforward and clear. The imitations, on the other hand, are fuzzy, tangled webs of lines, completely illegible, almost to the point of hysteria (illus. 58, 69). Rainer uses the difference to express the impossibility of regaining the (to him sovereign) sense of the unadulterated mark. Each painting bears a

180

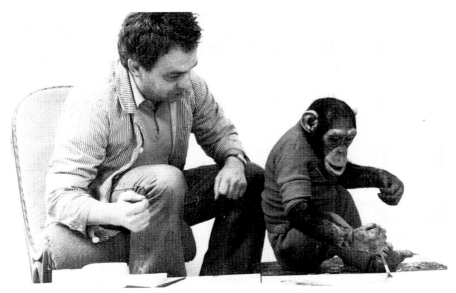

68 The Austrian painter Arnulf Rainer learning from a chimpanzee.

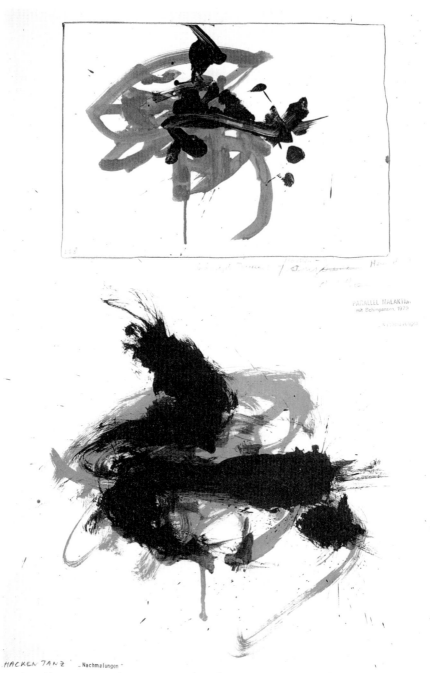

69 Arnulf Rainer, *Hackentanz*, mixed media on paper, 1979. The painting in the upper part of the picture is by a chimpanzee, Lady.

title which, as an attempt to produce poetic effects as well as a mental image, also bears witness to man's loss of the primal pictorial vigour of the marks made by the chimpanzee.

The domination of aesthetic presence and its effects, and formal ideality, reach their apogee of course in painting as opposed to drawing. The fact that painting began to be used in the study of Primates more than half a century after drawing should not be seen as coincidental. Giving painting equipment to a monkey is a more serious cultural act than lending him a pencil, because artistic tradition gives more weight to painting than it does to drawing. This disparity in seriousness is more than just a matter of convention. It is based on the nature of painting as an activity: painting involves a more critical generation of form than does graphic art. The unique quality of painting is the way the gesture is transmuted into 'something formal' immediately and in spectacular fashion. A basic pencil line looks more like just a line than does a brush-stroke. Apes themselves make no bones about it: they prefer painting. However great their indifference to what happens on the paper once the last stroke has been added, the first moment of metamorphosis fascinates them.

This also explains why, unlike drawing, ape painting was labelled as 'art' from the outset. The immediate appropriation of ape painting by the art establishment is one of the most striking aspects of the whole phenomenon. Almost with one voice, the public welcomed Congo's paintings into the art world. A place had been set aside for them, *a priori*, in make-believe culture, even before Desmond Morris rose to his commanding position. The exhibitions in London were responsible for exploiting this fact rather than creating it. Neither the scandal nor the enthusiasm that they aroused would have had any raison d'être if the paintings had not compelled recognition by the artistic establishment, even at the risk of being thrown out *manu militari*. The strength of their claim represented the strength of the pictorial mark, generally endorsed in aesthetic terms whatever its origin. It is interesting to note that the authors who denied the aesthetic dimension of ape art confined their investigations to drawing.

A monkey painting is not a work of art. We can grasp this rationally, but cannot *see* it. Our eye remains attached to the painting as a product. Our ability to attach the formal structure of monkey

paintings to something as specific as a creation whose typically simian motivation is familiar to us does not mean that we can dismiss the aesthetic effects of duration, presence, formal ideality – in short, the illusion of a work of art. It is useless trying to remind ourselves that the forms are nothing more than gestures made visible, and that from the animal's point of view they are devoid of interest. In spite of everything our glance will grant them the same weight as any other work of art. The act of studying these paintings implies lengthy analysis, with the eyes lingering over them; for us these are objects 'to be looked at closely, with one eye, for about an hour', in the words of Marcel Duchamp.[7] This concentration of attention on the painting confers a visual longevity that does not exist for the ape. And in turn hints of ideality begin to emerge from the effect of presence conferred on the painting by the act of contemplation.

It thus turns out to be impossible to get rid of the visual impression that the well-orchestrated forms painted by the ape are the result of deliberate efforts on his part to create a subject for aesthetic contemplation. Of course, the illusion of presence and formal ideality operates even better because the monkey is not trying to look gestural, because he is devoting his effort totally to the game of rendering his gesture visible on the canvas, with no thought for anything else. The strength of the illusion is experienced during analysis itself: it is impossible to make a complete mental recreation of the pictorial gestures, and the order in which they were made, from the shapes visible on the paper. In general it is not feasible to reduce the shapes on the paper to the succession of pictorial acts required to create them. Evidence of the gestural sequence appears right away, the marks manifestly representing a succession of brush-strokes, but these are now fossilised. The paths of the various strokes are muddled and lost in the coloured material. If the spectator tries to follow the pathways, his gaze goes astray, lost in the brush-strokes; Ariadne's thread gets tangled and frayed in these painted marks. This is the way a monkey painting comes to look like a work of art.

The aesthetic perception of monkey art therefore makes it into something of a mixture: nothing that is specifically simian is gained without subsequently getting lost, nothing simian appears unless it is already on its way, muddled and messy with the effects of resemblance. It is as if a particular image of the artist monkey were being kept alive by a kind of persistence of vision in front of the

pictures; it re-animates their flesh by means of this deathless fiction. Beyond a certain level of comprehension the extraordinary attraction exercised by monkey paintings cannot be dissociated from their mixed, paradoxical nature, nor from the total spontaneity of the animal: these attributes are diffracted through the complex exterior of the painting. Our fascination, in other words, begins where the monkey's interest leaves off. The effect of our game of artistic contemplation on his work leaves the monkey cold, just as the monkey's indifference to the finished work remains incomprehensible to us.

References

Introduction

1 D. Morris, *The Biology of Art: A Study of the Picture-making Behaviour of the Great Apes and its Relationship to Human Art* (London, 1962).

2 In his journalistic account of the story of modern art Jean-Louis Ferrier devotes a whole column to the story of Congo. He presents it as a colourful anecdote, a curiosity, evidence of the state of mind of a period long past; it has the out-of-date flavour of an old newsreel, in which long-forgotten events that aroused passionate feeling at the time are rediscovered with amazement. (*L'aventure de l'art au XXe siècle*, Paris, 1988, p. 552).

3 Cf. D. Morris, *op. cit.*, pp. 13-14. See also the catalogue to the exhibition *Paintings by Chimpanzees*, Institute of Contemporary Art, London, 17 September – 21 October 1957.

4 M. Schapiro, 'On Some Problems in the Semiotics of Visual Art. Field and Vehicle in Image-Signs', *Semiotica*, I/3 (1969), pp. 223-42. Schapiro talks about the 'iconic field' in his study of relations between the field and representational signs. The concept also applies to 'non-mimetic elements of the image'. We are dealing solely with the latter here, as monkey painting carries no 'iconic signs', therefore we prefer the expression 'pictorial field'.

5 On the characteristics of the support in mural painting in the Palaeolithic period, see M. Lorblanchet, 'Le Support' in '*L'art pariétal paléolithique. Techniques et méthodes d'études* (Paris, 1993), pp. 69-80. On the materials used by the Palaeolithic painters, see M. Groenen, *Les récentes découvertes d'art sur paroi rocheuse. André Leroi-Gourhan, trente ans après* (Cahier spécial des *Annales d'Histoire de l'Art et d'Archéologie de l'Université de Bruxelles*, 5) (Brussels, in preparation).

6 M. Groenen, in conversation.

7 See W. Kraiker, *Die Malerei der Griechen* (Stuttgart, 1958). One of these objects is reproduced in the catalogue to the exhibition *The Human Figure in Early Greek Art*, Washington, DC, Kansas City, Los Angeles, Chicago and Boston, 1988-9, no. 18. The discovery of a Mycaenian plaque may indicate an earlier origin, but this is not certain because we have no way of knowing how the image was presented. Cf. R. Hampe and E. Simon, *Tausend Jahre Frühgriechische Kunst* (Munich, 1980), pp. 46-9.

8 Schapiro, *op. cit.*

9 H. W. Janson, 'After Betsy, What?', *The Bulletin of the Atomic Scientist*, XV, (1959), p. 71.

10 In another important article, Janson discusses the general question of chance in artistic images in Western tradition: 'The "Image made by Chance" in Renaissance Thought', in M. Meiss, ed., *Essays in Honor of Erwin Panofsky* (New York, 1961), pp. 254-66.

11 The legendary image of the 'acrobat-painter' originates unquestionably from Hokusai himself: the frontispiece to his teaching book (*Yehon Saishiki Tsu*, 1848) is a self-portrait of the painter writing Japanese characters using both hands and both feet at once, in what looks an impossibly contorted position (this engraving is

reproduced at the beginning of J. Hillier's *Hokusai: Paintings, Drawings and Woodcuts*, Oxford, 1978).

12 Cf. J. Hillier, *Hokusai: Paintings, Drawings and Woodcuts* (Oxford, 1978), p. 41. See also H. Focillon, *Hokusai* (Paris, 1914), p. 76. It is notable that Hokusai once painted a picture of a cock and a hen walking beneath the branches of a tree (Hillier, *op. cit.*, p. 98) in which there is a remarkable 'rhyme': the cock's extended foot at the lower edge of the page is echoed at the top in the shape of a leaf. Hokusai's virtuosity had reached a stage when his hand could be replaced by a cock, but it also required the eyes of a master to spot a cock's foot in a maple leaf and vice versa.

13 H. Focillon, 'Eloge de la main', in *Vie des formes, suivi de: Eloge de la main* [1943] (Paris, 1988), p. 122.

14 See T. A. Sebeok, 'Prefigurements of Art' in *Semiotica*, XXVII/1-3 (1979), pp. 3-73; J. Diamond, 'Art of the Wild', *Discovery* (February 1991), pp. 78-85.

15 Cf. W. H. Thorpe, *Animal Nature and Human Nature* (London, 1974).

16 K. Lorenz, *Vergleichende Verhaltensforschung: Grundlagen der Ethologie* (Vienna, 1978).

17 The three preceding paragraphs are adapted from a paper I presented at this colloquium, to be published in a volume being prepared by Brett Cooke and Jan-Baptist Bedaux.

18 I. Eibl-Eibesfeldt and C. Sütterlin, *Im Banne der Angst. Zur Natur -und Kunstgeschichte menschlicher Abwehrsymbolik* (Munich, 1992). By Eibl-Eibesfeldt, see also 'The Biological Foundation of Aesthetics', in I. Rentschler, B. Herzberger and D. Epstein, eds., *Beauty and the Brain: Biological Aspects of Aesthetics* (Basel, 1989), pp. 29-68.

19 E. Dissanayake, *Homo Aestheticus: Where Art Comes from and Why* (New York, 1992); from the same author, see also *What is Art for?* (Seattle, 1989), and 'Chimera, Spandrel or Adaptation. Conceptualizing Art in Human Evolution', in *Human Nature*, VI/2, (1995), (*Bio-aesthetics: Bridging the Gap between Evolutionary Theory and the Arts*), pp. 99-117.

20 A. Alland, *The Artistic Animal: An Inquiry into the Biological Roots of Art* (New York, 1977).

PART I History

1 Conditions and omens

1 Cf. A. H. Schulz, 'The Rise of Primatology in the Twentieth Century', *Folia Primatologica*, XXVI/1, (1972), p. 5-7.

2 A compromise solution between current usage and taxonomic correctness consists in calling the *Pongidae* 'large anthropoids'. For the taxonomy and nomenclature of monkeys I use the synthesis published by Stephen I. Rosen in J. L. Fobes and J. E. King, eds., *Primate Behaviour* (New York, 1982), pp. 23-52.

3 The engraving and Dr Tulp's text, a highly original work, are reproduced with commentary by V. Reynolds, *The Apes: The Gorilla, Chimpanzee, Orangutan and Gibbon, their History and their World* (London, 1968), pp. 42 *et seq.*

4 See Reynolds, *op. cit.*, pp. 47 *et seq.*

5 Janson, *Apes and Ape Lore*, p. 14.

6 Ibid., pp. 18-20.

7 J.-J. Rousseau, *Discours sur l'origine et les fondements de l'inégalité parmi les hommes* (1755), in *Oeuvres complètes*, III, Bibliothèque de la Pléiade (Paris, 1964), p. 210.

8 Cf. Janson, *op. cit.*, pp. 336-7.

9 On representations of the monkey in literature, see H. J. Gerick, *Der Mensch als Affe in der deutschen, französischen, russischen und amerikanischen Literatur des 19. und 20. Jahrhunderts* (Hütgenwald, 1989).

10 W. Köhler, *The Mentality of Apes* [1916] (New York, 1925), pp. 100-01.

11 See R. M. Yerkes, *Chimpanzees: A Laboratory Colony* (New Haven, 1943), pp. 41-53. The main findings of these studies of Japanese macaques are published in Thorpe, *op. cit.*, pp. 242-6.

12 Cited by F. Bourilière, *Zoologie*, Encyclopédie de la Pléiade, 4 (Paris, 1963), p. 979. See also Thorpe, *op. cit.*, p. 301.

13 For a more thorough examination of these questions in the light of phenomenological theory, see M. Groenen, *Leroi-Gourhan. Essence et contingence dans la destinée humaine* (Paris and Brussels, 1996), pp. 137-68.

14 Cf. D. Premack, *The Mind of an Ape* (New York and London, 1983), p. 2.

15 D. Morris, catalogue to the exhibition *Paintings by Chimpanzees*.

16 Cf. Janson, *Apes and Ape Lore*, chapter 10. This book was developed from a note (note 2 of chapter 4) in which Erwin Panofsky set out the main outlines of the question in *Idea. Ein Beitrag zur Begriffsgeschichte der älteren Kunsttheorie* (Leipzig and Berlin, 1924).

17 Cf. Janson, *op. cit.*, p. 309 *et seq.* See also I. Roscoe, 'Mimic without Mind: Singerie in Northern Europe', *Apollo*, CXIV/234 (August 1981), pp. 96-103.

18 A.-M. Lecoq deserves credit for having drawn this fundamental ambiguity to our attention, and for warning of the danger of interpreting the theme too narrowly ('Le Singe de la nature', in the catalogue to the exhibition *La peinture dans la peinture*, Musée des Beaux-Arts, Dijon, 18 December 1982 – 28 February 1983, pp. 45-7).

19 This work is reproduced in the catalogue to the exhibition *Bruegel, une dynastie de peintres*, Palais des Beaux-Arts, Brussels, 18 September – 18 November 1980, no. 207.

20 Roscoe, *op. cit.*, reproduces an engraving by an unknown artist parodying Quentin de La Tour's portrait of Madame de Pompadour: the celebrated model has the head of a monkey.

21 Cf. Janson, *op. cit.*, p. 312.

22 The visual connection between the paintbrush and the phallus is made extremely explicitly, for example, in Edouard Manet's bookplate. Cf. V. I. Stoichita, 'Manet raconté par lui-même (11): la forme du nom', *Annales d'Histoire de l'Art et Archéologie de l'Université de Bruxelles*, XIV, (1992), p. 109.

23 See Roscoe, *op. cit.* See also J.-J. Gerdinge, 'Harmonie et singeries', *Connaissance des Arts*, 356 (October, 1981), pp. 106-11.

24 Cf. Lecoq, *op. cit.* On the history of the painting and its different versions, see the catalogue to the exhibition *Chardin*, Grand Palais, Paris, 29 January – 30 April 1979, pp. 221-4.

25 Watteau's *Monkey Sculptor* is known through copies, one of which is in the Musée des Beaux-Arts, Orléans; cf. P. Rosenberg and E. Camesasca, *Tout l'oeuvre peint de Watteau*, Paris, 1970, pl. VIII. Chardin's artist monkey also had a pendant, the *Monkey Antique Dealer*.

26 Janson, *op. cit.* p. 311. In contexts where iconological correctness is not the main priority the other formula (which reverses the meaning of the image) is the one most often found: the 'monkey painter'. See for example the text accompanying the picture in the catalogue to the *Chardin* exhibition, *op. cit.* The suggestion put forward by E. K. Levy and D. E. Levy ('Monkey in the Middle: Pre-Darwinian Evo-

lutionary Thought and Artistic Creation', in *Perspectives in Biology and Medicine*, XXX/1, Autumn 1986, pp. 95-106) that paintings featuring monkeys (*singeries*) by Breughel, Teniers and Chardin might be interpreted as anticipating evolutionist theories seems to me to be anachronistic and to display a lack of comprehension of the epistemological status of the imagery. It seems revealing also that the authors identified the figures of monkeys in painters' garb in these pictures as 'chimpanzees'.

27 Cf. the autobiographical note by Decamps, *Revue Universelle des Arts*, 4, (1856-7).

28 Cf. D. F. Mosby, *Alexandre-Gabriel Decamps, 1803-1860* (London and New York, 1977), I, pp. 99 and 143-6. The book is well provided with illustrations, including the works mentioned here.

29 Janson, *op. cit.*, p. 314.

30 Brassaï, *Conversations with Picasso* (Paris, 1964), p. 230.

31 Ibid., p. 20.

32 A. Dumas, *Le Capitaine Pamphile* (Paris, 1840), pp. 15 and 18-21.

33 On this subject, see K. Artinger, 'Der Beobachtete Mensch. Gabriel Max' "Affen als Kunstrichter" und Paul Meyerheims "Affenakademie" im Kontext des Anfänge der Anthropologischen Forschung', *Münchner Jahrbuch der Bildenden Kunst*, XLVI (1995), pp. 163-74.

34 Cf. D. Morris and R. Morris, *Men and Apes* (London, 1966), p. 91.

35 Cf. B. Rensch, 'Malversuche mit Affen', *Zeitschrift für Tierpsychologie*, XVIII/3, (1961), p. 347; J. M. Brewster and R. K. Siegel, 'Reinforced Drawing in *Macaca mulatta*', *Journal of Human Evolution*, V (1976), pp. 345-7.

36 E. and J. de Goncourt, *Manette Salomon* (Paris, 1868), I, pp. 202-5.

37 Cf. D. Morris, *The Biology of Art*, p. 56.

38 Ibid., pp. 135-7.

39 A painting by Giovanni Francesco Caroto (?1480- 1555), in the Museo di Castelvecchio, Verona, depicts a young boy proudly showing a very clumsy drawing. This is a very rare instance.

2 Dates to remember

1 H. Coupin, *Singes et singeries. Histoire anecdotique des singes* (Paris, 1907), p. 16. This work reflects one of the mutations with which the history of primatological difference is littered. It consists of a collection of anecdotes designed to 'instruct while entertaining', on the classic theme of the monkey as a 'caricature of man' (p. 7). All the anecdotes, however, are presented from a scientific point of view and are composed of comparisons in which the outlines of the primatologists' ape can be discerned.

2 Ibid, p. 15.

3 R. Garner, *Gorillas and Chimpanzees* (London, 1896), quoted by A. Margoshes, 'The First Chimpanzee Drawings', *The Journal of Genetic Psychology*, CVIII (1966), pp. 55-60. Margoshes is critical of Desmond Morris for omitting Garner's evidence, while himself ignoring the observations made by Henri Coupin twenty years earlier. In history, where facts are always presented sequentially, it is nearly always possible to find a first that pre-dates the first...

4 The results of this study were not published until 1935 (N. Kohts, *Infant Ape and Human Child*, Moscow, 1935). The book, written in Russian, contains a résumé in English that is often quoted in primatological literature.

5 Morris gave prominence to these documents in his own book (*The Biology of Art*, *op. cit.*, pp. 18-20).

6 Köhler, *op. cit.*, p. 198.

7 C. Klüver, *Behaviour Mechanisms in Monkeys* (Chicago, 1933).

8 W. T. Shepherd, 'Some Observations on the Intelligence of the Chimpanzee', *Journal of Animal Behaviour*, V (1915), pp. 391-6.

9 A. Sokolowski, *Erlebnisse mit wilden Tiere* (Leipzig, n.d.), p. 33. As far as I know, this illustration is the first drawing by a non-human primate ever published.

10 W. N. and L. A. Kellog, *The Ape and the Child* (New York, 1933).

11 W. Felce, *Apes: An Account of Personal Experience in a Zoological Garden* (London, 1948), pp. 18-19.

12 P. H. Schiller, 'Figural Preferences in the Drawings of a Chimpanzee', *Journal of Comparative Psychology*, XLIV (1951), pp. 101-11. The Yerkes Laboratories of Primate Biology, established in Florida in 1930, after the closure of the German station in Tenerife, remains one of the world's leading centres for primatological studies.

13 Schiller emphasises the fact that Alpha was never rewarded for her drawing. He also stresses the limited concentration span of the chimpanzee in drawing sessions (a few minutes).

14 L. Hess, *Christine, the Baby Chimp* (London, 1954), p. 31. The book contains photographs of Christine at work, and of two of her paintings.

15 *Collier's* (22 January 1954).

16 *Picture Post* (1 June 1957).

17 Cf. D. Morris, *op. cit.*, p. 26.

18 Ibid, p. 25.

19 Instead of captions, *Picture Post* accompanied its portraits of Betsy at work with imaginary conversations in the first person; the artists expresses her pride in the finished work and boasts of the speed with which she can knock off a painting.

20 Klüver, *op. cit.*, had already obtained drawings and paintings from a capuchin monkey. Nadjeta Kohts obtained the same a few years after B. Rensch in 1958.

21 B. Rensch, 'Ästhetische Faktoren bei Farb- und Formbevorzugungen von Affen', *Zeitschrift für Tierpsychologie*, XIV/1 (1957), pp. 71-99.

22 B. Rensch, 'Die Wirksamkeit ästhetischer Faktoren bei Wirbeltieren', *Zeitschrift für Tierpsychologie*, XV/4 (1958), pp. 447-61.

23 G. T. Fechner, *Vorschule des Ästhetik* (Leipzig, 1876).

24 Rensch, *op. cit.*, pp. 458-9.

25 Rensch, 'Malversuche mit Affen'.

26 Cf. Rensch, 'Uber ästhetische Faktoren im Erleben höherer Tiere', *Naturwissenschaft und Medizin*, IX, (1965), pp. 43-57; 'Asthetische Grundprinzipien bei Mensch und Tier', in *Kreatur Mensch. Moderne Wissenschaft auf der Suche der Humanum* (Munich, 1969), pp. 134-44. 'Play and Art in Apes and Monkeys', *Symposia of the Fourth International Congress of Primatology*, I, (1973), pp. 102-23.

27 Cf. Rensch, 'Uber ästhetische Faktoren im Erleben höherer Tiere', pp. 143-4. Subsequently Rensch extended his reflections to the biological and psychological roots of human aesthetics, publishing, in 1984, a systematic study of art as such (*Psychologische Grundlagen der Wertung bildender Kunst*, Essen, 1984).

28 Cf. H. Goja, 'Zeichenversuche mit Menschenaffen', *Zeitschrift für Tierpsychologie*, XVI, (1959), pp. 369-73.

29 On the paintings of Desmond Morris, see P. Oakes, *The Secret Surrealist: The Paintings of Desmond Morris* (Oxford, 1987). A recent retrospective exhibition has provided a complete overview of his work: cf. catalogue to the exhibition *Desmond*

Morris: 50 Years of Surrealism, text by S. Levy, City Museum and Art Gallery, Stoke on Trent, and Wollaton Hall, Nottingham, 1996.

30 D. Morris, *Animal Days* (New York, 1986), p. 114.

31 Morris, *The Biology of Art*, p. 26.

32 Morris was obviously familiar with the classic theme of the artist monkey. He says nothing on the subject in *The Biology of Art*, but devotes several paragraphs to it in *Men and Apes*, using it as a background to his response to criticism and negative responses to his enterprise (*op. cit.*, pp. 42-5).

33 See Morris, *The Biology of Art*, pp. 45-58 and 158. More recently, R. A. Gardner and B. T. Gardner have discussed the question of this method in contrast to the traditional behaviourist method ('Feedforward versus Feedback: An Ethological Alternative to the Law of Effect', *Behavioural and Brain Sciences*, XI, 1988, pp. 429-93).

34 Morris, *Animal Days*, p. 199.

35 Cf. K. J. Hayes, 'The Cultural Capacity of a Chimpanzee', *Human Biology*, XXVI, (1954), pp. 288-303.

36 Morris, *op. cit.*, p. 199.

37 D. Morris, *The Story of Congo* (London, 1958).

38 D. Morris, 'Pictures by Chimpanzees', *The New Scientist* (14 August 1958), pp. 606-11; 'Primate's Aesthetics', *Natural History*, LXX/1, (January 1961), pp. 22-9; 'The Behaviour of Higher Primates in Captivity', *Proceedings of the XVth International Congress of Zoology* (1958), section 1, p. 34.

39 P. Oakes, 'Young man at the Zoo', *Punch* (7 February 1962). The author of this article later wrote the introduction to the book on Desmond Morris' painting mentioned above.

40 Morris, *Animal Days*, p. 202.

41 When the book appeared in 1962, a critic on the *New York Herald Tribune* announced: 'A foul, cruel and possibly fatal blow is struck at action-painting in this book by Desmond Morris, curator of mammals at the London Zoo' (12 August 1962).

42 Quoted by G. Geffroy, *Claude Monet, sa vie et son oeuvre* (Paris, 1924), p. 77.

43 *The New York Times Magazine* (6 October 1957).

44 *The Daily Worker* (17 September 1957), and *The Daily Telegraph*, same date.

45 *The Times* (17 September 1957).

46 *The Daily Sketch* (17 September 1957).

47 *The New York World-Telegram* (28 September 1962).

48 Reported by Fernande Olivier, *Picasso et ses amis* (Paris, 1933), p. 99. Helen Kay informs us that the monkey was called Monica (*Picasso et le monde des enfants*, Paris-Grenoble, 1965). On Picasso's painting by Congo, reproduced in *The Biology of Art*, see Morris, *Animal Days*, p. 204.

49 Morris, *op. cit.*, p. 201.

50 Herbert Read was one of the few critics to take a genuine interest in monkey painting. He wrote that it represented an important discovery that must certainly affect the philosophy of art in the future. ('Ape Art', *The Studio*, CLXIII/829, May 1962, p. 173.)

51 This exhibition was held at Rotterdam Zoo, where a chimpanzee and big Sophie had won fame. The accompanying booklet gave a very good account of the current state of affairs (*Apenexpressies*, Introduction by C. Feekes and G. J. Boeckenschoten, Rotterdam Zoo, n.d.).

52 Presented in a benign spirit by the *Association pour le Progrès Intellectuel et Artistique de la Wallonie*, the exhibition aroused some hysterical reactions.

53 See, for example, H. S. Terrace, *Nim* (London, 1980); M. K. Temerlin, *Lucy Growing Up Human. A Chimpanzee Daughter in a Psychotherapist's Family* (New York, 1975); C. J. Kirby and C. J. Mahoney, 'The Concept of Kindergarten for Infant Chimpanzees (*Pan troglodytes*) in a Biomedical Facility', *American Journal of Primatology*, XX (1990), pp. 169-248, (Abstracts of Papers to be Presented at the Thirteenth Meeting of the American Society of Primatologists, 11-14 July, 1990, University of California, Davis).

54 Cf. Sebeok, *op. cit.*; A. Whiten, 'Primate Perception and Aesthetics', in D. R. Brothwell, ed., *Investigations into the Nature of Visual Art* (London, 1976), pp. 18-40.

55 Cf. S. T. Boysen, G. G. Bernston and J. Prentice, 'Simian Scribbles: A Reappraisal of Drawing in the Chimpanzee (*Pan troglodytes*)', *Journal of Comparative Psychology*, CI/1 (1987), pp. 82-9; D. A. Smith, 'Systematic Study of Chimpanzee Drawing', *Journal of Comparative and Physiological Psychology*, LXXXII/3 (1973), pp. 406-14.

56 Cf. Morris, *The Biology of Art*, pp. 135-7.

57 *Sciences et nature/ Natura Oggi*, I (May 1990), pp. 64-5.

58 Cf. M. Vancatova, Z. Jerabkova and L. A. Fistov, 'Orangutan Picture-making in Zoo Usti Nad Labem', abstract of the paper presented at the international conference *Primate Ontogeny*, Trest, Czech Repubic, September 1995.

59 Cf. I. Schretlen, 'Kijk op krabbels', *VU Magazine*, Amsterdam (December 1990), pp. 18-27.

60 Cf. the paper 'Van Krabbel tot Kunst. Op zoek naar de biologische oorsprong van de creativeteit', *Wetenschap, Cultuur en Samenleving* (January-February 1995).

61 There is another, persistent lacuna with regard to gibbons, far less frequently studied in captivity than the other large anthropoids: to my knowledge, no study exists of their drawing or painting abilities.

62 The painting session specially organised for the BBC team in Morris' documentary lasts for only two or three seconds: the bonobos were not very inspired that day.

63 Cf. D. H. Henley, 'Facilitating Artistic Expression in Captive Mammals: Implications for Art Therapy and Empathicism', *Art Therapy, Journal of the American Art Therapy Association*, IX/4 (1992), pp. 178-82. It is worth pointing out that this paper, which makes no distinction in the use of the word 'art', whether it is applying it to animals or to humans, places the fieldwork (in itself very interesting) in a conceptual framework which is conceptually very weak; I have drawn attention to this weakness in my article *Animal Aesthetics and Human Art*, in B. Cooke and J. -B. Bedeau, eds., *Sociobiology and the Arts* (Rodopi, Amsterdam, in preparation).

64 Cf. *Le Soir* [Belgium] (26 January 1995); *Femme actuelle* [France], no. 560 (19-25 June 1995).

65 'Thirty paintings were sold and made more than fifty thousand francs. According to the experts, their value will increase. Really. These must be the only rising values in the wilderness, the fraud and eyewash of modern art. All you need to do is to pop in to the FIAC [Foire Internationale d'Art Contemporain] or any of the upmarket galleries to realise that the successors to Picasso or Kandinsky have four feet and an attractive reddish coat (...)' (Ph. Cusin, 'Le singe au pinceau', in *Le Figaro*, 6 March 1995).

66 *Congo*, directed by Frank Marshall (after the novel by Michael Crichton), 1995.

67 Heather Busch and Kenneth Silver, *Why Cats Paint: The Theory of Feline Aesthetics* (Ten Speed Press, Berkeley, CA, 1994).

68 In correspondence with the author, 19 September 1996.

PART 2 Aesthetics

1 The game of the disruptive mark

1 Greg, *Achille Talon et le quadrumane optimiste* (Paris, n.d.), pp. 17-22.
2 Cf. Morris, *The Biology of Art*, p. 80.
3 Ibid., pp. 84-5.
4 E. H. Gombrich, *The Sense of Order* (New York, 1979), p. 13. Gombrich was the only major art historian to welcome monkey painting entirely positively.
5 Cf. the catalogue to the exhibition *The Lost Image: Comparisons in the Art of Higher Primates*, Introduction by Mervyn Levy, Royal Festival Hall, London. 15 September – 12 October 1958. See also M. Levy, 'Chimpanzee Painting: The Roots of Art', *The Studio*, CLXI/818 (June 1961), pp. 203-7.
6 M. Levy, 'Dalí, the Quantum Gun at Port Lligat', *The Studio*, CLXII/821 (September 1961), pp. 83-5. Before making this declaration (carefully transcribed in italics), Dalí had given a truly Dalí-esque slant to proceedings: he announced that he had in his possession some paintings by sea urchins which were soon to be exhibited in New York, adding that whereas only a few chimpanzees knew how to paint, *all* sea urchins were born artists.
7 See for example D. Morris, *The Naked Ape* (London 1967), p. 29 *et seq*; J.-J. Petter, 1984 (33), chapter 4: '*Le triomphe de la vision*'; J. L. Fobes and J. E. King, *Primate Behaviour*, chapter 6: '*Vision: The Dominant Primate Modality*'.
8 See J. Sparks, 'Allogrooming in Primates: A Review', in D. Morris, ed., *Primate Ethology* (London, 1967), pp. 148-75.
9 Holding the implement in the right hand is the norm: monkeys find ambidexterity easier than humans, but in general prefer using the right hand.
10 See Morris, *The Biology of Art*, pp. 90 *et seq*.
11 Ibid., p. 22.
12 Morris's study was constructed around the twin notions of calligraphy and composition, defined by him as the two essential components of monkey art.
13 Ibid., p. 22.
14 Cf. D. Morris, 'The Behaviour of Higher Primates in Captivity', *Proceedings of the XVth International Congress of Zoology* (1958), section 1, p. 34.
15 See W. H. Thorpe, 'Ritualization in Ontogeny: 1. Animal Play', in J. Huxley, ed., *A Discussion on Ritualization of Behaviour in Animals and Man*, Philosophical Transactions of the Royal Society of London, Series B., Biological Sciences, no. 772/251 (29 December 1966), pp. 247-526; on play in monkeys, see especially P. Dolhinow, 'At Play in the Fields', *Natural History*, LXXX/10 (December 1971), pp. 66-71; S. J. Suomi and H. F. Harlow, 'Monkeys at Play', pp. 72-6; C. Loizos, 'Play Behaviour in Higher Primates: A Review', in D. Morris, *Primate Ethology*, pp. 176-218.
16 Cf. Vancatova, *op. cit.*
17 Cf. Hess, *op. cit.*, p. 31. Another chimpanzee, little Viki, also used to play this game (cf. Hayes, *op. cit.* p. 49). See also Karl Groos, quoted by Roger Caillois, on the subject of 'destructive tendencies in the capuchin monkey', *Les jeux et les hommes* (Paris, 1967), pp. 76-8, 344.
18 Cf. Morris, *The Biology of Art*, p. 135, fig. 47.
19 W. N. Kellog and L. A. Kellog, *The Ape and the Child*, p.41.
20 L. Van Elsacker in a letter to the author, October, 1996. The gesture of spreading the shreds of wood wool with a sideways movement of the hand is reminiscent of the gesture used by chimpanzees to flatten the coat during grooming. Since grooming is one of the activities that uses the eye-hand axis to the fullest extent, it is not

surprising that the operational systems deriving from it should recur in the explora-
tory games of the larger anthropoids. H.S.R. Glaser has highlighted a case in which
the motor patterns of grooming were transposed to the act of scribbling ('Differen-
tiation of Scribbling in a Chimpanzee', in *Proceedings of the Third Congress of Pri-
matology* [Zürich], III, 1970, pp. 142-9).

21 Cf. Rensch, 'Malversuche mit Affen', p. 362; Smith, *op. cit.*; Boyen, Bernston and
Prentice, *op. cit.*

22 Note the all-embracing nature of the idea of disruption: theoretically, it would be
possible to be aware of order without any consciousness of disorder, but the reverse
would not be possible.

23 Cf. Morris, *op. cit.*, p. 70.

24 Ibid., pp. 94-102.

25 Morris, *Animal Days*, p. 199.

26 Morris, *The Biology of Art*, p. 97.

27 R. Kellogg, *Analyzing Children's Art* (Palo Alto, 1970), p. 88. The author also
stresses the absence of secondary combinations in the drawing of the anthropoid
apes.

28 Cf. Morris, *The Biology of Art*, pp. 115-40. R. Kellogg calls the forms that are more
sophisticated than the most basic '*scribbles*', '*diagrams*': 'diagrams' represent an
refinement of the basic formal pattern, as, for example, a well-shaped cross or a
circle. '*Combines*' are a combination of two diagrams (for example, a cross inscribed
in a circle). After that come the '*aggregates*', third degree forms obtained by
combining several '*diagrams*' or '*combines*' (four small circles in a large circle, a
cross with eight points in a square etc.). These '*aggregrates*' constitute the basis of
'*pictorials*', in which there is explicit graphic symbolisation.

29 Ibid., fig. 45.

30 Ibid., fig. 47.

31 Ibid., fig. 48.

32 Cf. Rensch, *op. cit.*, p. 348.

33 Alland, *op. cit.*, fig. 4.

34 This notion concerning the spatialisation of the field appeared in an article: 'La
peinture des singes: une approche critique à la lumière de la théorie de l'art', *Cahiers
d'éthologie*, XII/4 (1992), pp. 529-42.

35 See the books on the subject, already quoted, by W. Köhler, W. N. and L. A.
Kellog, C. Hayes, M. K. Temerlin and W. Felce. See also F. Patterson, 'Self-
awareness in the Gorilla Koko', *Journal of the Gorilla Foundation*, XIV/2 (1991),
pp. 2-5.

36 Cf. R. K. Davenport and C. M. Rogers, 'Perception of Photographs by Apes',
Behaviour, XXXIX (1971), pp. 318-20.

37 Hayes, *op. cit.*, chapter 11 ('The Very Strange Story of the Imaginary Toy').
Francine Patterson also tells of a moment when the famous female gorilla, Koko,
realised she was being watched and stopped playing; she had been talking to a
collection of stuffed animals using ASL ('Self-awareness in the Gorilla Koko', *op.
cit.*, p. 4).

38 Cf. Fobes and King, eds., *Primate Behaviour*, p. 382.

39 Felce, *op. cit.*, p. 42.

40 For a general survey of the research into communication by signing amongst apes,
see especially R. A. Gardner, B. T. Gardner and T. E. Van Cantfort, eds., *Teaching
Sign Language to Chimpanzees* (New York, 1981); E. Linden, *Apes, Men and
Language* (Harmondsworth, 1981); T. A. and J. Sebeok, *Speaking of Apes: A*

Critical Anthology of Two-Way Communication with Man (London and New York, 1980).

41 Cf. R. A. and B. T. Gardner, 'Comparative Psychology and Language Acquisition', *Annals of the New York Academy of Sciences*, CCCIX (1978), pp. 37-76.

42 Cf. K. Beach, R. S. Fouts and D. A. Fouts, 'Representational Art in Chimpanzees', *Friends of Washoe*, III/4 (1984), pp. 2-4. This article is a pre-publication of the authors' research project.

43 Cf. Premack and Premack, *op. cit.*, p. 94.

44 Cf. G. Y. Thomas and A.M.J. Silk, *An Introduction to the Psychology of Children's Drawings* (New York, London, Toronto, Sydney and Tokyo, 1990), p. 35.

45 The paragraphs that follow, to the end of the chapter, are adapted from an article: 'Ape Painting and the Problem of the Origin of Art', *Human Evolution*, X/3 (1995), pp. 205-15.

46 Although the interpretation proposed here clearly contradicts the idea of expressive intention in ape painting, it does not exclude the aesthetic aspect of their intention. In fact, the game of the disruptive mark, as practised by subjects of research like Congo or others, complies with the formal characteristics of the pictorial field, which means more than showing constraint towards a preference for pre-marked patterns, recognised as 'good figures'. I therefore do not agree with D. A. Smith (*op. cit.*) who, although rightly doubting the expressive intention of chimpanzees, goes too far in refusing to consider ape painting from an aesthetic point of view.

47 The ability shown by chimpanzees to distinguish between an object and the name of that object is certainly a remarkable fact (cf. Premack and Premack, *op. cit.*, pp. 29-31), but it is in no way equivalent to the development of a meta-language.

48 D. M. Rumbaugh, E. S. Savage-Rumbaugh and J. L. Scanlon, 'The Relationship between Language in Apes and Human Beings', in Fobes and King, *op. cit.*, p. 362.

49 Ibid., p. 383.

50 I have discussed an approach to this question elsewhere: 'Esthétique et différence anthropologique', in *Critique et différence*, Actes du XXIIIe Congrès de l'Association des Sociétés de Philosophie de Langue Française (Hammamet, Tunisia, 1994), pp. 563-7.

51 Seen on Canal +, 9 October 1996.

2 What is a monkey painting?

1 J. Huxley, 'The Origins of Human Drawing', *Nature*, CXLII/3788 (1942), p. 637.

2 R. Rosenblum, 'The Origin of Painting: A Problem in the Iconography of Romantic Classicism', *The Art Bulletin*, XXXIX (December 1957), pp. 279-94.

3 It is not certain that the gorilla realised that this shadow was its own, although this is not completely unthinkable. A study of the use of the mirror concluded that gorillas, in contrast to chimpanzees and orang-utans, are incapable of recognising themselves in the mirror (S. D. Suarez and G. G. Gallup, 'Self-Recognition in Chimpanzees and Orangutans, but not Gorillas', *Journal of Human Evolution*, X, 1981, pp. 175-88). But Francine Patterson (*op. cit.*) maintains the opposite position on the basis of numerous recorded observations: Koko could perfectly well recognise her own image in the mirror; it is true that Koko was a virtuoso user of ASL, but there is nothing to prove that her education was a *sine qua non* of her ability for self-recognition.

4 Köhler, *op. cit.*, pp. 79-80.

5 Jared Diamond's conclusion seems to be particularly unfortunate: 'If the ancestors of

wild chimps had had more leisure time, chimps today would be painting.' (*op. cit.*, p. 85). When in zoos, chimpanzees are forced to have time to play with a pictorial device, they do so in their own special way, a way showing clearly that it is not just time that is necessary to invent painting.

6 Cf. catalogue to the exhibition *Arnulf Rainer. Nachmalungen, Kopien von Schimpansenmalereien*, Galerie Ulysses, Vienna, 1979, pp. 183-7; cat. exp. *Arnulf Rainer*, Berlin, Baden-Baden, Bonn and Vienna, 1981; See also A. Rainer, *Primate. Portraits, Persiflagen, Paraphrasen, Parallelen* (Cologne, 1991).

7 The phrase is to be found on a work of 1918, in MOMA, and serves as its title.

Bibliography

1 Books

Alexander Alland, *The Artistic Animal: An Inquiry into the Biological Roots of Art* (New York, 1977)

Pons-Augustin Alletz, *Histoire des singes et autres animaux curieux, dont l'instinct et l'industrie excitent l'admiration des hommes* (Paris, 1752)

Brassaï, *Conversations avec Picasso* (Paris, 1964)

Heather Busch and Kenneth Silver, *Why Cats Paint: A Theory of Feline Aesthetics* (Ten Speed Press, Berkeley, CA, 1994)

Roger Caillois, *Les jeux et les hommes* (Paris, 1967)

Henri Coupin, *Singes et singeries. Histoire anecdotique des singes* (Paris, 1907)

Ellen Dissanayake, *Homo Aestheticus: Where Art Comes from and Why* (New York, 1992)

–, *What is Art for?* (Seattle, 1989)

Alexandre Dumas, *Le Capitaine Pamphile* (Paris, 1840)

G. T. Fechner, *Vorschule des Aesthetik* (Leipzig, 1876)

Winifred Felce, *Apes: An Account of Personal Experiences in a Zoological Garden* (London, 1948)

Jean-Louis Ferrier, *L'aventure de l'art au XXe siècle* (Paris 1988)

J. L. Fobes and J. E. King, eds., *Primate Behaviour* (New York, 1982)

Henri Focillon, *Hokusai* (Paris, 1914)

R. A. Gardner and T. E. Van Cantfort, eds., *Teaching Sign Language to Chimpanzees* (New York, 1981)

R. Garner, *Gorillas and Chimpanzees* (London, 1896)

Gustave Geffroy, *Claude Monet, sa vie et son oeuvre* (Paris, 1924)

H. J. Gerick, *Der Mensch als Affe in der deutschen, französischen, russischen und amerikanischen Literatur des 19. und 20. Jahrhunderts* (Hütgenwald, 1989)

E. H. Gombrich, *The Sense of Order* (New York, 1979)

Edmond and Jules de Goncourt, *Manette Salomon* (Paris, 1868)

Greg, *Achille Talon et le quadrumane optimiste*, (Paris, n.d.)

Marc Groenen, *Leroi-Gourhan. Essence et contingence dans la destinée humaine* (Paris and Brussels, 1996)

–, *Les récentes découvertes d'art sur paroi rocheuse. André Leroi-Gourhan, trente ans après* (= Cahier spécial des *Annales d'Histoire de l'Art et d'Archéologie de l'Université de Bruxelles*, 5) (Brussels, in preparation)

R. Hampe and E. Simon, *Tausend Jahre frühgriechische Kunst: 1600 – 600* (Munich, 1980)

Cathy Hayes, *The Ape in our House* (New York, 1951)

Irenäus Eibl-Eibesfeldt and Christa Sütterlin, *Im Banne der Angst. Zur Natur- und Kunstgeschichte menschlicher Abwehrsymbolik* (Munich, 1992)

Lilo Hess, *Christine, the Baby Chimp* (London, 1954)

J. Hillier, *Hokusai: Paintings, Drawings and Woodcuts* (Oxford, 1978)

H. W. Janson, *Apes and Ape Lore in the Middle Ages and the Renaissance* (London, 1952)

Helen Kay, *Picasso et le monde des enfants* (Paris-Grenoble, 1965)

W. N. and L. A. Kellog, *The Ape and the Child* (New York, 1933)

Rhoda Kellogg, *Analyzing Children's Art* (Palo Alto, 1970)

C. Klüver, *Behaviour Mechanisms in Monkeys* (Chicago, 1933)

Wolfgang Köhler, *The Mentality of Apes* (New York, 1925)

Nadjeta Kohts, *Infant Ape and Human Child* (Moscow, 1935)

W. Kraiker, *Die Malerei der Griechen* (Stuttgart, 1958)

Eugene Linden, *Apes, Men and Language* (Harmondsworth, 1981)

Konrad Lorenz, *Vergleichende Verhaltensforschung: Grundlagen der Ethologie* (Vienna, 1978)

Desmond Morris, *Animal Days* (New York, 1980)

–, *The Biology of Art: A Study of the Picture-making Behaviour of the Great Apes and its Relationship to Human Art* (London, 1962)

–, *The Naked Ape* (London, 1967)

–, *The Story of Congo* (London, 1958)

–, ed., *Primate Ethology* (London, 1967)

– and Ramona Morris, *Men and Apes* (London, 1966)

D. F. Mosby, *Alexandre-Gabriel Decamps, 1803-1860* (London and New York, 1977)

Philip Oakes, *The Secret Surrealist: The Paintings of Desmond Morris* (Oxford, 1987)

Fernande Olivier, *Picasso et ses amis* (Paris, 1933)

Erwin Panofsky, *Idea. Ein Beitrag zur Begriffsgeschichte der älteren Kunsttheorie* (Leipzig and Berlin, 1924)

Jean-Jacques Petter, *Le propre du singe* (Paris, 1984)

D. Premack and A. J. Premack, *The Mind of an Ape* (London and New York, 1983)

Bernhard Rensch, *Psychologische Grundlagen der Wertung bildender Kunst* (Essen, 1984)

Vernon Reynolds, *The Apes: The Gorilla, Chimpanzee, Orangutan and Gibbon, their History and their World* (London, 1968)

Pierre Rosenberg and Ettore Camesasca, *Tout l'oeuvre peint de Watteau* (Paris, 1970)

Jean-Jacques Rousseau, *Discours sur l'origine et les fondements de l'inégalité parmi les hommes* (1755), in *Oeuvres complètes*, III, Bibliothèque de la Pléiade (Paris, 1964)

T. A. Sebeok and J. Sebeok, *Speaking of Apes: A Critical Anthology of Two-Way Communication with Man* (London and New York, 1980)

Alexander Sokolowsky, *Erlebnisse mit wilden Tiere* (Leipzig, n.d.)

M. K. Temerlin, *Lucy Growing Up Human: A Chimpanzee Daughter in a Psychotherapist's Family* (New York, 1975)

H. S. Terrace, *Nim* (London, 1980)

G. Y. Thomas and A.M.J. Silk, *An Introduction to the Psychology of Children's Drawings* (New York, London, Toronto, Sydney and Tokyo, 1990)

W. H. Thorpe, *Animal Nature and Human Nature* (London, 1974)

R. M. Yerkes, *Chimpanzees. A Laboratory Colony* (New Haven, CT, 1943)

Zoologie, Encyclopédie de la Pléiade, IV (Paris, 1963)

2 Articles

Kai Artinger, 'Der Beobachtete Mensch. Gabriel Max' "Affen als Kunstrichter" und Paul Meyerheims "Affenakademie" im Kontext des Anfänge der Anthropologischen Forschung', *Münchner Jahrbuch der Bildenden Kunst*, XLVI (1995), pp. 163-74

K. Beach, R. S. Fouts and D. H. Fouts, 'Representational Art in Chimpanzees', *Friends of Washoe*, III/4 (1984), pp. 2-4

S. T. Boysen, G. G. Bernston and J. Prentice, 'Simian Scribbles: A Reappraisal of Drawing in the Chimpanzee (*Pan troglodytes*)', *Journal of Comparative Psychology*, CI/1 (1987), pp. 82-9

J. M. Brewster and R. K. Siegel, 'Reinforced Drawing in *Macaca mulatta*', *Journal of Human Evolution*, V (1976), pp. 345-7

R. K. Davenport and C. M. Rogers, 'Perception of Photographs by Apes', *Behaviour*, XXXIX (1971), pp. 318-20

Alexandre-Gabriel Decamps, 'Notice Autobiographique', *Revue Universelle des Arts*, IV (1856-7)

J. Diamond, 'Art of the Wild', *Discovery* (February 1991), pp. 78-85

Ellen Dissanayake, 'Chimera, Spandrel or Adaptation. Conceptualizing Art in Human Evolution', in: *Human Nature*, VI/2 (1995) (*Bio-aesthetics: Bridging the Gap between Evolutionary Theory and the Arts*), pp. 99-117

P. Dolhinow, 'At Play in the Fields', *Natural History*, LXXX/10 (December 1971), pp. 66-71

H. Focillon, *Vie des formes, suivi de: Eloge de la main* [1943] (Paris, 1988)

R. A. Gardner and B. T. Gardner, 'Comparative Psychology and Language Acquisition', *Annals of the New York Academy of Sciences*, CCCIX (1978), pp. 37-76

–, 'Feedforward versus Feedbackward: An Ethological Alternative to the Law of Effect', *Behaviour and Brain Sciences*, XI (1988), pp. 429-93

J.-J. Gerdinge, 'Harmonie et singeries', *Connaissance des Arts*, 356 (October 1981), pp. 106-11

H.S.R. Glaser, 'Differentiation of Scribbling in a Chimpanzee', in *Proceedings of the Third Congress of Primatology* (Zürich), III (1970), pp. 142-9

Herman Goja, 'Zeichenversuche mit Menschenaffen', *Zeitschrift für Tierpsychologie*, XVI (1959), pp. 369-73

K. J. Hayes, 'The Cultural Capacity of a Chimpanzee', *Human Biology*, XXVI (1954), pp. 288-303

D. H. Henley, 'Facilitating Artistic Expression in Captive Mammals: Implications for Art Therapy and Empathicism', *Art Therapy, Journal of the American Art Therapy Association*, IX/4 (1992), pp. 178-82

Irenäus Eibl-Eibesfeldt, 'The Biological Foundation of Aesthetics', in I. Rentschler, B. Herzberger and D. Epstein, eds., *Beauty and the Brain: Biological Aspects of Aesthetics* (Basel, 1989), pp. 29-68

C. J. Kirby and C. J. Mahoney, 'The Concept of Kindergarten for Infant Chimpanzees (*Pan troglodytes*) in a Biomedical Facility', *American Journal of Primatology*, XX (1990), pp. 169-248 (Abstracts of Papers to be Presented at the Thirteenth Meeting of the American Society of Primatologists, 11-14 July 1990, University of California, Davis)

E. K. Levy and D. E. Levy, 'Monkey in the Middle: Pre-Darwinian Evolutionary Thought and Artistic Creation', in *Perspectives in Biology and Medicine*, XXX/1 (Autumn 1986), pp. 95-106

J. H. Huxley, 'The Origins of Human Drawing', *Nature*, CXLII/3788 (1942), p. 637

H. W. Janson, 'After Betsy, What?', *The Bulletin of the Atomic Scientist*, XV (1959), pp. 68-71

–, 'The "Image Made by Chance" in Renaissance Thought', in: M. Meiss, ed., *Essays in Honor of Erwin Panofsky* (New York, 1961), pp. 254-66

Anne-Marie Lecoq, 'Le Singe de la nature', in *La peinture dans la peinture, Musée des Beaux-Arts de Dijon*, exhibition catalogue, 18 December 1982 – 28 February 1983, pp. 45-7

Thierry Lenain, 'Ape Painting and the Problem of the Origin of Art', *Human Evolution*, X/3 (1995), pp. 205-15

–, 'La peinture des singes: une approche critique à la lumière de la théorie de l'art', *Cahiers d'Ethologie*, XII/4 (1992), pp. 529-42

–, 'Esthétique et différence anthropologique', in *Critique et différence*, Actes du XXIIIe Congrès de l'Association des Sociétés de Philosophie de Langue Française (Hammamet, Tunisia, 1994), pp. 563-7

E. K. Levy and D. E. Levy, 'Monkey in the Middle: Pre-Darwinian Evolutionary Thought and Artistic Creation', *Perspectives in Biology and Medicine*, XXX/1 (Autumn 1986), pp. 95-106

Mervyn Levy, 'Chimpanzee Painting: The Roots of Art', *The Studio*, CLXI/818 (June 1961), pp. 203-7

–, 'Dali, the Quantum Gun at Port Lligat', *The Studio*, CLXII/821 (September 1961), pp. 83-5

Caroline Loizos, 'Play Behaviour in Higher Primates: A Review', in D. Morris, ed., *Primate Ethology* (London, 1967), pp. 176-218

M. Lorblanchet, 'Le support', in : *L'art pariétal paléolithique, Techniques et méthodes d'études*, Paris, 1993, pp. 69-80

A. Margoshes, 'The First Chimpanzee Drawings', *The Journal of Genetic Psychology*, CVIII (1966), pp. 55-6

Desmond Morris, 'Pictures by Chimpanzees', *The New Scientist*, XIV (August 1959), pp. 606-11

–, 'Primate's Aesthetics', *Natural History*, LXX/1 (January 1961), pp. 22-9

–, 'The Behaviour of Higher Primates in Captivity', *Proceedings of the XVth International Congress of Zoology* (1958), section 1, p. 34

Philip Oakes, 'Young man at the Zoo', *Punch* (7 February 1962)

F. Patterson, 'Self-awareness in the Gorilla Koko', *Journal of the Gorilla Foundation*, XIV/2 (1991), pp. 2-5

Herbert Read, 'Ape Art', *The Studio*, CLXIII/829 (May 1962), pp. 172-3

Bernhard Rensch, 'Aesthetische Faktoren bei Farb- und Formbevorzugungen von Affen', *Zeitschrift für Tierpsychologie*, XIV/1 (1957), pp. 71-99

–, 'Aesthetische Grundprinzipien bei Mensch und Tier', in *Kreatur Mensch. Moderne Wissenschaft auf der Zuche der Humanum* (Munich, 1969), pp. 134-44

–, 'Die Wirksamkeit ästhetischer Faktoren bei Wirbeltieren', *Zeitschrift für Tierpsychologie*, XV/4 (1958), pp. 447-61

–, 'Malversuche mit Affen', *Zeitschrift für Tierpsychologie*, XVIII/3 (1961), pp. 347-64

–, 'Play and Art in Apes and Monkeys', *Symposia of the Fourth International Congress of Primatology*, I (1973), pp. 102-23

–, 'Uber ästhetische Faktoren im Erleben höhere Tiere', *Naturwissenschaft und Medizin*, IX (1965), pp. 43-57

Ingrid Roscoe, 'Mimic without Mind: Singerie in Northern Europe', *Apollo*, CXIV/234 (August 1981), pp. 96-103

Robert Rosenblum, 'The Origin of Painting: A Problem in the Iconography of Romantic Classicism', *The Art Bulletin*, XLIX (December 1957), pp. 269-94

Meyer Schapiro, 'On Some Problems in the Semiotics of Visual Art. Field and Vehicle in Image-Signs', *Semiotica*, I/3 (1969), pp. 223-42

P. H. Schiller, 'Figural Preferences in the Drawings of a Chimpanzee', *Journal of Comparative Psychology*, XLIV (1951), pp. 101-11

A. H. Schultz, 'The Rise of Primatology in the Twentieth Century', *Folia Primatologica*, XXVI/1 (1972), pp. 5-7

T. A. Sebeok, 'Prefigurements of Art', *Semiotica*, XXVII/1-3 (1979), pp. 3-73

W. T. Shepherd, 'Some Observations on the Intelligence of the Chimpanzee', *Journal of Animal Behaviour*, V (1915), pp. 391-6

D. A. Smith, 'Systematic Study of Chimpanzee Drawing', *Journal of Comparative and Physiological Psychology*, LXXXII/3 (1973), pp. 406-14

J. Sparks, 'Allogrooming in Primates: A Review', in D. Morris, ed., *Primate Ethology* (London, 1967), pp. 148-75

V. I. Stoichita, 'Manet raconté par lui-même (II): la forme du nom', *Annales d'Histoire de l'Art et Archéologie de l'Université de Bruxelles*, XIV (1992), pp. 95-110

S. D. Suarez and G. G. Gallup, 'Self-Recognition in Chimpanzees and Orangutans, but not Gorillas', *Journal of Human Evolution*, X (1981), pp. 175-88

J. Suomi and H. F. Harlow, 'Monkeys at Play', *Natural History*, LXXX/10 (December 1971), pp. 72-6

W. H. Thorpe, 'Ritualization in Ontogeny: 1. Animal Play', in J. Huxley, ed., *A Discussion on Ritualization of Behaviour in Animals and Man*, Philosophical Transactions of the Royal Society of London, Series B., Biological Sciences, DCCLXXII/251 (29 December 1966), pp. 247-526

Andrew Whiten, 'Primate Perception and Aesthetics', in D. R. Brothwell, ed., *Investigations into the Nature of Visual Art* (London, 1976), pp. 18-40

3 Exhibition Catalogues

Apenexpressies, Introduction by C. Feekes and G. J. Boeckschoten, Rotterdam Zoo, n.d.

Bruegel, une dynastie de peintres, Palais des Beaux-Arts, Brussels, 18 September – 18 November 1980

Chardin, Grand Palais, Paris, 1979

Desmond Morris: 50 Years of Surrealism, text by S. Levy, City Museum and Art Gallery, Stoke on Trent, and Wollaton Hall, Nottingham, 1996

Paintings by Chimpanzees, Institute of Contemporary Art, London, 17 September – 21 October 1957

The Human Figure in Early Greek Art, Washington, Kansas City, Los Angeles, Chicago and Boston, 1988-89

The Lost Image: Comparisons in the Art of Higher Primates, Introduction by Mervyn Levy, Royal Festival Hall, London, 15 September – 12 October 1958

Arnulf Rainer. Nachmalungen, Kopien von Schimpansenmalereien, Galerie Ulysses, Vienna, 1979

Arnulf Rainer, Berlin, Baden-Baden, Bonn and Vienna, 1981

4 Issues of newspapers and weekly magazines

Collier's, 22 January 1954

The Daily Sketch, 17 September 1957

The Daily Telegraph, 17 September 1957

The Daily Worker, 17 September 1957

Femme Actuelle (France), no. 560, 19-25 June 1995

Le Figaro (France), 6 March 1995

Le Soir (Belgium), 26 January 1995

The New York Herald Tribune, 12 August 1957

The New York Times Magazine, 6 October 1957

The New York World-Telegram, 28 September 1962

Picture Post, 1 June 1957

Sciences et Nature/Natura Oggi, 1 May 1990

The Times, 17 September 1957

Vrije Universiteit Amsterdam Magazine, December 1990

Wetenschap, Cultuur en Samenleving, January-February 1995

Photographic Acknowledgements

The author and publishers wish to express their thanks to the following sources of illustrative material and/or permission to reproduce it:

Author's collection, Brussels: illustrations 4, 38, 39, 40, 41, 55, 56, and any otherwise uncredited photographs; Royal Zoological Society of Antwerp: 33; Werner Müller collection, Bavois (Switzerland): 6, 26, 27, 28, 29, 30, 35, 36, 37, 43, 46, 47, 52, 53, 57, 59, 60, 63, 64; Paul Aron collection, Brussels: 42; Jean-Paul Lang collection, Brussels: 45; Périer-D'Ieteren collection, Brussels: 44, 51; Musée des Beaux-Arts, Chartres: 8; Olga Davenport collection, Chelsea: 3; R. A. and R. T. Gardner, *Annals of the New York Academy of Sciences* (1978): 66, 67; Studio 9, Liège: 25, 54; Museo del Prado, Madrid: 7; D. Morris, *The Biology of Art*: 1, 2, 12, 17, 21, 31, 32, 65, Desmond Morris collection, Oxford: 5, 49, 62, 65; Jacques Münch, Nice: 34; Agence Photographique de la Réunion des Musées nationaux, Paris: 8, 10, 23; Bibliothèque Nationale de France, Paris: 9; Musée du Louvre, Paris: 10; Atelier Arnulf Rainer: 58, 68, 69; B. Rensch: 11, and from *Zeitschrift für Tierpsychologie* (1961), 18, 19, 20, 61, and from *Symposia of the Fourth International Congress of Primatology* (1973): 48; Musée des Beaux-Arts, Rouen: 23; P. H. Schiller, *Journal of Comparative and Physiological Psychology* (1951): 13, 14, 15, 16; Brian Worth: 3; and Yerkes Laboratory: 50.

Index